THE JUG
AND RELATED STONEWARE
OF BENNINGTON

THE JUG

and
Related Stoneware
of
Bennington

by
CORNELIUS OSGOOD

CHARLES E. TUTTLE COMPANY
Rutland, Vermont

REPRESENTATIVES

CONTINENTAL EUROPE
Boxerbooks, Inc.
Zurich

AUSTRALASIA
Paul Flesch & Co., Pty. Ltd.
Melbourne

BRITISH ISLES
Prentice-Hall International, Inc.
London

CANADA
M. G. Hurtig Ltd.
Edmonton

*Published by the Charles E. Tuttle Company, Inc.
of Rutland, Vermont & Tokyo, Japan
with editorial offices at
2-6, Suido 1-chome, Bunkyo-ku, Tokyo, Japan, 112*

*Copyright in Japan, 1971, by
The Charles E. Tuttle Company, Inc.*

First edition 1971

Book plan by Roland A. Mulhauser

*Library of Congress catalog card no. 73-152111
International standard book number 0-8048-0888-0*

PRINTED IN JAPAN

TO THE MEMORY OF
HARRIETT KEENEY OSGOOD
1905-1962

CONTENTS

ILLUSTRATIONS

Maps and Text Figures

Color Plates

Black and White Plates

Note: On the captions for each of these plates the following symbols are used to identify the various items shown:

UL: Upper left UM: Upper middle UR: Upper right
LL: Lower left LM: Lower middle LR: Lower right

PREFACE

MANY ARE THE REASONS that bring a book into existence. Most of them are special and curious, and not a few may cast light on the work itself. It is worth insisting that the better one knows a writer, the more comprehensible is his presentation.

I happen to like jugs. The broad shouldered ones thinning off toward the base appeal to me most. I enjoy the touch of their cool bodies in summer and the uniform unevenness of their salt-glazed skin. I am old enough to remember as a boy the common use of the jug, to remember the admiration I had for a man who in an unconscious rhythmic gesture could swing a jug into the crook of his arm and allow the mouth to settle gently against his own. I remember later how the liquid splashed over my face when I tried to swallow, and the laughter that followed. Then in time I learned that a jug could hold a man's drink that was not shared with boys. For a while, after I was grown, I was not particularly aware of jugs. If, between World War I and World War II, there was one in the house, I do not remember it.

When peace returned for the second time, my wife and I were middle-aged and we spent more time driving around New England. She was not very well, tiring easily under the restraint of sitting in a car, and she took advantage of antique stores in order to walk about. Since we were lacking in local antiquarian tastes, she found the owners more attractive than their wares, and they responded to her warm and easy friendship. I do not ever remember being pushed toward a purchase but I was sometimes asked by way of helping me to find it if there was anything I would like. With intent to please, I looked.

One day I found a jug, old and pot-bellied, with a delicate underglaze design in blue. It cost only a dollar or two, and I left it in our house in the hills. Afterward, buying a jug became something to do. For some of my friends and intimates to whom a collection of jugs seemed strange, I explained that, having discovered a wonderful spring of water in Vermont, I was acquiring the jugs with the prospect of eventually retiring in that state to make whiskey. The unlikelihood of that intent made them laugh.

If the initial cause of my purchasing a jug was lightly motivated, the continuing acquisition was soon rationalized. In the course of my anthropological career, I had been involved in sufficient archeological research to appreciate any features of pottery that facilitate dating. The jug that I first acquired bore a stamped Bennington mark which I had been informed was the equivalent to a dated period, one of a series shown me in *The Potters and Potteries of Bennington* by John Spargo. It was inevitable that I would set out to collect a Bennington jug of each and every mark so that in the end I would have a verifiable demonstration of the change in the shape of an artifact over time.

It is not to be expected that people will become excited merely by the anticipation of acquiring such knowledge, or at least not many. My interest was strongly reinforced by another rivet in the specialized structure of learning. For years, among other activities, I had been teaching Chinese culture to graduate students in anthropology at Yale. The subject has numerous ramifications, most of which I knew less about than I would have liked. With Chinese ceramics, however, I had early become familiar, a fact due to my archeological training and to my wife's early devotion to the creations of the T'ang dynasty (618–907). Then as an intellectual exercise shortly before an interest in Vermont jugs was thrust upon me, I had begun a study of blue-and-white Chinese porcelain with a view to evaluating shape as a criterion for distinguishing age. I was not overly fond of blue-and-white porcelain, but it does represent the longest continuous series of one kind of ware as well as the most widely diffused technique of ceramic decoration in the world. Curiously, blue-and-white potsherds had become significant time indicators in some aboriginal American sites, the diffusion of this Chinese porcelain having resulted from the Spanish trade passing through Mexico in the sixteenth and seventeenth centuries. In China, the production of blue-and-white porcelain between 1723 and 1735 reached a technical standard that has never been

surpassed; it was underglazing in cobalt blue of uttermost perfection.[1]* Aware of these facts, how could one overlook a jug with cobalt blue under its salt glaze, an expression of rural American craftsmanship at the opposite end of the range of complexity? It is the surfeits of sophistication that often lead one to an appreciation of the primitive.

Before a hundred jugs had been amassed in the second decade of collecting, it had proved impossible to resist the attractions of other Bennington pieces— a dated churn, a huge crock for potting cheese, a spouted batter pail covered with brown Albany slip, an ornate basket of flowers on a butter jar. Type, size, glaze, and decoration, all were of significance for one interested in American culture and, as opportunity offered, other examples were salvaged to sit in the company of the jugs. One cracked jar was recovered from the cellar of a Vermont cousin's farmhouse, it almost certainly having been in this same family for over a hundred and twenty-five years.

From examinations of museums, it was soon realized that earlier collectors had little appreciation of nineteenth century, salt-glazed stoneware. These creations were too commonplace. For the most part, unless a piece bore decoration of exceptional merit, it was not acceptable. Even the unique aggregate of ceramics in the Bennington Museum did not suffice to tell the story of this simple aspect of the potter's art. Pieces of white Parian and of the blue with the pitted ground, of white granite ware and of Rockingham numbered into the thousands, while pieces of the daily utilized pottery of the common people amounted to only a few score. For some people this simple stoneware is the most beautiful product of the Vermont kilns. Clearly, it deserves a more complete presentation in museums and this fact will eventually be realized. In the meantime, we shall try to make Vermont salt-glazed stoneware more meaningful to all who share our affection for a jug.

CORNELIUS OSGOOD

* References to sources are grouped together at the end of the volume. See pp. 213–216.

INTRODUCTION

To Appreciate a Jug

THE JUG HAS BECOME a symbol of traditional hospitality and refreshment to Vermonters, both native and adopted. Now most conspicuously found as the door ornament of town and village houses, the jug of the centuries past was the conveyor and repository of highly appreciated kinds of food and drink such as molasses and cider. In common use during that first three hundred years of New England history beginning with the landing of the Pilgrims in 1620, the great period of the jug was only reached during the nineteenth century when the technically superior salt-glazed stoneware supplanted the earlier earthenware and the art of underglaze decoration in cobalt blue became a distinguishing feature (Color plates, pp. 89–96).

By chance, a young potter of Goshen, Connecticut, moved north to settle in Bennington, Vermont, late in the eighteenth century, thereafter establishing a tradition of craftsmanship that survived in the same family for a hundred years. Thus, one town became perhaps the most famous in America for its production of handmade, salt-glazed stoneware. It is consequently reasonable and necessary, if one wishes to have a true appreciation of a jug, to comprehend the antecedents, development, and products of the kilns of the Norton family at Bennington over a period of pottery-making that extended from 1793 to 1894.

In our attempt to provide this essential information, we shall set forth such facts as may be required for a brief history of pottery from the earliest days, after which we shall turn to the ceramicists for technical data which we shall try to refine into statements of effective simplicity with respect to the understanding of stoneware. This done, it will remain to summarize the pertinent

17

knowledge now available on the early potters of New England and New York, completing our survey by devoting especial attention to the Nortons themselves. Finally, we shall return directly to the jug and related types of stoneware, outlining their varieties, their variations in size, as well as their changes in shape and in decoration during the course of a century.

A Brief History of Pottery

The exact circumstances surrounding the invention of pottery will never be known but they may be conjectured. It was perhaps noticed that the substance we call clay hardened when in contact with a hot fire, the latter perchance having been built on top of a layer of that material. Children who have a natural propensity for playing in the mud may have discovered that clay is a plastic material easily rolled into balls or pressed into simple forms. Such creations might then have been dropped into a fire and there hardened.

Man developed his tools and implements slowly over hundreds of thousands of years and it is not likely that fabricated vessels were among that first group of manufactures which consisted of stone hammers along with cutting and perforating tools, plus invaluable lines devised from skins, roots, and bark which, being impermanent, have often been inadequately appreciated. When the desire arose to transport and store liquids, natural containers such as the gourdlike plants and the visceral sacs of the larger animals undoubtedly attracted attention. Much later when complex implements were developed out of simple ones, single lines were tied into netted bags and the process of weaving was discovered, thus bringing about a new era of technology. Nevertheless, containers still had serious limitations. They would not keep out rodents and other pests and, as far as those holding liquids were concerned, they were delicate and could not be used in direct contact with fire.

What led the primitive genius to recognize the possibility of forming clay into a receptacle and then fire-hardening his creation remains a mystery. Possibly clay was first used to coat baskets. Perhaps tiny pots, accidentally conceived, were elaborated into utilitarian ware. There must have been many periodic attempts with unsatisfactory results before the procedure became

practical and put into consistent use. After all, pottery fired at low temperature is not only exceedingly fragile but will not readily hold liquids.

Fortunately for the archeologist, earthenware which has been fired at medium to relatively high temperature has great endurance, if only when reduced to fragments, and consequently potsherds have become one of the best records of the existence of prehistoric peoples and the changes that have taken place in their cultures. It is true that not all primitive tribes have enjoyed the benefits of pottery and not a few have continued to the present day without such utensils. For the majority, however, the acquisition of pottery has been an early symbol of cultural advancement.

Despite the great improvement in exact archeological dating during the past fifty years, a determination of the time when a cultural trait first appears introduces special problems and always must be considered revisable on the basis of new discoveries. From the viewpoint of the third quarter of the twentieth century, it seems probable that pottery of survivable quality was independently originated as part of man's aggregate of utensils in at least three different regions of the world. These three areas are far enough apart to leave little doubt as to the originality of the several developments. It must be added, however, that there are a few other cases of pottery existing within more diffusable distances that have also been claimed as examples of independent invention, and such instances cannot in our present state of knowledge be entirely ruled out.

The most generally effective method of dating early pottery came through a combination of the discovery of carbon 14, a determination of its half-life (5730±40 years), and the development of an adequate means of measuring the carbon samples that were submitted. This contribution to science was achieved in 1949 and corrected in 1962.[2] To use this method, however, it is not sufficient to find the ancient handiwork of man but the latter must also be clearly associated with a deposit of carbon. Luckily, pottery is often found with charcoal remaining from cooking fires.

Up until now, the most ancient sites containing pottery have been found in Asia, the reported series of early carbon 14 dates ranging from before 10,000 B.C. in Taiwan (Formosa) down to 7,500 B.C. in Japan.[3] It is not unlikely that even older pottery sites will be discovered in China when more time has been allowed for the expanding archeological work in that country.

Our second oldest group of dated pottery sites are in Iraq, these being of approximately 7,000 B.C. In the Near East also, the age of ceramics may ultimately prove to begin earlier. Finally, we have a date of approximately 3,000 B.C. for the appearance of pottery in Mexico with little likelihood that the tradition of ceramics in the New World can be other than an independent invention. Indeed, the rise of pottery about a thousand years later in what is now the southeastern part of the United States is by some archeologists considered a separate cultural florescence, although most authorities would probably concur that diffusion is responsible as it certainly was for the spread of aboriginal pottery into what is now the New England states in roughly 1,000 B.C.

The Achievements of China and Europe

Although it is beyond the scope of this introduction to outline the early development of pottery over the entire world, it may be illuminating to do so succinctly for China. This is because in no other area has the ceramic industry had such a complex and culturally meaningful history, even though an older continuous record exists for the Near East. To this survey we shall add a résumé of discoveries and importations in northern Europe. With these stages of ceramic evolution briefly presented, it will be possible to fit the folk art of Bennington into the series and thus gain perspective on our more narrowly delineated subject.

Pottery begins with primitive earthenwares, products which do not require finely washed clays or burning in fires of high temperatures. Curiously, the oldest sherds of which we know, even within the broader reaches of what is now China, date from perhaps no earlier than 5,000 B.C.[4] This so-called Gobi pottery of Mongolia which has a brownish-gray color is a type of ware that was common to much of the adjacent circumpolar region.[5] It was apparently modeled by hand and baked in an open fire. Later in this Neolithic period, both red and black earthenwares appeared in northern China proper.[6] Certainly before 2,000 B.C., the potter's wheel had come into use and the vessels were being fired in specially constructed, roughly square, dome-shaped kilns with fire pits beneath them.[7] A greater heat was thus

supplied in the burning, probably for the most part between 800° and 900° centigrade (1472 and 1652°F.) but in certain cases perhaps reaching 1050°C. (1922°F.).[8]

It was during the millenium after 2,000 B.C., however, that the great discoveries were made. In those literate and civilized times, generally referred to as the Shang period, there was apparently a demand for vessels that would hold water or wine, and the potters, having experimented with hotter fires and discovered clays that would withstand the greater temperatures, created stoneware. The secret was simply to find sufficient fuel as well as clay materials that would not melt out of shape when the heat of firing—at least in excess of 1050°C. (1922°F.)—was sufficient to consolidate the texture into a mass solid enough to prevent clear liquids from permeating the walls. The kilns themselves had been improved, taking on a round shape and having heat vents opened between the fire pit and the pot chamber, as well as tubular chimneys in some cases.[9] All this happened in the period preceding the great development of bronze casting, also an amazing technological achievement, the Chinese devotion to which may have influenced subsidiary ones in ceramics.[10]

Another fundamental discovery was the pure white clay known as kaolin from which the Chinese produced the first white pottery early in the dynastic period of the Shang (1751–1111 B.C.).[11] These unique vessels, always relatively rare and sometimes beautifully engraved, were formed both by the beater method and by being turned on the wheel, then being fired at about 900° to 1000° centigrade (1652 to 1832°F.), a temperature much lower than that required for stoneware.[*12] As proficiency in working metals increased in China, the technical skills demanded of the ordinary potter diminished and the wheel was less used than at an earlier time. Actually, ceramics lost rather than gained distinction until almost the end of the following Chou dynasty (1111–206 B.C.).[14]

Toward the end of the latter dynasty, however, the situation was reversed. Metallurgy decayed while the anciently discovered art of making stoneware was revived by the discovery that a new combination of materials (feldspar, clay, and laterite) would produce a superior grade of vessels that technically

* In one source the firing temperature has been stated to be as high as 1125°C. (2057°F.), but as the pots are soft-bodied, or earthenware, complications appear in accepting this statement.[13]

approached the threshold of porcelain—that hard, translucent, almost white stoneware which itself is simply called china.[15]

Glaze, the thin glasslike coating commonly used on pottery, had apparently been developed by the Chinese early in the Shang period, but an analysis of its composition, it would seem, has yet to be made.[16] By the Han dynasty (206 B.C.–220 A.D.), an alkali glaze was being generally used[17] and the elaboration of porcelain and other glazes followed rapidly thereafter. For many centuries, the glazes constituted the principal decoration of the pottery apart from the modeling of the clay. Incising and molding, known from prehistoric times, did not entirely disappear but, for a long period, these methods were seemingly overwhelmed by the power of color in the brilliant glazes of the yellow-green-blue hues. During the T'ang dynasty (618–907 A.D.), the control of glazes became greater and it was possible to overlay the pottery in intricate designs. The painting of pottery in complex patterns using simple pigments had been known from prehistoric times, but that technique could not be used on stoneware since ordinary pigments would not withstand the increased heat of firing.

During the Sung dynasty (960–1280), one solution was found to resolve this problem. The decoration was simply brushed on the stoneware in the ancient manner *after* being subjected to the necessary high firing, and then the pieces were re-fired at a lower temperature to solidify the pigments which, at this later period, were mixed with fine clay and are usually referred to as enamels. Shortly thereafter, a second and more versatile solution to the problem of painting on stoneware was developed, the initial process apparently being borrowed from the Persians.[18] This consisted of applying cobalt with a brush to the clay body of the ware before a transparent glaze was added and before the pottery was fired at a high temperature, it having been discovered that this exceptional blue pigment could tolerate such heat. From the Ming dynasty (1368–1644) onward, when Chinese blue-and-white ware had arrived at great esthetic distinction, technical proficiency in both pottery and painting continued to improve, reaching ultimate heights in the later Ching dynasty (1644–1911).

Chinese porcelain had begun to spread westward overland—as well as to Korea, Japan, and southeast Asia—soon after its discovery. The first white wares of the T'ang dynasty (618–907) have been found in the ruins of the

short-lived city of Samarra north of Babylon, necessarily having been deposited there in the ninth century. Then in the Ming dynasty (1368–1644), the great spread of celadon and blue-and-white wares began, first across central Asia and then over the sea routes, carried by those ships of the Dutch East India Company, founded in 1609, that traded into the ports of south-eastern China, as well as by those of the British East India Company, which followed in 1631.[19] The acquisition of porcelain became a mark of sophistication and wealth in the capitals of the West, and great collections were made by emperors and kings.

In passing, it is perhaps worth noting that the civilization of Europe, lacking the invention of porcelain, had, as an unconscious cultural compensation, in large measure concentrated on glass for the creation of objects of similar ornamental and practical use. Glass, on the other hand, although known to the Chinese at least by the Chou dynasty (1111–206 B.C.), was one of the earliest trade objects from the West where it had been manufactured perhaps as early as 2900 B.C.[20] In China, it was still cut and treated as were valuable stones until porcelain was discovered, however, after which time, the role of glass was overwhelmed by this new ceramic material because of its multiple potentialities.

Pottery, of course, had been made in the West from very early days and the decoration of such earthenware had achieved a great florescence under the hand of Attic painters in the Golden Age of Greece. The Romans who inherited their ceramic traditions from multiple sources produced not only alkaline silicate glazes akin to glass, but the more tractible and adhesive lead silicate glazes as well. After the collapse of Rome, the art of glazing earthenware was lost until about the tenth century when the lead glazes were reintroduced probably from Byzantine sources. These, being mixed with glass and tin oxide, provided the opaque surface of the various Islamic, majolica, and Delft wares.[21] Earthenwares of one kind or another continued to be made by peasant potters everywhere in Europe, except perhaps in England after the fifteenth century.[22]

It was some time between the ninth and fourteenth centuries that the important technique of making stoneware gradually developed in the area along the Rhine.[23] Excellent clays were available and the thickly forested areas of northern Europe provided the great supply of fuel necessary to heat from

1200° to 1400° centigrade (2192 to 2552° F.) the primitive kilns that were still used.[24] Then about the beginning of the sixteenth century came the discovery of the relatively simple process of salt glazing in which the glaze does not have to be applied directly to the pottery, the salt (sodium chloride) merely being tossed into the heated atmosphere of the kiln to spread as a vapor over its contents. It is recorded that the salt-glazed stoneware of Cologne was fabricated in 1540 and continued thereafter,[25] while such stonewares were manufactured in England from about 1684.[26] Interestingly enough, this uncomplicated and effective method of glazing was never used by the Chinese,[27] unless the unanalyzed glaze of the Shang period was produced in an analogous manner. Indeed, we know of salt glazing nowhere in Asia except possibly for the coating on the ceramics of Imbe, in Bizen province, Japan, where the burning of seaweed seems to have given a coincidental result.[28]

The first Chinese porcelain had appeared in Europe at the latest in the fifteenth century.[29] For a considerable period no one understood how it was made and the Italians tried to copy it by adding quantities of ground glass to their clays. By the beginning of the eighteenth century, however, the Germans had discovered the right combination of materials, and the first true Western porcelain began to be manufactured at Meissen in 1709.[30] The technique spread over much of Europe in the next sixty years, porcelain being produced, for example, in Russia in 1745 and at Sèvres in France in 1769.[31]

The Europeans, however, had not waited to copy the now-famous blue-and-white Chinese designs, the Dutch factory at Delft which flourished between 1650 and 1750 being perhaps best known for so doing.[32] Such contemporary copies of K'ang Hsi ware, although not porcelain, remained highly appreciated, but they never supplanted the Chinese originals which were spread over the Western world by vessels carrying as many as a half a million pieces on a single voyage. Up until the present time, these blue-and-white patterns are still produced on pottery and porcelain wherever it is made.

When we consider the stoneware of Vermont against this background of the history of ceramics, we may quickly and correctly presume that the techniques of high firing and salt glazing were inherited from the original Rhineland potters although, as we shall see later, they were not introduced into America until long after the establishment of the first European settlers. As

for the typical decoration in underglaze blue, we may recall that the cobalt pigment went from Central Asia to China where it was highly appreciated. Cobalt, however, was also available in Western Europe which became a prime source of this material. It was the immense technical and esthetic impact of Chinese blue-and-white porcelain in the seventeenth century, however, that made underglaze designs in blue so popular, as well as their adaptability for the decoration of high-fired stoneware. As for the designs themselves, few of them that decorate Vermont jugs can be conceived of as other than the creations of New England folk art.

THE TECHNICAL ASPECTS
OF CERAMICS

The Process

BEFORE GOING ON to consider the pottery of New England, it may be well to make sure of our vocabulary and to examine in somewhat greater detail the technical aspects of the ceramic industry. We shall begin with a survey of clays—the basic material—and then proceed to outline the method of forming it into jugs and various other shapes, adding a brief description of the means of immediately ornamenting the newly-formed clay ware. Then we shall take up the processes of drying the clay ware, of decorating it, and finally of firing the ware in the kiln, leaving the specialized subject of glazing to the end.

Clays and Fillers

Clay is a widely distributed, unctuously plastic material when wet which becomes hard when baked in a fire. There are three important classes of clay minerals and, of these, kaolinite, a hydrated aluminum silicate (Al_2O_3. $2S_1O_2.2H_2O$), comprises the chief constituent of most high grade clays. By use of the electron microscope, kaolinite has been discovered to consist like other clay minerals of platelike crystals which, when water has worked between them, readily slide back and forth as would a sandwich of liquid between two slices of glass.[33] Since the pieces hold whatever shape is given them, clay can be formed in the hands.

The clay minerals result from the decomposition of the readily altered

feldspars in igneous rocks.[34] When they remain in contact with such rocks, they are called residual, or primary. If, on the other hand, they are carried away by water, wind, or glaciers and deposited elsewhere, such clays are referred to as transported, or secondary.[35] Whether one or the other, they are never free of impurities, although the purer they are, the whiter they are.[36] The most famous Chinese clay, for example, is a residual clay of the purest kind. Some residual clays, however, are red and of low quality,[37] but most red clays, colored by iron oxides, have been transported.[38] Transported clays may also be nearly white, but the majority of all clays are colored, ranging from cream through yellow and red to gray and black. Except for the fact that white clay and white pottery have a constant color relationship in the sense that white pots must be made from white clay and white clay produces only white pots, the color of unfired clay is no indication of the color of the resultant ware, or vice versa. This is because the chemical content of the clays combined with the method of firing them often cause a change in the color.[39]

After clay has been recovered from natural deposits, it must be prepared for the potter. Clay from deep deposits has to be spread out to weather for considerable periods, while clay dredged from the shores of rivers or lakes needs no exposure.[40] In either case, however, extraneous matter may be removed. The Chinese did this in preparing their fine porcelain by a method called elutriation in which the clay is suspended in water, the heavier particles falling to the bottom, while the lighter are carried off for a continuation of the process in tanks below.[41] Content with the opposite extreme in refining, primitive potters merely picked out the larger inclusions by hand.

Once cleaned to any degree, the clay must then be cut, beaten, and rolled into an even consistency. This long and often arduous procedure, called wedging, also may be achieved by hand, although simple machines not unlike butter churns were used in nineteenth century New England, while larger factories adopted an invention known as a pug mill for this purpose.[42]

From the potter's standpoint, the plasticity of clay is extremely important. He wants material that can be formed easily in his hands and then retain its shape. The ordinary, transported red clays are of this type, and even those that are relatively pure are more plastic than the residual kind.[43] Indeed, they are often too plastic and too subject to shrinkage in firing, in which case

they are called fat, long, or rich and must be mixed with extraneous material to stiffen them. Any such addition, which may range from sand to shell and from sponge spicules to feathers is called filler or, more often by archeologists, temper.[44] One convenient and useful type of filler consists of ground up pieces of pottery of which there are always many discards, referred to as wasters, around a kiln. Brick or tile will do as well, and such filler that has already been subjected to firing may be specifically identified as grog.[45] It should be appreciated that while filler stiffens the clay and reduces shrinkage, it also weakens the body; sand weakens it most, however, and grog does so least.[46] When clay has an excess of temper it is called lean, short, or mealy since it cannot be readily shaped.[47] Also, high temperatures in the kiln affect the filler, thus making only certain types effective for the manufacture of stoneware.[48]

Forming and Preliminary Ornamentation

The next step in pottery making is to give form to the prepared clay, the latter being referred to as a body.[49] The primary treatment of the body may be divided into three categories, the first being direct forming with the hands, while the second requires molds, and the third depends on the potter's wheel. With the basic shaped achieved, the body may then be given subsidiary additions and surface ornamentation. We shall summarize each of these potentialities for treatment in turn.

The simplest method of direct forming is by squeezing or pinching the clay body. Indeed, to do so is childplay and too simple for even most primitive potters who usually prefer to construct their wares from coils or rings of clay, although others may piece them together from flattened, cut out slabs.[50]

More sophisticated is the creation of shapes with the use of molds, the clay being either pressed into them or diluted in water to a soupy liquid termed slip and then poured into the molds. This latter technique is even more advanced, however, requiring porous ceramic molds which allow the slip to dry.[51]

The most distinctive method of forming the clay body is by use of the potter's wheel, the characteristic tool of the trade which we have already noted

was known in China and the Near East thousands of years ago. Sometimes clay pressed into molds is placed on wheels and worked with templets as the mold revolves, but the traditional forming on the wheel consists of pressing and drawing the body clay upward into a desired shape as it whirls around counter-clockwise under the impetus of the potter's right foot.[52] Also these methods may be combined. A large jug, for example, may have a molded base, sides constructed of rings, and a hand-modeled neck.[53]

The secondary treatment in the forming of the clay ware gains its name because it takes place after the primary work has been completed, not because it is less essential. Typical is the application of special parts such as handles or spouts, the latter usually being made by wrapping a flat piece of clay around a stick or a finger and then pushing the tube of clay either against or through a hole in the wall of the vessel before firming it in place.[54] Clay ware may also be cleaned up with a knife after forming, a procedure called fettling.[55]

With the functional features of the clay ware completed, most potters have a concern for decoration. One of the earliest methods of ornamenting a vessel was to impress its surface with shells, cords, or various other implements. All-over patterns made with stamps soon followed, and probably smoothing the entire surface of a piece of clay ware with a wet hand or cloth should be mentioned among these basic treatments of the piece as a whole.

When we think of more specialized designs, incising comes to mind. Although such cutting is usually simple, in its most elaborate form, the clay may be tooled out in patterns and then inlaid with a clay which will fire in another color. This technique is one of the distinguishing features of some of the celadons made in Korea during the Koryo dynasty (918–1392).[56]

Another simple procedure is to apply a piece of clay to the damp surface of the ware and then press or tool it into an ornamental form. Potters soon elaborated upon this method by modeling or molding the decorative piece before fastening it to the vessel.

Drying and Decorating

Whether or not any decorative treatment described above has been given the clay ware, it must be dried to a certain degree or the moisture in the walls

may turn to steam and blow the vessel apart when fired. In hot climates this necessary drying can be achieved by placing the pottery in the open air but, in temperate regions, drying is more difficult and especially so during the winter.[57] One solution, of course, is to form the clay ware only in the warmer part of the year; another is to set up a drying oven in the potter's workshop.[58] In either case, the clay ware in the process of becoming leather-hard usually spends a longer or shorter time spread out on the ground or on shelves awaiting further treatment. This preliminary drying which still leaves 8 to 15 per cent of the superficial water in the clay can be essentially disregarded by the primitive potter who expects no more than imperfect results from his labors.[59]

Leather-hard ware may be shaved down and trimmed after placing it on the potter's wheel or on a lathe. Also the surface may be burnished by rubbing it with a smooth, hard, round-faced tool which may vary from a water-worn pebble to a specialized, modern implement. Again this may be done freehand or with the vessel placed on the wheel.[60] Incising, incidentally, cannot be effectively carried out on leather-hard ware except in straight lines.[61] On the other hand, handles, spouts, and decorative elements may be fastened on to the leather-hard ware by using some slip as one would glue. This method of attachment is called luting. Such additions, of course, lack the integrated strength that they would have were they worked into the damp clay ware.[62]

Slip consists merely of clay in water with the varying consistencies of cream gravies. Slip clay usually has a finer grain than body clay and is often of a lighter color, its usual purpose being merely to improve the appearance of the ware. Normally, the ware either is dipped into a container of slip or the slip is poured over the ware but, for special effects, it may be brushed on.[63] A more elaborate procedure is to make simple freehand designs by applying the slip through a tube as though one were icing a cake. This method, which is called slip-trailing, was sometimes carried out in colonial America by means of an implement consisting of quills inserted through a clay cup.[64]

Glaze, the application of which parallels that of slip, may be added over the slip, or directly over the leather-hard ware. This material which supplies a glasslike, impermeable coating to ware and colorful decoration as well, is more important than slip, and infinitely more complicated. Glaze is mentioned here, however, merely to show its place in the manufacturing process

which the more detailed consideration reserved for a later presentation might well confuse.

To conclude our discussion of the drying and decorating of the ware, we must mention painting, or the application of pigments by brush to produce simple or complex designs, pictures, writing, numbers, or dates. Such treatment was known on earthenware from the earliest days, but was severely restricted when raising the temperature in order to fire stoneware resulted in burning off the commonly used paints. A new method of adding color to pottery had to be perfected. This problem will be clarified as we turn to the procedure of firing and when we elaborate on the constituency of glazes.

The Kilns and Firing

The basic problem in the manufacture of ceramics of high quality is the control of the firing of the clay ware, satisfactory solutions having been found only after thousands of years of effort. If one thinks in evolutionary terms, one can set apart an early stage when pots were baked without recourse to a special oven. Perhaps the most primitive procedure was to place the modeled clay at the edge of the household fire, periodically turning another face of the vessel against the flames. Interestingly enough, this method has survived into modern times in peripheral parts of the civilized world.[65] From such beginnings it was not a difficult step to build a special and larger fire surrounding a number of pots.

A technical leap forward was achieved when someone conceived of building an enclosure over the pots to hold the heat in. There was still the weakness of having the clay ware and the fire in too close association which resulted not only in uneven baking but also in breakage caused by collapsing fuel. This difficulty was resolved by placing the fire in a pit and stacking the pottery above on flooring with vents through which the flames could rise to lick at the clay ware. With this arrangement, the kiln, or ceramic oven, was born.

Gradually, improvements were made with the ultimate discovery that even greater heat could be obtained from wood fires if flames entering at one side of the kiln could be deflected off the roof of the kiln by a downdraft, thus exhausting the fumes near the base of the opposite side of the kiln. A baffle

was positioned to protect the stacked pottery from the direct fury of the fire. We should add that the stokeholes of kilns were usually placed so as to face the prevailing winds.[66] Also, we must note that the size of the kilns expanded considerably. The first ones were undoubtedly small, but as technical skill in stacking and firing the ware increased, kilns reached considerable size. It is reported, for instance, that most medieval European kilns could accommodate about two hundred average-size pots.[67]

Before going further, it may be helpful to review the results that can be desired in firing clay ware. The first thing is to harden the piece so that it will retain its shape with careful use. The second and technically more advanced goal is to fire the piece at a higher temperature so that the outside—and only the outside—surface melts. This process is called sintering. Then when the melted surface cools and congeals, the pot will not only retain its shape, but will have been sealed off so as to hold liquids. Ceramics that have been successfully fired to the sintering point thus become stoneware as distinguished from the lesser-fired earthenware.

As so often, the procedure is not quite as simple as it seems. Clays, after they reach their sintering point, will begin to vitrify which, in ordinary terms, is to say that the whole clay body begins to melt. Inevitably, at a certain temperature, they start to sag out of shape and, if the heat increases enough, they will ultimately collapse as does molten glass. Such results are ruinous to the potter and he becomes vitally concerned with the maturing temperature of his clay, an expression which may be defined as the highest temperature at which clays will retain their shape.[68]

The sintering, maturing, and vitrifying points of different clays vary. The common red clays used for making earthenware mature between 1000° and 1200° centigrade (1832° and 2192° F.) but contain so much flux, or material that will make them flow, that they will vitrify almost as soon as they sinter.[69] For stoneware, only clays which vitrify more slowly can be used, but such clays will not sinter except at temperatures from 1200° to 1300° centigrade (2192° to 2372° F.).[70] The relatively pure residual clays from which porcelain is made must be fired at over 1300° centigrade to make them sinter, and then only when fluxes such as soda, potash, lime, or similar materials have been added. To prepare such clays and create such heat was a special problem. Pure kaolinite, it may be noted, vitrifies at no less than 1770° centigrade

(3218° F.).[71] With these basic facts in mind, we can now turn to the manner of firing a kiln.

Placing the pottery in the kiln so that it will be fired effectively has always required meticulous care to avoid breakage and, especially when glazes are involved, to prevent the pieces from fusing together. Also the arrangement must follow a pattern in which each piece is exposed to the proper amount of heat. With experience, a kiln can be set or charged, as they say, with little or no loss, the pieces, one straddling two beneath with wedges or bars of clay used to provide bearing surfaces. Plates and other open shapes may be stood on end in rows, each piece then being separated by small bits or pins of clay —often multi-pointed—which are known as spurs. These are particularly needed when over-all glaze is applied before firing. A protruding ring of clay may be left unglazed on the base of a piece to prevent sticking but, interestingly enough, such foot-rings were seldom if ever formed by the early potters of New England.[72] In the case of fine porcelain dishes, each piece is usually placed in its own pre-fired, covered, refractory clay box, which is known as a sagger—a quick, if corrupt, way of saying a safeguard.[73] With everything in its proper place, the openings used to charge the kiln are blocked up.

The actual firing of a kiln involving the control of fluctuations in temperature required great empirical skill until very recent times as the kiln master was forced to make his judgments by the changes of color in the contents of the kiln and in the gas and smoke that escaped from it. In recent times, a series of standardized pyrometric cones have been made available, each melting at an established temperature. The kiln master can thus easily determine when each stage of required heat has been reached.

Although the highest levels of temperature will vary according to the type of clay being used and the type of pottery being made, it has long been necessary for the kiln master to plan his firing according to stages. These we shall arbitrarily present as four in order to simplify comprehension. The first stage consists of a small fire for the purpose of gradually dehydrating the remaining superficial water in the leather-hard ware. This preliminary heating called water soaking is carried out over a considerable period of hours after the temperature in the kiln has been slowly brought to 100° centigrade (212°F.). In the second stage, the temperature is again allowed slowly to rise so that changes in the molecular structure of the clay bodies will not cause destruc-

tion by too rapid expansion. Quartz inclusions, for example, may increase about 2 per cent in volume. At the same stage, water in chemical combination with the constituent elements of the clay will be lost. Again the ware is held at a steady temperature or, as they say, subjected to soaking. Once more the heat is slowly intensified, this time to the maturing temperature of the clay where it is held for the process called annealing. This done, the fourth and final stage begins when the fire is banked and the long period of gradual cooling begins.[74] All in all, the firing of the pottery will last for several days during which almost constant attention is required by those involved in the work, and the cooling may well last equally long.

In conclusion to this section on firing, we should mention muffle kilns, the subsidiary and specialized ovens that are used for re-firing at low temperatures the decorative paints and enamels that may be added to pottery that has already been subjected to high temperatures.

Glazing

A glaze is a complex material applied to the surface of earthenware so as to form a thin, glasslike coating in order to make the clay body impermeable or, similarly applied to stoneware in order to provide a smooth surface or decorative effect. The basic material consists of inorganic oxides, and especially silica.[75] One may think of glaze in two categories. The first is one that will modify the surface of the ware itself so that a vitrified film will be formed. The second, consisting itself principally of clay, is one that will melt at a temperature effectively lower than the body of the ware it covers. The glazes of the first category may be considered as consisting of two basic types—lead glaze and alkaline glaze—the latter varying according to the dominance of such materials as feldspar, limestone, wood ash, or salt. Most of these glazes are prepared as a simple suspension in water known as raw glaze which can be blown or painted on the ware before firing, or the ware may be dipped into a container of the liquid. Glazes of the second category are termed slip glazes and are usually applied by dipping.[76]

Two subtleties remain with respect to glaze which we can only suggest in words, a true knowledge depending on experience which potters themselves

acquire only after long devotion to their trade. The first bears on the fact that any glaze has to fit the leather-hard clay on which it is placed so that the contraction of each on cooling will be approximately in the same degree.[77] A slight variation will produce an intentional or accidental shattering of the glaze which, when considered decorative, is called crackle. If there is a greater variation, however, the pieces will be ruined. As a result of the necessity to fit, the basic varieties of glaze are largely limited in use to one class of pottery. Lead glazes for example, can only be applied to earthenware because they volatilize and disappear in the atmosphere when fired above the 1150° centigrade (2102°F.) that is required for stoneware.[78]

The alkaline glazes demand various temperatures to mature (i.e., to flow freely), and they are also capable in some instances of injuring the clay ware, in which cases they must first be partially fused over a fire and then ground up when cool, after which they too can be applied as a suspension in water. Subjected to such treatment, they are called fritted glaze. In this group, feldspathic glazes require the highest temperatures to mature and are therefore adaptable for coating porcelain clays. They constitute the great ceramic discovery of the Chinese from which we derive the name petuntse (pai tun tzu), or little white bricks, after the shape in which the material was transported. Petuntse, referred to by the Chinese as the "flesh" of the ware, consists of feldspar, kaolin, and quartz in approximately equal parts.[79] When properly fired, the glaze fuses with the kaolin body ("bones") of the porcelain.

Salt glaze is another special case, both in that it can be used only on clays maturing at a temperature close to 1250° centigrade (2282° F.)[80] and in that it is not applied directly to the ware but is thrown into the top of the heated kiln where it reacts with steam to produce, besides unused hydrochloric acid, sodium oxide which forms a thin orange peel glaze after contact with the silica in the ware itself. With a clay ware containing lime, a thicker glaze results.[81]

The second subtlety, of which words can give only an indication, involves the introduction of color into glazes. First of all, however, there is a relatively simple preliminary factor to be understood. It is the difference between firing a kiln with a full draft of air and firing it with only a limited supply of oxygen. In the first of these procedures which results in what has been called an oxidizing atmosphere, carbon is burned out of both the fuel and the ware.[82]

In the second, which produces what is called a reducing atmosphere, carbon from the fuel remains in the kiln to produce carbon monoxide, a greedy gas that will steal atoms of oxygen from various oxides, thereby changing their chemical structure. For example, the form of iron oxide designated ferric oxide (Fe_2O_3) will be reduced to ferrous oxide (FeO) by the theft of one of its oxygen atoms. The same type of robbery turns the copper oxide technically termed cupric oxide (CuO) into cuprous oxide (Cu_2O).[83] This has a great effect on what happens to the color of glazes and, although early potters did not understand the chemistry involved in such changes, they must have soon discovered that if their wood was damp, or their draft was weak and sooty, thereby spreading carbon through the kiln, the effect on the glaze was strangely and fundamentally different than the effect from a fire that burned clean in a bounteous draft of air.

When such oxides as those of iron, copper, cobalt, manganese, chromium, nickle, or tin were added to the glazes for color, all kinds of results might occur and, for most potters in most times, some of them came as a surprise, although not necessarily an unhappy one. For example, the ferric oxide mentioned above produces shades from pale yellow to a brown that is almost black[84] and, curiously enough, in small amounts, a creamy white.[85] Let a reducing atmosphere rob this glaze of oxygen, however, and the resultant ferrous oxide will startle the viewer with shades of green. Cuprous oxide contributes a different series of green to blue colors, while the slightest touch of copper itself will result in a red.[86] In summation, we can say that to appreciate fully the complexities of color in ceramics, one must realize that the endless hues and values result not only from the oxides in the glazes and the amount of oxidization or reduction in the kiln fire—conditions that can be alternated or changed by intention or accident,[87] but also result from the alkaline and acidic constituents in the body of the ware, from the temperature and duration of the firing, and finally from the rate of cooling of the ware. After this review of the technical aspects of ceramics, we can consider the history of pottery and its manufacture in New England.

POTTERY MAKING
IN NEW ENGLAND

A General Perspective

AS WE HAVE SEEN in our review of the developmental history of ceramics, both earthenware and stoneware were already widely available on the European continent in the early half of the seventeenth century at the time when the Dutch and the English established their colonies in America. Inevitably, pottery was brought across the Atlantic among the effects of the first settlers and it continued to be imported thereafter. Transporting relatively fragile objects of such bulk was expensive, however, and they sold in the New World for many times their value in England or on the continent. Since there was also a shortage of such utensils, emigrant potters attempted to meet the demand locally, well aware of the profits to be made from so doing. Within a few decades there seems to have been kilns in, or near, many of the principal towns of the colonies. Charlestown, Gloucester, Ipswich, and New Haven are examples, but there were also kilns in contemporary towns in New York and, at intervals, farther along the coast to the south.[88] Specific descriptions of the potteries are rare, but there are frequent references to local production. In literate New England where the records are the best and where investigation has been scholarly, we have evidence that by 1800, as many as 250 potters had been engaged in the trade, the first of whom was Philip Drinker who was working in Charlestown, Massachusetts, by 1635.[89]

The fact of greatest significance about all this early pottery made in America is that is consisted entirely of earthenware. As always, there was a combination of reasons responsible for this limitation. To begin their enu-

meration, stoneware was more complicated to produce, and the English immigrants did not know the technique. As we have indicated earlier, stoneware was not manufactured in Great Britain itself until about 1684, so that the early colonial artisans could not have been trained in that country.[90] Furthermore, we have no evidence that any of the early Dutch knew the technique either which, it is clear, for obvious reasons was carefully kept from popular knowledge by the continental producers. There is also the question as to whether the majority of the colonists could have afforded to buy stoneware in America had it been made, assuming that earthenware was available. Of course, stoneware had its obvious advantages, and it continued to be imported—mostly from the continent via England—for the satisfaction of the wealthy elite.

One more pertinent factor was the widespread need for brick, if only for chimneys. Actually, we know that bricks were made in at least four American colonies probably before 1630.[91] Not a few of the earliest potters apparently began as brickmakers, bricks being one of the simplest earthenware products. Brickmaking, after all, had been followed as a trade in Great Britain since the thirteenth century.[92] Indeed, the association of bricks with pots was a continuing one in New England for over two hundred years, although there were some brickmakers who did not make pots and some potters who did not make bricks.

A fact of corresponding significance to the dominance of earthenware during the first two centuries of American colonization is the rise in the production of stoneware beginning in the last decades of the eighteenth century. Again, there were a series of reasons that contributed to this development. In the first place, not only were the earthenwares functionally inadequate since liquids leaked through them when the glaze was too thin or chipped off,[93] but there was a growing recognition of the dangers of lead poisoning from this glistening material.[94] If these were motivations for expansion of the incipient American stoneware industry, the greatest impact probably resulted from the colonists' self-imposed general embargo on British goods following the imposition by Parliament in 1767 of duties on lead, glass, tea, paper, and painter's colors.[95] The War of Independence (1776–1782) further restricted imports from the mother country and afterward, when trade was resumed, the price of stoneware brought from Europe increased greatly as the new charges were

based on cargo space rather than on value.[96] This situation merely added to the growing tendency among Americans to reinforce their political freedom by economic independence as well. It is relevant that the first United States consul was stationed, not in Britain, but in Canton. That same year of 1784, an American ship brought back from that port to New York over six tons of Chinese porcelain.[97] A new ceramic era had begun and, if the rich were to have the greatest of stonewares, before long the common people were to have benefits too.

Potters had already anticipated a market for a cheaper type of stoneware, and some had been made in New York as well as in the more distant southern English colonies during the first half of the eighteenth century.[98] Such enterprises were not limited to the regions south of New England simply because of the continental influence there, as one might suspect, but rather because New England was lacking in accessible clay of suitable quality for the manufacture of stoneware. Following independence and a period of depression, transportation facilities improved and the American economy flourished, partly as the result of better technology, but mostly because the different colonies, often with strongly conflicting interests, had created a common government and become the United States. With the general situation in mind, we can now consider the problems of the developing pottery industry more specifically.

Earthenware

We shall make no attempt to trace the diffusion of the production of earthenware from town to town in New England. Even were the records complete enough to do so, they would probably show many unrelated instances reflecting the arrival of new immigrants with sufficient knowledge to attempt making bricks, and not a few who were experienced potters. That some knew how none too well is perhaps indicated by the stipulations of the General Court of the Massachusetts Bay Colony in 1679 as to the time when clay should be dug, when it should be turned over, and what should not be mixed with it.[99] Perhaps some brickmakers intentionally produced inferior, if not wholly inadequate building materials but, in general the New Eng-

landers were proud of their craftsmanship. Certainly the potters had to be, for if their wares did not sustain a certain standard, the makers would soon be without customers. Once attained, the necessary skills were readily passed on through sons or sons-in-law so that, as in other professions, they remained in the same family lines for generations, as did sometimes the potteries themselves.[100]

Clay, the basic material, was widespread, and plentiful supplies of the kind suitable for earthenware existed in the coastal section of Massachusetts where the majority of colonists first settled. In the logic of things, it had to be obtained in the fall before the ground froze or was covered with snow. To do so, the clay probably was most often just dug with a shovel and carried away in a wheelbarrow or cart, but sometimes a well-drained hillside deposit was plowed, harrowed, and then permitted to dry, the lumps perhaps being broken with a roller, a procedure that allowed the soluable salts to be drained off.[101] The clay was then brought in and, without any special cleaning, ground and stored in balls so that it would weather before further treatment in the late winter or spring. Some potters may not have allowed time for their clay to weather, but apparently the longer it did, the more plastic it became.

Just how much time was spent in the grinding, as well as the details of the early New England machinery, are not clear, but millstones were still being used into the nineteenth century. Certainly by 1817, however, potter's clay was being ground in a tub, and such mills have survived from later in the eighteen-hundreds along with descriptions of the process by eyewitnesses (Fig. 1, p. 43).[102] The clay which had been obtained was mixed with water to the proper consistency and then put into the vatlike container constructed of staves which had a capacity of six hundred pounds of the material. A heavy, vertical, wood shaft was pivoted in the center of the bottom of this tub as well as in a socket in the ceiling. Blades on the lower end of the shaft continually cut into the clay as the shaft was turned by two men pushing on horizontal capstan bars extending at a convenient height from opposite sides of the vertical shaft. In summer, the mill could be rigged in the open with a sweep in place of the capstan bars so that it could be turned by a horse.[103] One participant related that small boys were paid a penny to sit on the sweep and keep the horse moving for the hour of grinding that was required.[104] By the nineteenth century, many potteries were operating all year around.

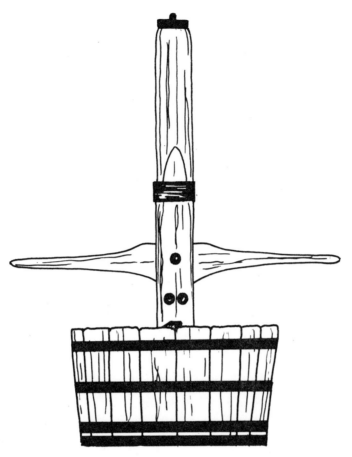

Fig. 1: A Clay Mill

In early New England, clay which had been stored in the shape of balls in the autumn was brought out in the spring, cut up, and thoroughly worked over by hand on the wedging table in order to bring it to an even consistency free of air bubbles. Then it was shaped into cylindrical pieces of the size predetermined as necessary for the kind of ware to be made. In the nineteenth century, scales are known to have been used so that finished pieces of a given size of the same type of ware would be consistent at least to the degree that there would be the same amount of clay in each.

Almost all the earthenware made in New England was turned on a potter's wheel. The wheels themselves were made by hand and consequently varied in minor details. The usual simple type consisted of a table perhaps three feet square in the center of which was a vertical shaft pivoted at the bottom and

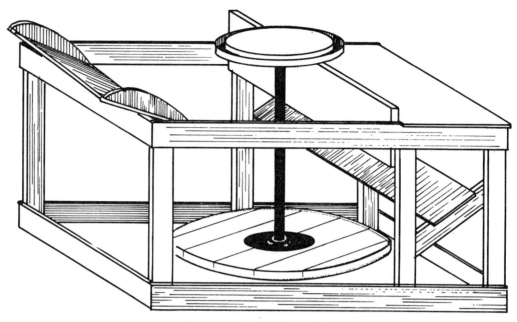

Fig. 2: A Potter's Wheel

supporting on its top above a bearing a disk made of heavy wood such as lignum vitae and, near its bottom a larger and heavier disk, sometimes of weighted pine,[105] which could be conveniently kicked into motion by the potter's foot (Fig. 2, p. 44). Since both disks, or wheels, were fastened directly to the vertical shaft, the top one moved in unison with the bottom one. Also, since most potters were right-footed, the wheels moved counter-clockwise. As might be expected, improvements which gave ease of propulsion or, for special purposes, greater speed to such wheels were introduced over the course of decades, but the basic construction remained the same.[106]

The forming of a vessel on a potter's wheel requires experience and skill that does not appear obvious to a casual observer. Theoretically, however, the steps of the process are simple enough and can readily be presented here by diagrams and a brief exposition. First, a lump of prepared clay of predetermined size was dropped on to the upper disk of the potter's wheel and sprinkled with water (Fig. 3, A, p. 45). The wheel was then set into motion and the lump of clay perfectly centered by the potter's hands which were always kept wet (Fig. 3, B). As the clay whirled on the wheel, the potter pressed his thumbs into the middle of the lump forcing the clay to bulge out at the sides

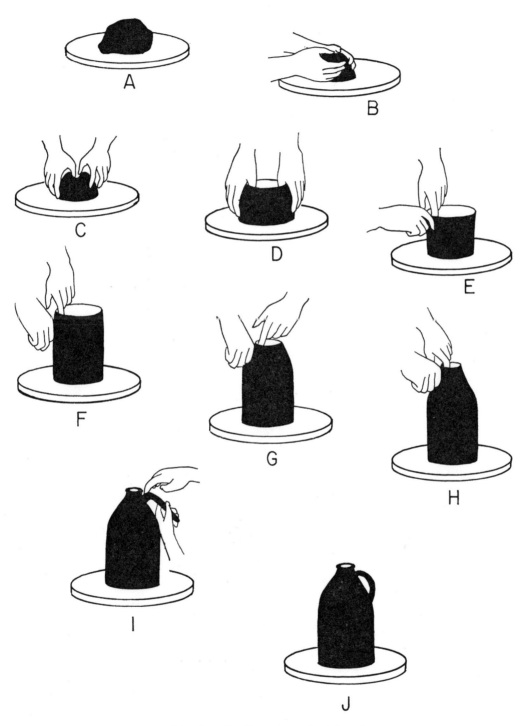

Fig. 3: The Forming of a Vessel

(Fig. 3, C). This pressure of the thumbs determined the thickness of the bottom of the vessel and by pressing them outward, its diameter, all in all, a delicate task (Fig. 3, D). Next the clay bulging above the bottom edges was drawn upward between the hands in one or more stages (Fig. 3, E, F). Then, if a jug were being formed, the potter would contract the top of the walls by drawing them inward (Fig. 3, G), finally fashioning the mouth of the jug around the forefinger of his left hand (Fig. 3, H). The vessel could then be freed from the wheel by sliding a wire under the damp clay and sooner or later completed by adding a strap of clay as a handle (Fig. 3, I, J).[107]

After the clay ware was formed, it had to be dried and, in early New England, this was done by setting the ware in the sun.[108] To make the procedure easier, as the ware came from the wheel it was placed on a long board of suitable width and length to be carried by two men.[109] The actual dimensions of these planks must have varied, but it is interesting to note that about two hundred feet of shelf boards are listed in the inventory of equipment left on the death of a potter of Newburyport, Massachusetts, in 1799.[110] The length of time that the ware dried also varied, no doubt, and it was sometimes longer than necessary. The diary of Daniel Clark, a potter of Lyndeboro, New Hampshire, records, for example, that in 1810 he fired ware formed in 1808.[111]

Early New England earthenware was apparently fired in brick kilns of various shapes. Basically rectangular, some kilns seem to have had inverted V-shaped tops in the form of corbelled arches.[112] Others had standard arched roofs.[113] Inevitably, they differed somewhat in size. They were usually built up for each firing and then torn down after use.[114] By this procedure, unbaked bricks could be fired at the same time as the earthenware inside the kiln and then be sold at a greater profit than bricks for the firing of which fuel had been burned primarily. Despite the support of bolted iron rods, the intense heat on occasions caused sufficient expansion to allow the roofs to fall in with a great loss to the potter.[115] This impermanency of kilns is largely responsible for the meagerness of our data.

Since the colonists had no native bricks to begin with and, since there are no descriptions of how the first kilns were made, we shall presume that imported English bricks were used, although it is tempting to consider other possibilities. In any event, thereafter the kilns were usually constructed from

bricks of the same clay as the earthenware.[116] A few such bricks have been measured and found to be $9 \times 4 \times 2\frac{1}{2}$ inches in size, or somewhat larger than those that were generally used for houses.[117]

The ware was placed in rows in the kilns, but not all potters added a second course above the first, for the danger of breakage was greatly increased by so doing.[118] Others certainly did, each piece above normally resting on two below, an arrangement which made for as much solidity and as even a dispersal of heat as was possible. For the same reasons, rows of one type of material might be alternated with rows of another, while plates or milk pans could be leaned against each other in rows on top, thus giving added protection to their glaze, while larger vessels were inverted for the same reason.[119] Slabs of clay or spurs were positioned for support where needed. One kiln in New Hampshire which was charged in the simplest fashion is stated to have held between 250 and 300 pieces[120] which, we may recall, is up to fifty per cent more than similar data indicate for the kilns of medieval Europe.[121] In no case were saggers utilized, these protective boxes being introduced into New England only much later for the fancier stonewares.[122]

The kilns were fired with billets of pine, or similar wood, which were cut and stacked so they would dry for the following year. The early potters, and later those in rural areas, had no difficulty in supplying their needs for fuel, but as the population expanded, the cost of obtaining wood became increasingly significant. Also, in the larger towns, there were attempts to limit the location and number of kilns since they gave off unpleasant quantities of fumes and smoke and created a fire hazard as well. Indeed, seemingly few of the potteries themselves escaped complete destruction from the flames every decade or so.[123]

The kilns were fueled through a series of stokeholes, perhaps as many as five,[124] so that the inside temperature could be kept even and high when necessary. Conditions inside the kiln might be judged periodically by pulling out various bricks from the wall with a pair of tongs in order to look inside for a minute.[125] As the piled-up ware matured, it settled, which was one indication that the necessary temperatures had been reached.[126] Actually, it was difficult to keep the earthenware kilns from becoming too hot and, as we have noted, if the temperature rose into the neighborhood of 1170° centigrade (2138° F.), the ware would simply vitrify and collapse, if the kiln bricks did

not do so themselves.[127] In most cases, however, the experienced potter fired his kiln successfully, the time varying from about thirty to seventy-two hours[128] and, after a period of slow cooling, had the satisfaction of selling his ware either at the pottery or by consignment to merchants in various towns.

It is perhaps worth emphasizing that three aspects of the potter's trade required his ultimate skill—first, the forming of the ware on the wheel; second, the setting of the ware in the kiln; and third, the control of the temperature in the firing. Subsidiary undertakings such as digging or grinding the clay, wedging it in preparation for forming, carrying the clay ware off for storage or drying, feeding the kiln fire, and unloading or storing the finished ware, required only little experience and reasonable care when supervised. Therefore, although a few potters did not employ regular helpers, most had one to three assistants including apprentices.[129]

Glaze, that complicated facet of ceramics which we have consistently set apart for special consideration, also demanded special knowledge, but a knowledge that was critical and more variable than the demanding skills mentioned above. Lead, in one form or another, was used to make glazes for almost all earthenware in America. A late formula for a clear glaze which was probably close to the early ones, required ten pounds of red lead to be mixed with three pounds of loam that had been screened through a horsehair sieve with about eighty meshes to the inch. With water added, this glaze material was ground by hand in a small stone mortar which, even in the late nineteenth century, could be relatively simple (Fig. 4, p. 49).[130] Sand could be used instead of loam, but the latter proved superior by introducing alumina through the clay it contained, thus increasing the viscosity of the glaze and making it cling to the ware.[131]

If not satisfied with the yellowish tinge of this clear glaze as it lay over the body of typical New England clay which fired red, the potter could add to the grinding other ingredients such as manganese producing browns and blacks, iron for yellows or, more rarely, the oxides obtained from burning and pulverizing shavings of brass which resulted in greens. Since impurities were always present, the exact result could never be predetermined, but some potters, either by fortune or long effort, distinguished themselves by the quality of their glazes. Fine greens, for example, were always not only rare but also more expensive, while the proportions for compounding the best

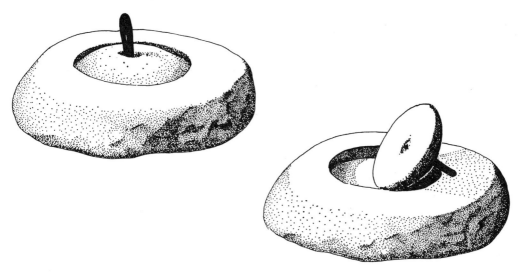

Fig. 4: A Stone Glaze Mortar (After Watkins)

ones were kept secret.[132] Mottled effects were also sometimes obtained by a secondary spotting with finger tips that had been dipped into a glaze of another color.[133]

It should be mentioned that whereas earthenware often was given an over-all glaze by dipping, milk pans and smaller dishes of similar shape were left unglazed on the outside, the glaze simply being poured into them and then, as quickly, out again.[134] Flowerpots, on the other hand, might not be glazed at all.[135] Finally, the bottoms of all kinds of ware was seldom, if ever, glazed.[136]

As to the shapes of earthenware, we have much less information than we would like. Only a very few pieces that are probably of seventeenth century manufacture have survived, and even those of the eighteenth century are limited in number. Part of this lack results from the difficulty of dating existing pieces with certainty for, although much of the ware has an individual character, the differences become insignificant when one considers all of the New England pieces with respect to both space and time. Some Connecticut pans are an exception, however, for they may be distinguished by ornate slip-trailing and fluted edges, the result of influence from colonies south of New England.[137] Furthermore, seldom has earthenware any identifying marks since the heavy glaze tended to cover them although what may be one of the more important exceptions occurs in the case of a Goshen, Connecticut,

potter who stamped his ware "H. Brooks" possibly quite early in the nine-teenth century.[138]

Still, without being definitive, we do know from later pieces and their uses a great deal about the function and shapes of the earlier ones. Considering the nature of the data, we have elected to simplify the usual recapitulation of earthenware shapes, choosing only sixteen for the three-hundred-year period of their New England manufacture, it being significant that a few potteries continued to make some of them into the twentieth century. These shapes, including some broadly inclusive categories, we have listed very roughly in order of their supposed appearance and frequency, illustrating typical exam-ples in outline of the first thirteen (Fig. 5, A–M, p. 51).

A. Pots (open)	I. Jugs
B. Pans	J. Teapots
C. Bowls	K. Flowerpots
D. Porringers (cups)	L. Churns
E. Mugs	M. Coolers
F. Pitchers	N. Tiles
G. Pots (covered)	O. Strainers
H. Chamber pots	P. Bed pans

The term *pot* was apparently used for almost any open-mouthed container, the height of which was larger than its width (Fig. 5, A, p. 51). Such excava-tions of kiln sites as have been made seem to indicate this to be the com-monest variety, or general shape, of early New England ware.[139] The pots were glazed inside and undoubtedly were used for storing foods and other materials, especially those which on standing tended to congeal or adhere. Lard and soft soap are obvious examples in the first group while dye and glaze exemplify the latter. They were also probably the original pots used for baking beans.

In the category of pans are included all broadly open dishes which might be listed under such other names as platters and plates (Fig. 5, B). Probably the best known pieces are the large milk pans, in some cases reaching 18″ in diameter and 3¾″ in height. Milk fresh from the cow was poured into them to cool in order to obtain the cream which could be more easily skimmed from

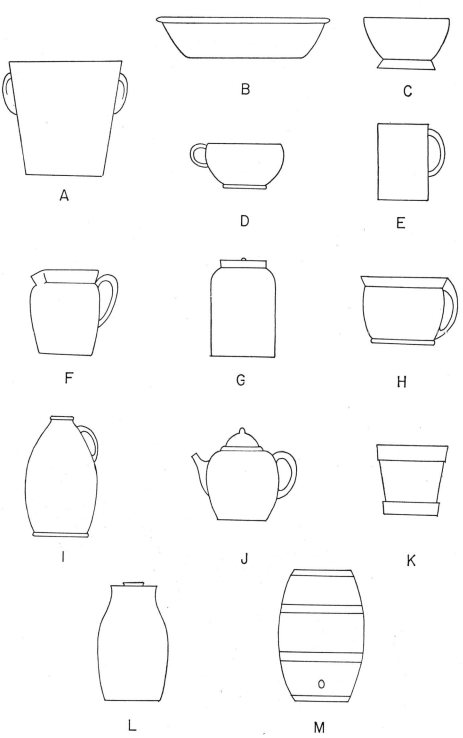

Fig. 5: Outlines of Earthenware Shapes

such broad and shallow containers. Pudding dishes and bread pans had higher walls while the pie plates were flatter. Ordinary plates from which to eat, it may be noted, were usually fashioned during the first two centuries of New England from pewter or wood.

Bowls were small, glazed inside and out, and used as tableware to hold tea, soup, porridge, or similar foods (Fig. 5, C).

The porringers differed from the bowls significantly only in having a vertical loop handle (Fig. 5, D). In this latter respect they are related to cups, and these have consequently been included in the same category of shapes. The function of all of the vessels was similar.

The mug differs from the cup basically in having its height greater than its diameter, although obviously the two shapes blend one into the other (Fig. 5, E). The sides may bulge, slant, or rise perfectly straight. Clearly, the mug— in early days often called a can—was primarily associated with alcoholic drinks such as ale, cider, rum, or various mixtures made from them. They were also used by men to make lather for shaving.

Moving on to forms perhaps less commonly represented, we find pitchers of various shapes distinguished by pouring lips and vertical loop handles (Fig. 5, F).

Then there is the pot, or jar, with the inset cover, a shape that is usually characterized by a distinctly narrower opening than the maximum diameter of the vessel (Fig. 5, G). Open pots, of course, could be covered, but here we are dealing with a form that is specially made for that purpose as may be seen from a cross section of the rim. Covered pots, it is presumed, were primarily used for storing foods.

Chamber pots, in shape and by their vertical strap handle are related to porringers and cups, but their size and function clearly set them apart, as we have done (Fig. 5, H).

The earthenware jug takes the ninth place on the list because it apparently was relatively uncommon in the earlier centuries (Fig. 5, I). It obviously functioned to contain liquids that needed to be stored over an extended period of time, but stoneware was so superior that imported articles proved worth the expense. Strap handles either connected the upper part of the body with the rim, or they curled back on the shoulder or neck.[140]

Teapots take on a well-known shape distinguished by their function, while

the spouts and vertical loop handles are diagnostic (Fig. 5, J). In New England many were made with a black glaze copying those imported from the mother country.[141]

Flowerpots may be, for sheer quantity, the commonest type of earthenware ever produced in America, and they certainly attest to the people's consideration for plants even in the earliest days (Fig. 5, K).

Churns are known to have been made of earthenware and to have inset covers with collared holes (Fig. 5, L).[142] Because of their single function of turning cream into butter, they were less common than most shapes. Also, like jugs, they were materially inferior to their counterparts in stoneware, and we assume that in the earlier centuries, wood churns made of staves were the usual implement with which to make butter.

Coolers for liquids comprise one of the rarer forms of earthenware (Fig. 5, M). They suggest a rather more sophisticated way of life, however, than probably existed in the average early American family.

There are a number of relatively rare shapes which because of the intrinsic inadequacies of earthenware, or their very specialized uses, played a small part in New England culture. Tiles, for example, could not withstand the fluctuating northern climate, while such items as strainers and bedpans, not to mention various other types, were rare.

Before concluding our comments on shapes, or varieties, of earthenware, a few remarks may be added with respect to their distribution in time. Open pots, it would seem, changed little during the several centuries under consideration.[143] It should be admitted, however, that datable specimens have not survived to verify such opinions. The earliest records in which a mention of pottery is found go back to 1644. Pans, pots, and jugs are listed, but there is no proof that they were made in America, and a high probability that at least most of the jugs were imported stoneware.[144] Pans, we believe, showed a constancy in form, the common earthenware type for cooling milk not being replaced until tin ones became popular about 1876.[145]

Teapots probably did not become common until well into the eighteenth century, although an importation of black ones has been recorded for 1715.[146] After all, the British East India Company brought less than 650,000 pounds of tea to Europe from the East in 1734, but then quadrupled that amount by 1746. By 1758, imports were over four million pounds and they increased

rapidly thereafter. It is only reasonable to believe that American habits reflected the English appreciation of tea and a demand for the pots.[147]

Finally, we may comment again on the manufacture of flowerpots which grew until it surpassed and outlasted all other types of earthenware.

Stoneware

The history of stoneware manufacture in New England with which we are more directly concerned is fortunately better documented than the making of earthenware. The reason is that it commenced later. We must remember that the European tradition of stoneware production first took hold in the colonies south of New England and for the primary reason that the clays for the purpose were abundant there. The earliest record we have refers to a French Huguenot immigrant named Anthony Duché who was reputedly making stoneware in Philadelphia before 1730.[148] Another potter, John Remmey, who emigrated from Germany began to fire stoneware in New York City about 1735.[149] Stoneware was also manufactured in Virginia at the same period, while Andrew Duché, the third son of Anthony Duché of Philadelphia, is reported to have created stoneware of porcelain quality in Georgia by 1738.[150]

Efforts to produce stoneware in New England soon followed.[151] There is the interesting story of Isaac Parker, a potter of Charlestown, Massachusetts, who in 1742 imported James Duché, a younger son of the Philadelphia potter, for that purpose. Parker died the same year, but his wife heroically carried on the attempt. Duché unfortunately did not understand the deficiencies of New England clays, and success was not achieved until the basic material was imported as well. Thus, by 1743, stoneware was actually manufactured in New England, but production was continued for only a few years because of the high cost.[152] As we shall see, cheap and easy transportation of clay from New York or New Jersey became an essential requirement.

Adam Staats (later anglicized to States), an immigrant from Holland, began the permanent tradition of stoneware making in New England by bringing clay to his home in Greenwich, Connecticut, from nearby Staten Island about 1750.[153] His brother, Peter States, was producing stoneware in Nor-

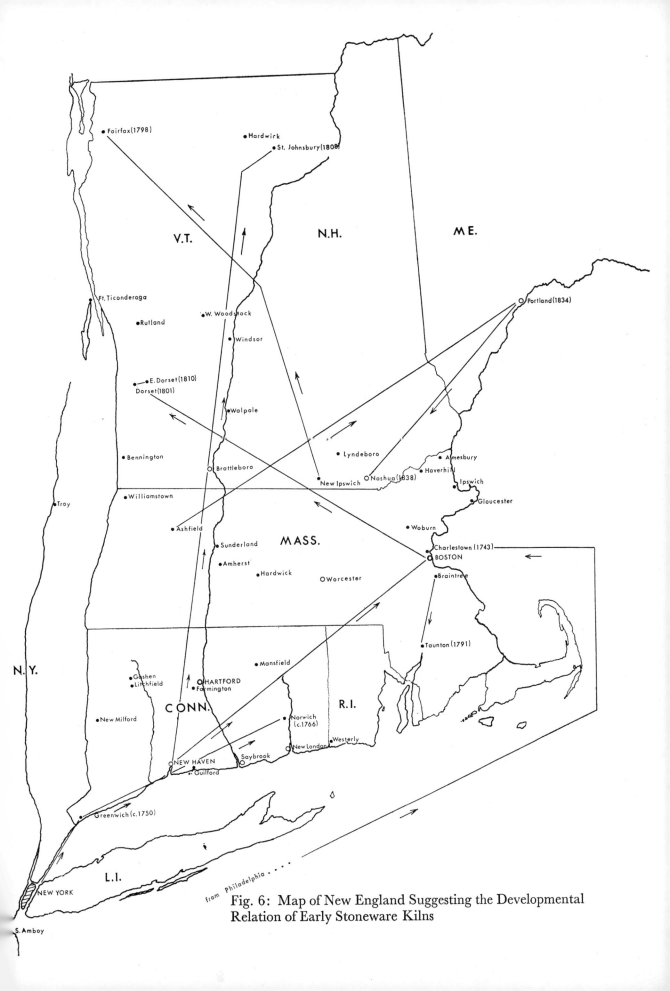

Fig. 6: Map of New England Suggesting the Developmental Relation of Early Stoneware Kilns

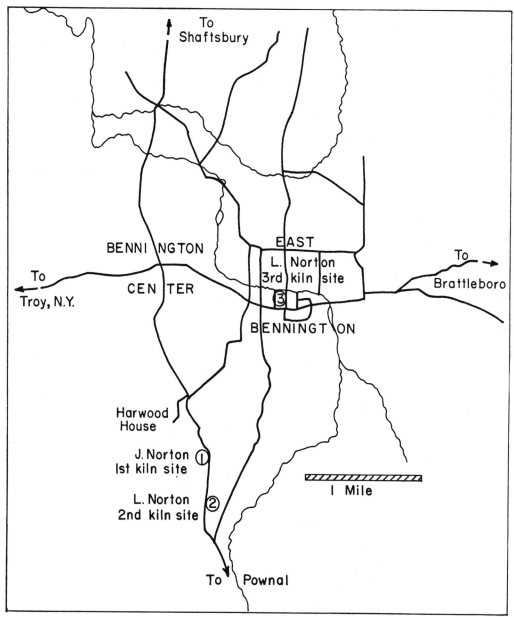

Fig. 7: Map Showing the Location of the Three Norton Kiln Sites

wich, Connecticut, soon after 1766,[154] and it was certainly made in other towns in the state, such as New Haven, before the end of the century.[155] As we shall see later, members of the Fenton family supplied ceramics fired at a high temperature immediately following the War of Independence.

Peter States, or his sons, were possibly also responsible for establishing the

first stoneware kilns in Rhode Island. The date could be as early as 1754 when Peter was known to be in Westerly, or after 1772 when he returned there. There is no record of his kiln, but he certainly was a practicing stoneware potter as late as 1769 in Norwich, Connecticut, and it would be unusual if he did not carry on his trade during some of the many years that he resided in Westerly, Rhode Island.[156] On the other hand, it must be borne in mind that in New England almost all potters were farmers as well, so that an extended shift in one's activities is not inconceivable.

The first successful stoneware potter in Massachusetts was William Seaver of Taunton who built a kiln in that town in 1772. Again, there is the problem of being certain whether stoneware, rather than earthenware, was actually made in Taunton as early as tradition reports. Seaver kept an account book after 1786 for more than a quarter of a century and only earthenware is mentioned in it until he sold a one-gallon stoneware jug in 1791. Thus it would seem we must accept that year until more satisfactory evidence to support an earlier date is forthcoming. Then, in 1794, Jonathan Fenton came from New Haven, Connecticut, and set up a stoneware factory in Boston.[157] As far as we know, this was the third and last case of stoneware being made in Massachusetts during the eighteenth century. Furthermore, there was none produced in the northern three states of New England before 1800.

We can consider the eighteenth century as the developmental period of stoneware manufacture in America, whereas it was only during the second and third quarters of the nineteenth century that it reached its florescence as a folk industry. Although Jonathan Fenton, formerly of Boston, possibly was the first to make stoneware in Vermont, he having set up a pottery kiln in Dorset soon after 1801, certainly only a limited amount of stoneware was made in that state before the end of the first quarter of the nineteenth century and, as far as the record shows, none was made in Maine until Martin Crafts carried the technique to Portland from Ashfield, Massachusetts, in 1834.[158] This same man had the distinction of also being the first to produce stoneware in New Hampshire which he did at Nashua in 1838.[159] Some of the principal lines representing the growth of the stoneware industry from town to town we have shown on a map, together with the times of arrival of the leading potters which, in certain cases, may have slightly antedated the first production of stoneware (Fig. 6, p. 55).

As for the technicalities of stoneware production in New England, we can summarize the important points in terms of their similarities to, or differences from, the previously described requirements of earthenware. The first and fundamental difference, as we have learned, was that the local clays had not proved adequate and that proper material with a sufficiently high vitrifying temperature had to be imported. Fortunately, an excellent bed of satisfactory clay stretched from Long Island to New Jersey and could be readily obtained in the region of South Amboy, a location convenient for coastal shipping which extended up several of the larger rivers. Also, as it happened, South Amboy was on the periphery of the population center of greater New York which meant that farm produce was being brought in by wagons and boats, few of which had such bulky consignments on their return to the interior regions and were consequently willing to carry clay very cheaply.

New Jersey clay had to undergo even less cleaning than that of New England, but it was certainly ground and probably most often in a horse-powered pug mill, as the machines that supplanted grindstones were called. It also should be mentioned that this imported clay was mixed to varying degrees with clay that was dug locally.

After being wedged, the stoneware clay was formed on the same wheels and in the same manner as the earthenware clay had been. At first, even the shapes of the ware were closely similar, and afterward, when they changed as we shall see, it was not primarily in consequence of the clay that was used. As the industry progressed in importance, kilns became part of the pottery enclosure and the clay was more often dried with the help of the external heat of the kiln than it had been in earlier days.

About the New England stoneware kilns, little detailed contemporary information has been found. We are tempted to presume that the well-known cylindrical form of updraft kiln topped by a cone-shaped chimney had been widely adopted in the nineteenth century, but the actual distribution of the type has not been recorded. One thing is certain, the kilns could not have been constructed of bricks from the local clay used for earthenware, as they had been formerly, for such bricks would have surely collapsed when exposed to the higher temperatures—1200° to 1300° centigrade (2192° to 2372° F.)[160] —which were needed for the firing of stoneware. Probably one detail that some earthenware and stoneware kilns had in common was the use of iron

rods or bands to reinforce the brickwork. In general, stoneware kilns also were of larger capacity, and the ware in them arranged in a larger number of courses, one upon another.

If the primary difference in the manufacture of the two basic types of ware can be said to lie in the clays that were used, it was not the greatest one. That distinction was reserved for the glaze. The lead glazes, intensifying the red of the clay bodies or glistening with the colors that were not infrequently added, could not be used on stoneware. The latter was normally coated with salt glaze which was not applied directly to the ware itself, but thrown into the top of the kiln during firing. Since salt glaze is transparent, and no color could be added to it, the finished ware varied from yellows and browns to grays reflecting the differences in clay and, in the latter case, the proportion from New Jersey. Indeed, not infrequently, the finished stoneware had a mottled appearance or scars of different shades (compare Pl. 5, UL). Besides such discolorations, the surface texture of the salt glaze often differed considerably.

Perhaps to offset the usual drabness, floral and other designs were painted on the damp clay ware in cobalt blue, a technique that had been known from earlier centuries in Germany. Less often a brown pigment was used instead of the blue.

Almost as distinctive as the salt glaze itself was the introduction of Albany slip glaze for coating the interiors of stoneware vessels, and sometimes all surfaces except the base. This treatment, applied directly to the ware by the usual means, not only had the advantage of supplying a smooth, washable surface in varying shades of brown, but could do so on surfaces not exposed to the salt glazing which was restricted to the outward faces of vessels stacked in the kiln. Thus smaller pieces placed inside larger ones also could be fired with this subsidiary glaze.

The shapes of the stoneware pieces at first were the same as those made of earthenware, except that some shapes were not formed at all. The common milk pan serves as an example. Old-fashioned ones were cheap as well as effective and, when earthenware milk pans were finally replaced, it was by tin ones, not stoneware. Earthenware, we must remember, continued to be manufactured, often if not usually, by the same potters who made stoneware.

Most of the earthenware dishes for individual use at the table also were not

replaced by salt-glazed stoneware. People preferred either imported blue-and-white Chinese porcelain, which was produced in an inferior quality and became cheaper after 1830,[161] or English bone china. Soon competitive ornate American copies obtained a share of the market. At the same time, drinking mugs were being rapidly replaced by glass. Notable among other things not copied in salt-glazed stoneware were teapots.

On the contrary, some earthenware shapes were reproduced in stoneware and were highly appreciated. Pots of various kinds and sizes, usually with inset or over set covers, stand as evidence. Salt-glazed stoneware also proved an ideal material for the primitive New England churn, ultimately to be replaced only by a technically new machine. Pitchers and coolers as well as even more specialized items were carried over into the stoneware trade and, above all, the jug, which became symbolic not only of that industry but of the intemperate nineteenth century New England culture which we shall soon briefly consider.

THE NORTONS
OF BENNINGTON

Early Bennington

BEFORE WE DIRECT our attention to the Norton family which produced the potters of Bennington, we shall attempt to sketch the historical background of the town in which they worked. Fortunately, with this subject we are on grassy ground over which we can walk quickly. The history of Bennington has two primary roots. The first stretches back to the royal governor of New Hampshire, Benning Wentworth, when he decided that his colony extended not merely to the Connecticut River but as far westward as did the colonies of Connecticut and Massachusetts. This not illogical notion was coupled with the even more obvious deduction that if he were correct, land grants could be made in that unpopulated mountainous area with considerable pecuniary benefits to the Governor and his associates. As a consequence thereof, on January 3, 1749, a group of men obtained a grant in the name of King George the Second for a township six miles square with its southern boundary that of Massachusetts and its western conceived to be twenty miles east of the Hudson River.[162] Obviously, a firm establishment of the more distant parts of the region, thereafter known as the New Hampshire Grants, would imply the right and intent to grant additional townships throughout the intervening area reaching to New Hampshire itself. Thus the king, without being too clear as to the area that was being granted in his name began to move "his trusty and well-beloved governor" on the way to becoming the largest English landholder on the North American continent, Benning Went-

61

worth having astutely arranged to reserve 500 acres, more or less, of each township for himself. Apparently in appreciation of this vice-regal program, the town formed from the first grant was named Bennington.

The plan for settlement of what is now Vermont did not advance as fast as was expected because of circumstances quite beyond control of the governor. Within five years, England became embroiled in the Seven Year's War (1754–63) which in its American phase was called the French and Indian War. During this period the colonial outposts of New England suffered sufficiently from Indian raids to deter any plans for settlement in an area that long had a reputation for conflicts even between the aboriginal inhabitants. The issue was met when the colonial militia was sent northward against the French and their Indian allies. In 1759, after years of intermittent fighting, the capture of Quebec alleviated fears of retaliation and opened the country to colonization. For more than twelve years, however, Bennington had remained an uninhabited wilderness.

While the war was in progress, plans for settlement in the New Hampshire Grants did gain momentum when members of the militia who had traveled over the territory were attracted to the land and decided to make it their home. One specific case was that of Captain Samuel Robinson who, according to the story told, when returning to Massachusetts lost his way and, passing through what was to become the future Bennington settlement, became enamored by the beautiful countryside. Thus we are led to the second root of the historical tree.[163]

The causes of events seldom prove simple and we find that it was complex social forces that directly impelled the pioneers to emigrate. In the middle years of the eighteenth century, it happened that the dominant church of New England had become involved in a schismatic conflict. Radical preachers such as Jonathan Edwards (1703–58) wanted less complacency with respect to the Calvinist doctrine of predetermination; in short, they demanded a greater appreciation of hell and more certainty as to whether a church member was going there or not. As a result, the revivalists created a division in which large sections of some congregations withdrew in a separatist movement. In certain instances these people were allowed to leave their church peacefully, but in others they were excommunicated and threatened with legal sanctions. At best, they had a tax problem since their new church

organizations were not considered independent enough to absolve them from paying taxes in support of the old.

Samuel Robinson belonged to the Separatist group of the church in Hardwick, Massachusetts, and he had Separatist friends in nearby Amherst and Sunderland. Together they decided to buy the rights to the Bennington land from the original grantees of 1749, none of whom as far as is known had ever set foot in the township or, for that matter, had ever intended to. The closest associates of Benning Wentworth were speculators. Thus, on June 18, 1761, having succeeded in the purchase, three families consisting of twenty-two individuals moved into the promised land with their church problem seemingly solved. Soon the number of immigrants had doubled and trebled.[164] Within five years, they had a meeting house, three schools, and a grist mill, but their troubles were really only beginning.[165]

No one can understand the creation of the state of Vermont without being familiar with the conflict which arose over the New Hampshire grants. Fortunately, the essential facts are few. The governor of New York became understandably envious of the monetary advantage of the land program of the governor of New Hampshire and, on not too clear evidence, decided that the area which has since become Vermont was actually in the domain of New York. Thereupon, the governor of the latter colony began to issue grants of the identical land previously assigned by the governor of New Hampshire, furthermore charging a higher fee for so doing. In consequence, the ownership of the land came into dispute from 1751 to 1764, at which time the king in council had given a decision favorable to New York despite Governor Wentworth's disposition of 124 townships during that period.[166]

From the point of view of those who had already settled on and paid for the land this action was not only ridiculous—since all the grants were made on the authority of the English king and were not intended to be contradictory—but a threat to life itself as many of the immigrants could not afford to pay a second and larger fee for their farms. Quite as important for a few was the preservation of sizable investments on much larger areas of land.

When it appeared that the New York governor intended to take possession by force of the land he had granted, the settlers decided on armed resistance and an aggressive young man named Ethan Allen was chosen as the leader of the group which became famous in history as the Green Mountain Boys.

This town-proclaimed militia not only drove off all the agents of New York from the Bennington area but moved eastward across the future state to subdue opposition to the Hampshiremen in a region where richer grantees had been willing to pay the superimposed New York fees for their relatively smaller holdings.

The direction of resistance was suddenly shifted with the beginning of the War of Independence and the capture of Fort Ticonderoga at the north end of Lake George on May 10, 1775 by American forces under the exuberant Ethan Allen. The French had established this outpost as Fort Carillon in 1755, having dominated the area since the visit of Samuel Champlain in July, 1609. In 1758, however, the French had evacuated it in order to support the defense of Quebec, and the fort since then had been occupied by the British. Ethan Allen was captured later in 1775 in the course of another daring attack on the British, but his family became even more significant in a Vermont under the political leadership of a younger brother, Ira Allen, who guided the new state from its declaration of independence on January 16, 1777, to its acceptance as the fourteenth in the American union on March 4, 1791.

During this period the population of Vermont had risen from about 7,000 to over 85,000. Even by 1785, the threat to one's land and one's person had both disappeared. Furthermore, Vermont, still being independent, was in less of an economic depression than most of the states which had fought through the war as a union. As a nation, the United States was burdened with debt and the money that had been issued was of questionable value. Vermont on the other hand was not obliged to give financial support to a Congress that had refused to recognize her political status. Taxes were still unknown in Vermont, and the frugal political leaders were financing the new state from funds raised on the estates of the dispossessed Yorkers. A land boom was in progress and the spirits of the major portion of the population were unified and optimistic.[167]

Therefore it is no surprise that Vermont appealed to prospective settlers not only as a secure and developing frontier but as a land that symbolized in an outstanding way the courageous and victorious struggle for American freedom. Ethan Allen was the soldier's hero in New England and, if for no other reason, young veterans such as John Norton were often attracted. In

John's case, however, there was even more of an attachment. John Norton's mother, Anna, the daughter of Cornelius Bronson, had a younger sister Mary, and this Mary was the wife of Ethan Allen whom she had married in 1762. Although Mary had died a few years before John Norton's move to Bennington, it would be hard to believe that Uncle Ethan and Vermont had not been frequently in John Norton's thoughts since 1775. Surely, if his was not another case of the typical immigration pattern of relatives following relatives, at least John Norton could expect recognition from his uncles and cousins.

John Norton

The man who originated the series of famous potteries in Bennington, Vermont, lived through the first quarter of the period during which stoneware was made, dying a few weeks short of seventy years of age on August 24, 1828. Of his various distinctions, perhaps none is more extraordinary than his having a wife who bore four sons and five daughters, each and every one of whom survived him. At his death he had not lost even a grandchild. In those days, such consistent vitality within a family could well be construed as a miracle. Even though our interest in the longevity of the family members is a minor one, we shall have to turn back to the ancestral history of the Nortons in order to discover how Captain John, as he was later called, came to Vermont and made jugs.

John Norton's great-grandfather, Thomas Norton, arrived in Boston in 1639 at the age of thirteen with his father of the same name. They had come from Surrey, England, with their pastor, Henry Whitefield, who immediately led his little group to the New Haven Colony where the Nortons settled in Guilford early in the summer of that year. Before 1661, the younger Thomas had moved to Saybrook where he married Elizabeth Mason in 1671. Their second or third son (he was a twin so it is hard to tell) was named Samuel. He was born in 1681 and, at the age of twenty-three, moved to Durham, Connecticut, where in 1713 he espoused the widow Dinah Birdsey Beach. Their sixth and youngest child, David, the father of John Norton the potter,

was born in 1726. Twenty years later, David moved west to Goshen, Connecticut, one of the proprietors' rights to which his father had purchased in 1738. There, David brought his bride, the previously mentioned Anna Bronson, in 1752, and there on November 29, 1758 was born their fourth child and fourth son, the John Norton who became the potter of Bennington.[168] That John and his children would have a reasonable life expectancy is clear for, although his father lived only to age forty-three, the average of John's four Norton progenitors in America was over seventy. Furthermore, his mother and his paternal grandmother died at an average age of eighty-three.

Goshen was a frontier town in the middle of the eighteenth century. It had suffered during the French and Indian War (1754–1763), and John grew up during the exciting period of increasing rebellion against England and the enactments of George the Third. Although the record of John's early life is brief, we know that he was with Captain Goodwin's revolutionary troops in New York before he was eighteen.[169] Also, as he mentioned on occasions to his contemporaries, he had been one of the guards at the execution of the British officer, Major John André, on October 2, 1780.[170] We also know that during his five years with the Revolutionary Army he attained the rank of Captain in the Eighteenth Connecticut Regiment.[171]

As a boy, John must have received that minimum education given to most youths in Connecticut towns of the period, an education that was reinforced by the long tradition of literacy among the New England populace. No doubt he had to attend church and became bored by the sermons as boys so often were. Of a certainty, he was taught the elements of farming, for it was the rare young man who was not. Even the men who practiced trades or professions in a community, usually farmed to raise food for their families as an adjunct to their basic activities.

Just how and with whom John Norton learned to be a potter is not clear. There seems to have been several kilns in Connecticut near the Goshen-Litchfield boundary around his time. The young potter John Pierce and his wife moved from Farmington, Connecticut, to Litchfield in 1752 and made red ware in the latter town during the following thirty years. Also the red ware potter, Jonathan Kettell was in Goshen by 1776, and perhaps John Norton began his training with him.[172] In any event, it would seem unlikely

that he served the usual long apprenticeship, or at least in the usual way for, as we have seen, he was in the military forces at seventeen and on duty four years later. For most men, the revolutionary army was not a steady occupation, since grain had to be sown and reaped.

Early in March, 1782, when he was still twenty-three, John Norton married Lucretia Buel, aged seventeen. That the potteries previously mentioned were close to her father's house impels a suggestion so obvious that it perhaps had better be ignored. The contemporary children of the Norton and Buel families must have been intimates anyway. Jonathan, one of Lucretia's brothers who was about ten years older than she, had married Marana Norton in 1774, a daughter of John's uncle; then Timothy, another of Lucretia's brothers about six years older, had married Marana's sister Olive in 1777. Apparently, the family attractions were mutually compelling.

We must add that Lucretia, the youngest daughter of Captain Jonathan Buel, may well have been considered a catch, for the Buels were people of distinguished reputation in the Goshen-Litchfield area. Lucretia's great-great-grandfather, William Buel, had settled in Dorchester, near Boston, in 1630, and later removed to Windsor, Connecticut. Deacon John Buel, the son of William's son Samuel, had moved to Litchfield in 1720 and became one of its leading citizens. There, Lucretia's father grew up, married, and lived in a house which to his surprise was found to be half in Litchfield and only half in Goshen where he expected it to be. It may be interpolated that the longevity of the Buels and their wives, in so far as is known, was even greater than that of the Nortons. Lucretia herself, for example, did not die until August 15, 1852, two months after her eighty-ninth birthday, the almost identical span of life enjoyed both by her mother[173] and by her paternal grandmother who had 410 descendants during her lifetime, 336 of whom survived her.[174]

It has been assumed, reasonably enough, that John Norton was a practicing potter when he married Lucretia in 1782. From whomever he learned his trade, he decided not to continue it in Goshen. Two years after his marriage to Lucretia, we know the young couple were in Williamstown, Massachusetts, for there, on February 9, 1785, their first son Luman was born. Presumably—since a winter journey was not likely to have been made in the last month of her pregnancy—they had been in Williamstown some

time. It has been suggested that at the same period there was a pottery in Williamstown at which John Norton worked,[175] an inference largely based on the simple fact that he stopped there although one source of 1829 does say that "potteries have been in successful operation in Lee and Williamstown for many years."[176] This is not altogether convincing evidence as it seems improbable that ware would have been produced during the winter in that locality at that period. Further, there is reason to believe that John Norton manufactured no pottery during his following eight years in Bennington where he and his wife with their new-born son arrived in the spring of 1785 and acquired a farm.[177] After all, to settle in a new country and to set up a kiln naturally required time, so the traditional date of 1793 for his doing the latter does not seem unreasonable.[178]

Little is recorded about the first twenty years of John Norton's life in Bennington except that his wife bore a child almost every two or three years. His farm, consisting of about 200 acres, was located a mile and a half south of the old center of town on the principal highway between western Massachusetts and Canada. It is recorded that in 1793 he became one of the charter members of the Temple Lodge of Masons in Bennington. This was the year that he built his first kiln. That he also operated a distillery is clear, but whether it was set up before he had re-established himself as a potter is not known.

Fortunately for the biographer, Captain John's neighbors to the north were the Harwoods, a family that had come to Bennington with the first group of settlers in 1761. Benjamin Harwood, born the next year—and not much younger than John Norton—was a friend with whom the latter frequently exchanged labor and other assistance. As was perhaps not unusual, Benjamin Harwood kept a diary which he began on March 22, 1805. More extraordinary, however, on October 23, 1810, his son Hiram took over the task of recording and he continued faithfully to write down even more fully the everyday affairs of the family and neighbors until October 23, 1837 when, suffering from an extreme intensification of his chronic depressions, he gave up writing and was later taken to a hospital in Brattleboro, Vermont, for treatment. Released after some time, he returned home only to commit suicide by hanging on March 6, 1839.[179]

Miraculously, the diary which covers a period of over thirty-two years has

survived to give us probably the most detailed extant account of farm life in Vermont during an early third of the nineteenth century. It is a pity that its principal author who so often expressed his sense of personal inadequacy could not have realized how great was his contribution.

Most of what we know or can infer about the life of John Norton's family comes from Hiram Harwood's diary. Captain John planted wheat and other grains, owning a fanning mill that the Harwoods periodically borrowed. He kept horses and some cattle but, at least later on, he depended on his neighbors for the beef that he ate. His hogs and sheep were more commonly mentioned, the latter when he washed them in the stream at the same time as the Harwoods did theirs. In the early days, there were wolves in the hills and their presence created a problem.

It is clear that as time went on John Norton preferred to avoid the heaviest labor. We note that he sowed Benjamin Harwood's flax while the latter dug a cellar hole for him. Probably the potter was already growing stout which was his tendency, although not approaching the corpulence that distinguished him in his latter years. At the time that he died, he weighed no less than 256 pounds which is singularly heavy for a man who was only about five feet ten inches tall.

The capacity of John Norton for specialized undertakings shows itself in small things as well as in large. He was occasionally called in to dock a colt, and more often to inoculate fruit trees and to graft them with cions. He apparently had a sizable orchard himself which supplied some of the cider for his distillery. Like most farmers on the frontier, he cooperated in the labor of haying, butchering hogs, and in the moving or raising of buildings.

We have no description of John Norton's first house in Bennington but it is written that another was built in 1809 and then painted in fine fashion two years later. Painting in those days was by no means considered necessary. His eldest son, Luman, had married at the age of twenty-three, the year before construction began and, for a period thereafter, the young couple shared a separate section of the family home.

Luman had been a practicing blacksmith for some years, a business his father had no doubt helped him to start if he had not engaged in it professionally himself. It was a day when farmers were required to demonstrate their skill in various trades and John Norton, if a jack at many, was also a

master of more than most men, and obviously with an eye to parceling them out among his sons.

Life was busy and harmonious on the Norton farm. The family was blessed with good health and common sense. Captain John was materially better off than many of his contemporaries, but he was no miser and died poor as far as money was concerned, but much loved and respected. Although it is not clear whether she meant specifically or socially, the Norton family was considered superior to her own by Hiram Harwood's sister Lydia, an opinion which apparently surprised her brother and one with which he did not readily concur.[180]

John Norton was mentioned as a storyteller and, like many of his contemporaries, he was fond of reading. His name is listed among the small group which founded the first free library in Bennington. Not infrequently there was dancing in the big upper room of the house, his many children inviting their friends. Numerous members of the family played instruments, a grandson, Julius, reputedly having a rare talent with the flute. No proof has been found that John Norton himself played any instrument, unless we take cognizance of an old pencil note on a manuscript that indicates he was a drummer in the War of Independence.

Nothing has been said of the activities of Lucretia, John Norton's wife, except that she raised nine children. Unquestionably, she was a good mother as well as a busy one. As late as 1811, she is recorded by Hiram Harwood as spinning flax, although by that date, the family were probably buying most of their cloth. She is said to have been also a pious woman who belonged to the church.

John Norton himself was not antagonistic to religion. He gave financial support to the church and has been claimed as a Christian. On the other hand, Hiram Harwood who knew him very well writes specifically at the time of John Norton's death: "as to Religion it will be sufficient to say that he was not a Professor of Christianity, yet no one could find fault with his general course of life—was always of a friendly, manly frank and noble disposition—his mind was too enlarged to permit him to stoop to the commission of an act of meanness in any circumstances whatever—fair and perfectly honorable in all his dealings amongst men. In short he was a good man in every sense of the word except that [of] being a 'Christian'."

In reflecting on this statement, it must be remembered that the last half of the eighteenth century, the formative period of John Norton's life, was a time when many outstanding individuals were deists, religious men who believed in a supreme god and creator of the universe, but not in any written revelation concerning him such as is presented in the Bible. It was a situation contributed to in New England by the bickering among preachers over points of theology. Among those who might be classed as deists was Hiram Harwood himself, but without doubt the man most verbally so in Vermont was John Norton's uncle Ethan Allen who published his views under the extreme guise of atheism, thereby arousing the ire of New England divines who became certain he was destined for hell. Captain Norton, we are sure, never suffered any such open condemnation.

Several of the sons and grandsons of the founding potter also played a significant role in the history of salt-glazed stoneware, but these men we shall introduce in our discussion of the Norton potteries.

Vermont Kilns Before 1810

Other than John Norton, we find only four or five potters recorded as living in Vermont in the eighteenth century. It is extremely unlikely, however, that any of them were making stoneware in the state at that period. Our most reliable authority implies that Charles Bailey, a potter who was born August 27, 1744, in Amesbury, Massachusetts, set up the first kiln sometime after 1772 in Hardwick, a town in the north central part of Vermont.[181] Unfortunately, we have not been able to find information that would confirm a specific date for the beginning of pottery-making in Hardwick, but it may well have preceded the date of 1793 which has been accepted for the first Norton kiln at Bennington.

If the latter was the second pottery, the third seems to have been operated by a man named Edson in Windsor, Vermont. Apart from Edson, it is reported that another potter, Moses Bradley, originally from Haverhill, Massachusetts, lived in Windsor from 1797 until June, 1800, when he removed to build a kiln at West Woodstock, Vermont, a village which lies a few miles to the northwest. Bradley, curiously enough, had spent seven years

at Chimney Point, Vermont, which is on Lake Champlain across from Port Henry, New York, before returning eastward to Windsor, but we have no evidence of his making pottery during that period.[182]

In 1798, a twenty-seven-year-old potter, Isaac Brown Farrar, left New Ipswich in south central New Hampshire to settle near Fairfax in northwest Vermont.[183] Like John Norton, he belonged to an expanding family, numerous members of which were potters who made stoneware in Vermont during various decades of the nineteenth century. Data on their kilns, and even on the relationships of persons of this name, are not adequate to detail the history of their establishments.[184]

Among the pottery families of Vermont, the only one which might be considered to have played as significant a role as the Nortons were the Fentons, a name we may remember in connection with the stoneware factory opened in Boston about 1794 by Jonathan Fenton who had gone there from New Haven, Connecticut. Indeed, the Fentons became so interrelated with the Nortons of Bennington, both by marriage and business associations, that it will be worth while to introduce them more explicitly at this point.

Jonathan Fenton, the stoneware potter, was born July 18, 1766, in Mansfield, Connecticut, to which town his great-grandfather Robert—first known in Woburn, Massachusetts in 1688—had moved in 1703. Jonathan's grandfather, Ebenezer, born August 29, 1710, was married twice, having five sons and two daughters by his first wife, and six sons and two daughters by his second. Of the sons, three are known to have been potters who worked in New Haven, Connecticut. The oldest was Nathan, born February 9, 1746 (47), the second, Solomon, born June 23, 1749, and the third, Jacob, born November 5, 1765, the second son of the second wife.

It is clear that the two older brothers were in the pottery business soon after the War of Independence since a New Haven, Connecticut, newspaper advertisement of April, 1783, states: "Crucibles to be sold, Wholesale or Retail by Nathan and Solomon Fenton, at their Potters-Works, near the Water-side in New Haven." Apparently, the brothers were making stoneware, but from whom they learned their trade is uncertain. Some connection with Adam Staats of Greenwich, the first stoneware-maker of Connecticut, however, is suggested for obvious reasons. Jacob, the younger half brother, married a girl from New Milford on September 13, 1790, and soon afterward

moved to New Haven where he made stoneware, probably having served his apprenticeship earlier with Nathan and Solomon. We also know that Jacob moved to Burlington, New York, at the end of the century, and produced pottery there for a number of years. Solomon likewise eventually went to New York State, but the date is uncertain.[185]

Jonathan, with whom we are primarily concerned, was the son of Nathan's and Solomon's eldest brother, also named Jonathan and who was born on May 17, 1741. Jonathan senior, joined the forces fighting the British on April 3, 1779 and served for two years. On July 11, 1762, he married Mary, the widow of Daniel Cary, and they had three sons and three daughters. There is no evidence that the elder Jonathan followed the potters trade as did both his second son Jonathan and his third son Richard Webber Fenton, the latter born September 4, 1771. It therefore seems reasonable to believe that the two brothers, Jonathan and Richard learned their trade with their uncles Nathan and Solomon in New Haven.

Richard Webber Fenton moved from the latter city to St. Johnsbury, in northern Vermont before 1804 and set up a kiln there in 1808. He is thought to have made stoneware, as well as earthenware, from the beginning. His son, Leander W. Fenton, it is recorded, continued a stoneware business until 1859.[186]

To return to Johathan Fenton, the New Haven potter, we can trace his career by following the list of birthplaces of his children. Jonathan married Rosalina Lucas on August 16, 1792, when he was twenty-six years old. Their first child, Harriet, was born in New Haven, Connecticut, on March 16, 1793. Two more girls followed, Sally and Melyndia, who were born in Boston September 26, 1794 and January 11, 1796, respectively. Then a year later, on January 22, 1797, Richard Lucas Fenton was born in Walpole, New Hampshire. Less than two years afterward, on November 12, 1799, Rosalina bore another girl, Almira, in East Windsor, Connecticut. When Maria, the next child was born on November 1, 1801, the parents were in Dorset, Vermont. Thus, in approximately eight years, they had lived in five widely separated localities and procreated six children which must be something of a record for combined mobility and fertility.[187]

The Fentons continued to have children, but for a period of about nine years they remained in Dorset where Jonathan operated a kiln. Four more

babies were born there—three girls, and finally Christopher Webber Fenton, born January 30, 1806.[188]

In April, 1810, Jonathan Fenton purchased land in East Dorset on which he set up a kiln. This site, just over the mountain from his previous pottery, was his last home. There his sons Richard and Christopher must have learned their father's trade, as did probably the son-in-law, Seth Curtis, who married Jonathan's daughter Melyndia. At least, the latter young man was associated in the family business from 1827 until 1830.[189]

Richard, the elder of Jonathan Fenton's two sons, was the first in the family known to be associated with the Nortons, he having worked for them in Bennington both as a farmer and potter between 1828 and 1830. Hiram Harwood immortalized him by recording in his diary that he could not or, at least, did not, pay his thirty-five cents school tax due as a resident.[190] In 1830, he joined his younger brother Christopher in making stoneware in East Dorset bearing the mark *R and C Fenton/Dorset, Vt.* (our vertical dash sets off a second line below the first). This venture lasted only until May, 1833, when they sold out to their father, Jonathan, who apparently continued the business a few years longer. Richard died the following year, July 25, 1834, his father surviving until 1848.[191]

It should be noted, however, that Richard Fenton's daughter Jane married Franklin Blackmer Norton, born May 23, 1829, the son of John Norton Jr. and grandson of Captain John (see Appendix B, p. 189), who with Frederick Hancock, another potter, moved from Bennington to Worcester, Massachusetts, where they opened a stoneware pottery in 1858.[192] As another indication of the interlocking of families of potters, it may be observed that this Frederick Hancock had married Charlotte Anne Ames, a niece of Jane's uncle, Christopher Webber Fenton.

The younger of Jonathan's two sons, Christopher Webber Fenton, was a brilliant but erratic man who became distinguished as a not altogether unsuccessful visionary in the ceramics industry. His significant role in Bennington we shall elaborate upon when we sketch the continuing history of the Norton potteries. First, however, we shall give summary consideration to the question of when stoneware was first produced in Vermont.

As we have already seen, earthenware may well have been made first by Charles Bailey in Hardwick; secondly, by John Norton at Bennington; and

third, by the little known potter named Edson at Windsor. Admittedly, this series of priorities is based largely on the simple presence of a potter in a town and the probability of—or reputation for—his having established a kiln at a certain date. The determination of priorities in the manufacture of stoneware is more complex, for not only must potters and towns be correlated, but special skill and the importing of clay must be accounted for as well. In last analysis, it would seem that it was the acquisition of the basic material from which stoneware is made that is the crux of the problem.

The facts that can be verified or demonstrated are few, and we can review them quickly. Stoneware was being produced by 1810 in both Dorset and Bennington. Fragments of this material have been excavated by ourselves and others at the Dorset kiln site which was abandoned in 1810.[193] Hiram Harwood on October 23, 1810, recorded the bringing of cartloads of clay to John Norton's pottery in Bennington from Troy, New York. As later evidence clearly substantiates, such clay was brought up the Hudson River from New Jersey for the single purpose of manufacturing stoneware. The problem has thus been confined to the question of how much before 1810 and where in Vermont was stoneware made.

As we know, there were at least three potters who came to Vermont before 1810 who were already experienced in making stoneware. These were Isaac Brown Farrar who was in northwest Vermont in 1798, Jonathan Fenton who was settled in Dorset by 1801, and the latter's brother Richard Webber Fenton who set up a kiln in St. Johnsbury in 1808. Lura Woodside Watkins, the estimable authority on early New England potters, states that since Richard Fenton had been trained as a stoneware potter, he probably made stoneware from the first.[194] It is not explained how stoneware clay could be brought to St. Johnsbury economically in 1808, and until this is done, we rule out any potential claim for that kiln being among the first two making stoneware. Farrar had an advantage in arriving earlier, but the same stricture holds and we consequently doubt that any stoneware was being made in the area of Fairfax before 1810.

We are left then with the decision as to whether John Norton or Jonathan Fenton first made stoneware in Vermont. Only Jonathan had experience behind him. On the other hand the source of the needed clay was somewhat closer to Bennington. Certainly no great effort was required to turn a potter

of John Norton's background into a successful stoneware producer. It is not incredible that he could have amplified his existing knowledge sufficiently by letter or a journey to the nearest stoneware kiln in operation. Even more obvious would be the contribution of a visiting journeyman. Unfortunately, the Norton records were burned,[195] and there is only a tradition stating that the first stoneware was manufactured in Bennington in 1800.[196]

As far as Jonathan Fenton's case is concerned, it may be assumed that it would take him some time to establish himself in Dorset and, as a newcomer, to make the necessary arrangements for the transport of clay from New Jersey. Certainly, once he did so and set up a kiln, John Norton would have known of it and paid him a visit. After all, Dorset lies only thirty miles to the north of Bennington. It is reasonable to believe that John Norton was adequately supplying the local market for earthenware when Jonathan Fenton arrived in the country. Perhaps the latter thought the introduction of stoneware would give him an advantage and that, still being within a reasonable source of supply of the essential clay, he could dominate the trade to the north, a region that was being flooded with settlers. Indeed, it would seem that Fenton's move to East Dorset was intended to establish a pottery on the main road.

The reader may have the pleasure of determining for himself who first made stoneware in Vermont. If forced to a decision, we would guess that Jonathan Fenton was the man, but with John Norton also producing stoneware within a year or two afterward, the latest date for the beginning of production in both towns being 1806 or 1807.

The Later Nortons and Their Potteries

The biographies of the later Nortons have been outlined in considerable detail in the first half of John Spargo's *The Potters and Potteries of Bennington*, and Lura Woodside Watkins has provided a sophisticated summary in a few pages of her outstanding book, *Early New England Potters and Their Wares*. *The Harwood Diaries* were the basic source of information for Spargo, and the long period required for our reading of them only proved that his search in them for data on the Norton potteries was thorough. Having studied these works intermittently for many months, we are impressed by how much of what we

would like to know was not recorded—but let us review the information that is available. To do this we shall divide our data into six chronological periods, the first five denoted by the dominant family member—or members—in each period, and with the last representing the decline of the long tradition of Bennington stoneware. The periods are as follows:

1. 1793–1812. John Norton
2. 1812–1827. The partnership of sons Luman and John, Jr.
3. 1827–1833. Luman Norton
4. 1833–1861. Julius Norton
5. 1861–1881. Edward and Luman Preston Norton
6. 1881–1894. The decline

1793–1812. The first period was obviously dominated by John Norton, the founder of the potting dynasty who in the year 1793, it would seem, built the original kiln a little to the north of his house which was about a mile and a half south of Bennington Center (Fig. 7, p. 56).[197] More than likely during the first years of operation the project was a trial venture to which only limited time was devoted and unquestionably only simple forms of earthenware such as milk pans were produced. Then, in 1796, it was arranged for Norman L. Judd, aged fourteen, to become an apprentice.[198] He, like John Norton himself, was a native of Goshen, Connecticut, and a son of the latter's wife's sister Mary.[199] Clearly, the pottery had proved a success, as it continued to be.

By the middle of the year 1800, John Norton was almost forty-two years of age and his two eldest offspring, Luman and John, Jr., were fifteen and thirteen respectively. The decade that followed can only have been a rewarding one. Good fortune and pleasant dispositions produced what seems to have been almost an idyllic situation. There were acquisitions of land to extend the family's farming activities, and an increasing labor force to develop specialized undertakings—the blacksmith shop, distillery, lime kiln,[200] and pottery. The boys must have soon become thoroughly familiar with all of them as well as technically capable of handling most aspects of the work they demanded. There were also three daughters old enough to help their mother, a woman who provided two more sons and two more daughters before she

stopped bearing children in 1806 at the age of forty-three (See Appendix B, p. 189 for the descendants of the potter, John Norton).

It was about that time that Captain John experimented with the manufacture of stoneware and succeeded. Luman came of age in 1806, and everything known of him suggests that he would have actively furthered such a step since he must already have anticipated one day directing the business himself. As we have already indicated, the date when stoneware was first made is conjectural. It is unfortunate that Hiram Harwood did not take over the task of a diarist until 1810, for his father commented on relatively little beyond the confines of his own farm, whereas Hiram probably would have recorded the event. Anyhow, the very fact that he writes so casually that year about clay being brought to the Norton kilns from Troy suggests that the procedure was no novelty.[201]

A major event occurred in the Norton family when the eldest son, Luman, married Lydia Loomis on November 16, 1808. The young couple shared the family home until 1817, but Luman was already operating his own part of the farm.[202] On September 23, 1809, Luman and Lydia presented John and Lucretia with their first grandson, Julius Norton. It was a signal for Captain John to begin thinking of retiring at least to the extent of sharing the direction of some of his holdings. This he apparently did during 1811 or 1812 when, on the basis of the manner in which Hiram Harwood designates the pottery, it is believed that Luman was made a partner.[203] Adding certainty to the matter, a handwritten bill survives in the Bennington Museum bearing the company name of John Norton and Son with the date of August 30, 1813. Then, on June 18, 1815, Hiram Harwood wrote that John Norton, Jr. had lately entered into the company with his father and Luman.[204]

1812–1827. In that second period of the Norton pottery, distinguished by the partnership of Luman and John, Jr., it seems logical that the eldest son dominated and, as it proved, eventually came to own the entire business. Luman had entered into it first and, according to Spargo,[205] he managed its affairs from 1812, leaving John, Jr., with primary responsibility for the farm. Inevitably, when required by the nature of the work, they helped each other, but the direction of their efforts was more or less predestined.

The year of 1812 was one of special excitement. On June 16, Luman's barn was burned down by an arsonist.[206] Luman pursued and captured the wrong

man as was indicated by the fact that on June 19, another barn was intentionally burned. After that, a night watch was set up, and there was considerable drinking. On June 23 came the news of the declaration of war against Great Britain. Finally, on July 3, the arsonist was caught in the process of setting fire to the Norton house. The young man, an apprentice of Luman's who had proved himself one of the most faithful of the watchmen standing guard at night, confessed his guilt after being apprehended.[207] From 1806 onward, when Norman L. Judd left to start his own business in Burlington, Vermont,[208] various apprentices and journeymen had been employed of which the one previously mentioned was probably the most unfortunate.

Early in 1823, Captain John Norton dissolved his partnership with his sons, retaining his original farm and the distillery. Luman received a three-quarters interest in the pottery and John Jr. the remainder. The latter, however, took two-thirds of the Atwood farm which was part of the estate, Luman receiving title to the southern third.[209] Almost immediately, Luman moved the kiln site from just north of his father's home to across the road from his own house farther south and two miles from Bennington Center. This was the second of the three locations of the Norton pottery (Fig. 7, p. 56).

The move perhaps reflected the declining interest of John Norton, Jr. in the pottery, although we continue to read in Hiram Harwood's diary of his activities in connection with it until March, 1827, by which time he seems to have taken over the family distillery as well as having established a store in East Bennington with his next younger brother, Jonathan Buel Norton.[210] It seems clear that before the end of 1827, John Norton, Jr., had somehow conveyed his interest in the pottery to his elder brother.[211] East Bennington, we hasten to add, is the present city of Bennington, once casually referred to as the Lower Village, or more derisively as Algiers or the Swamp. When necessary in order to avoid confusion we shall continue to use the term East Bennington to distinguish it from Bennington Center, the original village which is on higher ground one mile to the east and now incorporated as the Village of Old Bennington.

Before passing to a discussion of the next period, we may interpolate a few remarks about John Norton, Jr., for what we know indicates an interesting character. Hiram Harwood tells us the story of how John went to Boston at the age of twenty-two with a friend, Elisha Smith, who contracted typhus

[typhoid?] fever and was confined to bed in Waltham, Massachusetts, where he was kindly nursed for two months by a family of complete strangers. John, who scrupulously looked out for his friend, caught the same disease in Boston soon afterward and, in turn, was successfully returned to health by the same considerate couple.[212]

After coming back to Bennington, he taught school for a period, but the profession did not suit him.[213] He probably enjoyed travel for in April, 1813, he visited Charlestown, S.C., a place to which he returned on at least one occasion.[214] His marriage on February 16, 1815, ten days before his twenty-eighth birthday was no doubt an event which in some degree forced him to settle down. It was sudden, and, as Hiram Harwood, recorded, after eight years of courtship and considerable intimacy, was long overdue.[215] Later, we read of John, Jr. carrying pottery to Woodstock, Vermont, by wagon, and he probably undertook many similar trips.

His partnership in the store in East Bennington with his younger brother, Jonathan Buel Norton, lasted only a few years, for the latter committed suicide by jumping from a Hudson River boat while returning from New York City in November, 1831.[216] John Norton, Jr. continued to operate the store and apparently the family distillery as well.[217] In the fall of 1834, he was elected Representative to the Assembly.[218] He was sixty-three years of age when he died on November 27, 1850.

From the point of view of the history of Vermont stoneware, perhaps John Norton, Jr's. most significant role was in being the father of Edward Norton, born August 23, 1815, and of Franklin Blackmer Norton, born May 23, 1829, the eldest and youngest of his six children, both of whom became potters. The latter has already been mentioned as having established a kiln in Worcester, Massachusetts, while the former was destined to dominate one of the longest and most successful periods in the history of the Norton potteries as we shall see later.

1827–1833. It seems fair to state that Luman Norton, the eldest son, was an intelligent and ambitious young man and that he had strived faithfully to attain his ownership of the pottery. Hiram Harwood mentions in June of 1815 that he discovered Luman not working at his wheel and noted that fact as rare.[219] As was customary among stoneware potters, Luman regularly used a kiln to fire earthenware as well. Hiram Harwood writes of buying milk pans

and of Luman giving them a wash of red lead.[220] Hiram also bought stoneware, once a six gallon pot for cheese which was too heavy to carry home.[221]

There was apparently a problem in obtaining sufficient help at the pottery. After Luman had become the sole owner, his younger brothers naturally had less interest in it and directed their efforts toward advancing their own affairs. Luman seems to have employed some steady assistants but he relied considerably on journeymen potters for whom he sometimes went in search.[222] When there was an adequate complement of workers, homes had to be found in which they could board. Occasionally, the Harwood's took in one of his potters for a short period.[223] It is likely that the necessity of obtaining and satisfying such assistants was one reason for moving the pottery to East Bennington in the latter half of 1833 (Fig. 7, p. 56). Hiram Harwood mentions this new establishment as being finished off in September of that year and men making pottery there two months later.[224] Clearly, it was a changing point in Luman's life, for it symbolized the success of the founding potter's eldest son who was then forty-eight. In October, Luman talked of moving his own family from the farm into town, although it is not clear that he actually did so until several years later.[225]

Luman Norton's life had been one of broad experience. He had been trained as a blacksmith and had later given up that activity in order to concentrate on potting, but he continued to farm and to acquire land.[226] As late as 1830, Hiram Harwood speaks of his friend haying. With his move into town, he became more of a gentleman farmer, or at least one who had tenants.

Most young men of the period had served in the militia at one time or another, and Luman Norton was no exception. He obviously enjoyed the companionship of such groups which, during most of his lifetime, were more social than military. By the eighteen-twenties he had achieved the rank of major and that was the title he was usually given by the diarist Hiram Harwood.

Despite the various demands on his time, Luman Norton also found the opportunity to read, and the books that he chose were of consequence, ranging from Greek literature through history to the latest technology of the day. He subscribed to a weekly New York City newspaper and was keenly interested in the changing social and political affairs of the new nation. Although

without benefit of much formal education, like many others of his day, he became by his own efforts a cultivated man.

It is clear that after his move into town, Luman Norton's ambition directed itself toward what in modern terms would be called upward social mobility. Whereas his father showed an independent attitude toward society, Luman Norton wanted recognition. Having been an active member of the Congregational Church in Bennington Center, it is significant that sometime after taking up residence in East Bennington he joined the Episcopal Church.[227] Before his move he had been made an Assistant Judge of the county, and after 1831, Hiram Harwood refers to him either as Judge or as Major.[228] It is not surprising to discover that shortly before Luman Norton died in 1858, he was elected to the Legislature of the State of Vermont.

Luman Norton's removal of his pottery to East Bennington in 1833, was more than an expansion of his business, it was an ascent into another world, after which his pottery became more of a means than an end. It is perhaps fortunate under the circumstances that at the same time, his eldest child and only son, Julius Norton, who was then twenty-four, had set his heart on controlling the pottery as his father had succeeded in doing before him. To his son Julius, we shall now turn.

1833–1861. Julius Norton did not receive complete control of the pottery in 1833, and it is not certain when the final transition actually occurred. We know that he was taken in as a partner that year, apparently having determined to move to either Rutland, Vermont, or to Portland, Maine, to set up business for himself if he were not.[229] It is unquestionable that by 1838 stoneware was being produced with the typical imprint *Julius Norton/Bennington, Vt.* (our vertical dash sets off a second line below the first), for the Bennington Museum has such a jar with the date added in cobalt blue. By early in 1841, Julius was advertising under his own name, and it must be correct as Spargo has assumed that Luman Norton had definitely withdrawn by that time.[230] Neither is there reason to doubt Spargo's conclusion that Julius was more interested in money and more successful as a businessman than either his father or grandfather.[231] He also had more formal education than either of them, but was somewhat shy. If he read less than his father, he was certainly the best flautist in the family. In 1836, he married Maria Spooner, a schoolteacher in town, but she died on May 22, 1837, barely two months after

giving birth to their son Luman Preston Norton. Julius did not remarry until four years later, his second wife increasing the family only to the extent of two daughters.

The major break in the twenty-eight year period dominated by Julius Norton was the partnership for a little over two and a half years with his brother-in-law Christopher Webber Fenton, and the fire which occurred soon after that business relationship began. As Spargo devoted himself to clarifying the role of the latter potter, we need to do little more than summarize the data.

Christopher Webber Fenton, as has already been mentioned, was one of the younger children of the early stoneware-maker, Jonathan Fenton, who was working in Dorset, Vermont, at the time of the birth. As a potter, Christopher was no doubt skilled, as a business man he was highly imaginative in his conceptions, but he was not infrequently in financial difficulties. His personality was extremely appealing to some individuals, and one of these was Louisa Norton, the elder of Luman Norton's two daughters. Their marriage on October 29, 1832, united the two most distinguished families of stoneware potters in Vermont.

Since the record shows that Christopher sold out his interest in the East Dorset pottery to his father the following May and was for many years thereafter associated with Bennington, it is unlikely that he was not involved in some way with Norton pottery there. Indeed, his activities almost certainly must have included the making of bricks as he obtained a patent for a new type in 1837.[232] He was then only thirty-one and his wife, Louisa, twenty-five.

In 1838, his father-in-law, Luman Norton, built the two-family brick house still standing at 206–8 Pleasant Street, Bennington, which was shared with Christopher and Louisa until Luman's death twenty years later. Both before that time and after it, Christopher and his brother-in-law Julius, who was almost four years younger, undoubtedly tried to help each other. It is true that their personalities were entirely different, but that would have been no bar to affection. More important, they were both devoted to the ceramic industry and to becoming wealthy by means of it.

In any event, as John Spargo has shown, their mutual interests developed into a partnership sometime between July, 1844 and the beginning of the following year.[233] That the factory was destroyed by fire on June 6, 1845 was not auspicious. A greater difficulty arose over the direction which the devel-

opment of the industry should take. Christopher Fenton was an innovator for whom the risks of experimentation were the necessary zest of life; Julius seems to have preferred a more cautious approach without being unappreciative of technical improvements. In last analysis, Julius was a conservative business man and Christopher's genius, if genius it was, was too disturbing a threat to enjoy comfortably. Consequently, on June 25, 1847, they dissolved their partnership, Julius devoting himself to the more traditional developments in stoneware manufacture and Christopher going on as the dominating figure in the creation of the various elaborate wares still considered elegant American creations by those with Victorian taste.[234] The story of the development and the depiction of the products of the U.S. Pottery of Bennington, as it was called, may be enjoyed in the works of John Spargo and of Richard Carter Barret.

In 1850, Julius took a cousin, Edward Norton, the son of his father's brother, John Norton, Jr., into the firm as a partner. Edward, born August 23, 1815, was six years younger than Julius who perhaps had a premonition that he might not live as long as had most members of his family and wanted the business safe and secure in family hands while his only son grew up. In any event, it must have been a gratification that he was able to add his son, Luman Preston Norton to the partnership in 1859, soon after the latter's twenty-first birthday. Julius survived the event only a short period, dying on October 5, 1861 at the age of fifty-two.[235]

1861–1881. The twenty-year period of the partnership of Edward and Luman Preston Norton may be described as the culminating one in the history of the family potteries. The two men had inherited a long-established, greatly enlarged, and financially sound industrial plant which they continued to guide harmoniously for a score of years. Edward, whose primary business training had been in his father's store no doubt had been in part responsible for the expansion, as he seems to have been the first partner who devoted most of his time as a salesman traveling in Vermont and the adjacent states. When first taken into the company, his partnership apparently included the right to buy into the actual ownership with his share of the profits, a procedure that resulted in his having acquired a one-third interest by April, 1861 and a full 50 per cent by 1865.[236]

The latter year was a good one for Edward as his first son was born on

March 20, 1865. His life had been marred by the loss of his first wife in 1860 after four years of marriage. With two infant girls left on his hands, he had married again after a year and a half. Thirteen months later, he had fathered a third daughter. As a man with a traditionally family business, the advent of son was no doubt particularly welcome.

Luman Preston Norton, the son of Julius, was distinguished by being the first college graduate to enter the family business, having completed his studies at Union College, Schenectady, New York.[237] Spargo speaks of him as manager of the firm and one who gained the highest respect because of his sterling character and business sagacity.[238] Actually, in the latter respect, he had weaknesses, as we shall see.

Just as the pottery survived the severe economic depression in the early eighteen-thirties, so it did during the difficult Civil War years (1861–65). Then came the significant March twentieth of 1874. Curiously, it was not only the thirty-seventh birthday of Luman Preston Norton, but the ninth birthday of Edward Lincoln Norton, his partner's son. As so often has happened, fire spread into the timber framework of a kiln. The danger was discovered and subdued only to be later fanned into fury by a strong wind after it had been thought that the fire had been put out. As a result, the pottery was almost completely destroyed with a loss estimated at $30,000. It was one time when Luman Preston Norton's business sagacity proved not always sufficient, for he had permitted his long-carried insurance to lapse some time before. The pottery was immediately rebuilt on a larger scale, however, and was again in full operation within six months.[239]

Luman Preston Norton, a man of various interests, was one of the cultivated leaders of Bennington society. There is a suggestion that he preferred his role of President of the Bennington County Savings Bank to that of a potter. In any event, in 1881, he conveyed his interest in the family business to Edward Norton who became its sole owner.[240] It is significant that the following year when the Village of Bennington obtained a new charter, that Luman Preston Norton became head of the local government.[241] His disassociation with the pottery was wise, for the role of salt-glazed stoneware in American culture was waning. We presume he found satisfaction in his wisdom, for Luman Preston Norton lived to be sixty-nine, dying on October 12, 1906.

1881–1894. The decline of the Norton stoneware business was inevitable,

but it was also hastened by fate. Edward Norton had married late and his son, Edward Lincoln Norton, was not born until the father was in his fiftieth year. The latter was already approaching seventy when he took over the business, no doubt with an eye on his adolescent son. In 1883, however, he sold the half interest recently acquired to C. W. Thatcher of Bennington who thus became the first partner in the Norton potteries during its ninety-year history who was unrelated by descent or marriage.[242] Perhaps Edward Norton needed to reinforce his cash position but, quite as likely, he also wanted to have a mature, experienced businessman in the firm should he die before his son was mature, a reasonable anticipation at his age. As the matter turned out, the action was none too soon, for he survived only until August 3, 1885.

His son, the fourth generation of Nortons in the pottery, thus succeeded his father when only twenty years old. Nonetheless, according to Spargo, it was this son's idea that the firm should become wholesale dealers in glassware, china, and pottery of all kinds. Like his father, Edward Lincoln Norton was primarily a salesman.[243]

Some local production of stoneware was continued until 1894 at which time it was planned to elaborate on the few kinds of pottery being produced. Then fate dealt the final hand, death eliminating the last Norton from the one-hundred-year-old family concern on December 13, 1894, at the young age of twenty-nine.[244]

Although this latter event necessarily ends an account of the Nortons who produced stoneware, it may be noted that the wholesale business of the company apparently continued into the first years of the twentieth century. This fact is attested by a dated billhead in the possession of the Bennington Museum.

It remains to make a few summary comments on the potteries themselves before turning to their products. As has been previously indicated, we are impressed by how little is known of the technical details of the manufacturing process. Spargo, who wrote in a day when he could still talk with surviving workers in the Norton pottery, failed to record the data which would complete the picture, and fifty years later it is apparently too late. We have knowledge of the location of the three kiln sites but, except that both earthenware and stoneware kilns were both used, we have only the slightest evidence of their actual construction.

Without doubt, the first pottery in the eighteenth century included only one kiln and that for earthenware. Quite likely, the bricks of which it was made were sold after each firing, and a new kiln made. This statement is purely conjecture, however. When the manufacture of stoneware was introduced, more permanent kilns were probably introduced so that at least two types may have been in use for decades thereafter.

The original shops were of wood, and most likely of one story. Enlargements were made in the general pattern of construction during the 1827–1833 period of Luman Norton. The second pottery in East Bennington, if not the first, had an upper floor which was used as a storeroom.[245]

We are told that after the fire of 1845, the pottery building was reconstructed of brick instead of wood and that it was much larger than the old one, consisting of a hollow square, 114 by 92 feet (Fig. 8, p. 104). Christopher Webber Fenton was said to have designed the kilns, introducing some new features, unfortunately undescribed.[246] Whatever innovations, they apparently did not supplant the framework of heavy timbers built around each kiln to constrain the bricks from expanding too much during the firing. It was the ignition of these timbers that caused the conflagrations of both 1845 and 1874.[247] We can add that the brick walls of the last building used, and which were still standing in 1969 were based on a U-shaped plan with one arm of the U shorter than the other. The long, single-story, south face of the factory measured approximately 125 feet, while the east face, or longer arm of the U, was 92 feet long and 37½ feet wide. The front, or south, side had a gable rising to provide two floors for the rest of the building which had an almost flat roof. The Walloomsac River, in this place a brook, flows westerly behind the factory.

The increase in the size of the potteries is a correlate of their production and the number of men working in them. Spargo supposed, and reasonably enough, that not more than six men including the Nortons themselves, were employed before 1823. The number was doubled by 1830, and apparently quadrupled by 1835, the total number of workers, he thought, reaching forty by 1850.[248] It is quite possible that the figure had increased by the heyday of the 1861–81 period, but, if so, it soon declined.

We might also note that, whereas Captain John Norton and all of his four sons were practicing potters at one time or another, it is the third generation

Julius Norton who has received the most praise for his skill in throwing clay.[249] Furthermore, it is perhaps significant that the Nortons who followed him in the business, whether they could throw a jug or not, were essentially businessmen, not practicing potters.

About the other equipment of the potteries, we know even less than we do of the kilns. Wheels are mentioned by Hiram Harwood at various times. Inevitably, they must have conformed to the general pattern of such machines, but of their actual size we know nothing, nor of the material from which they were made. The same lack of information exists about the mills for grinding the clay. That the pottery when moved to East Bennington in 1833 was built on a water privilege suggests that water power may have been used in grinding, but that is a guess. The stream may simply have been dammed to insure an adequate supply of water in all seasons. Water, after all, was primarily necessary for mixing the clay, and tons of the latter were used. What was made from it is now to be seen.

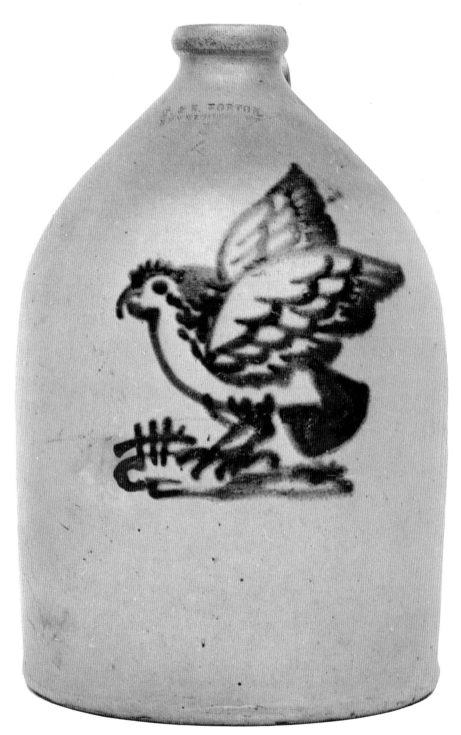

Plate A: The Cock on a 2-gallon Jug. *J. and E. Norton*, 1850–59

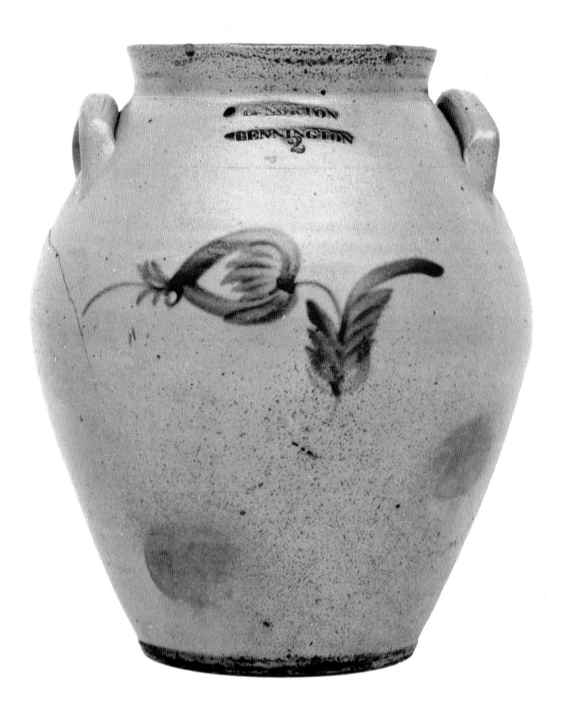

Plate B: Early Blue Flower on a 2-gallon Jar with Inset Cover. *L. Norton and Co.*,
1823–28

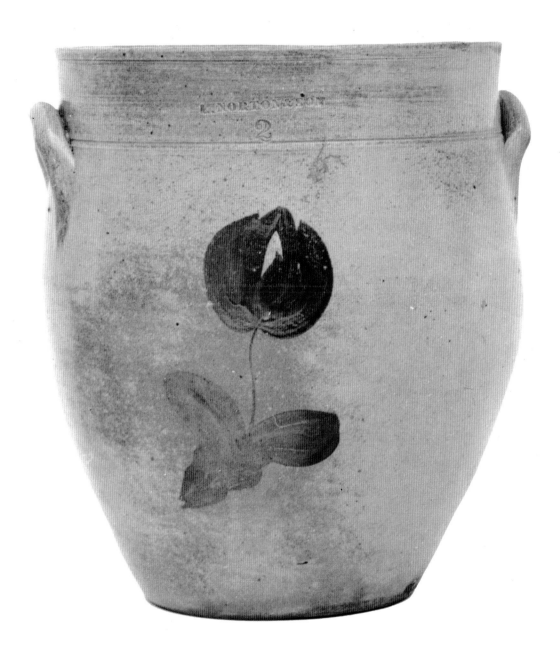

Plate C: Early Ocher Flower on a 2-gallon Bulging, Wide Mouth Jar. *L. Norton and Son*, 1833–38

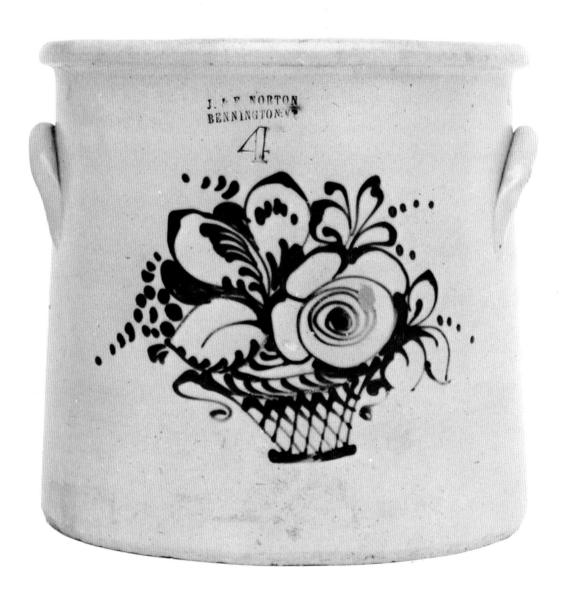

Plate D: The Basket of Flowers on a 2-gallon Jar with Vertical Sides. *J. and E. Norton, 1850–59*

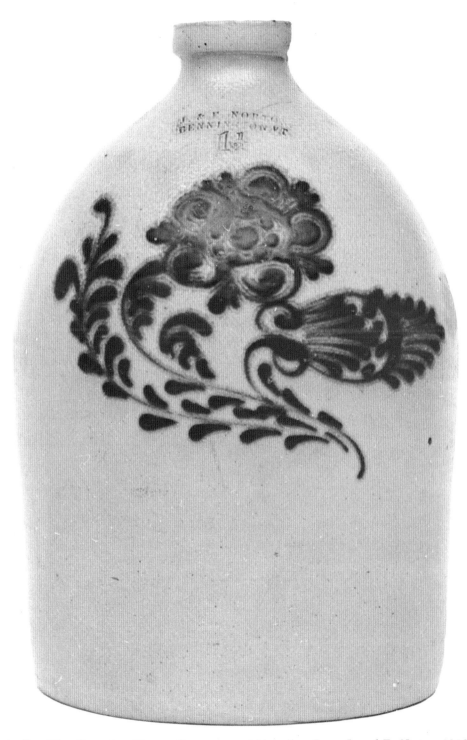

Plate E: The Complex Flower Spray on a 1½-gallon Jug. *J. and E. Norton*, 1850–59

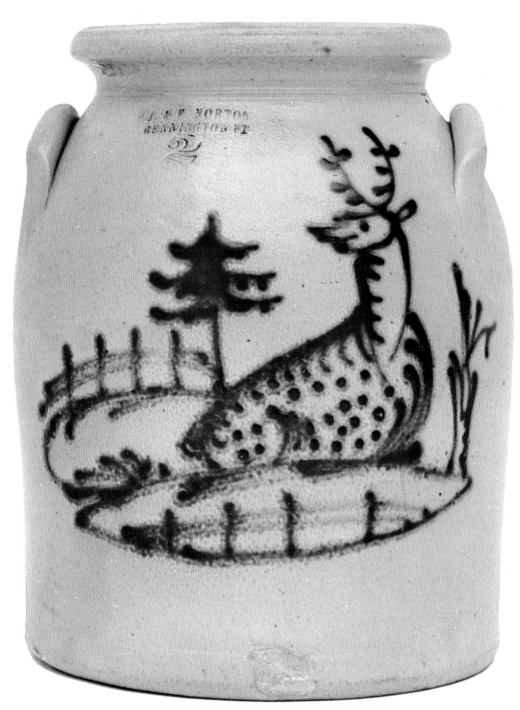

Plate F: The Deer on a 2-gallon Jar with Inset Cover. *J. and E. Norton*, 1850–59

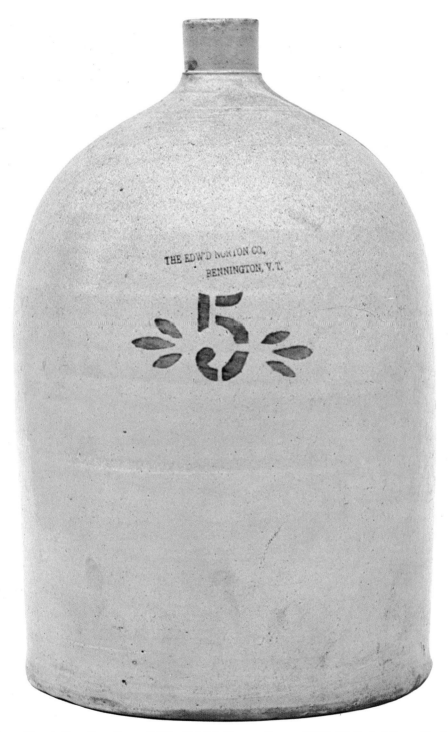

THE EDW'D NORTON CO.,
BENNINGTON, V.T.

5

Plate G: A 5-gallon Jug of *The Edw'd Norton Co.* or 1886–94 Subsidiary Period

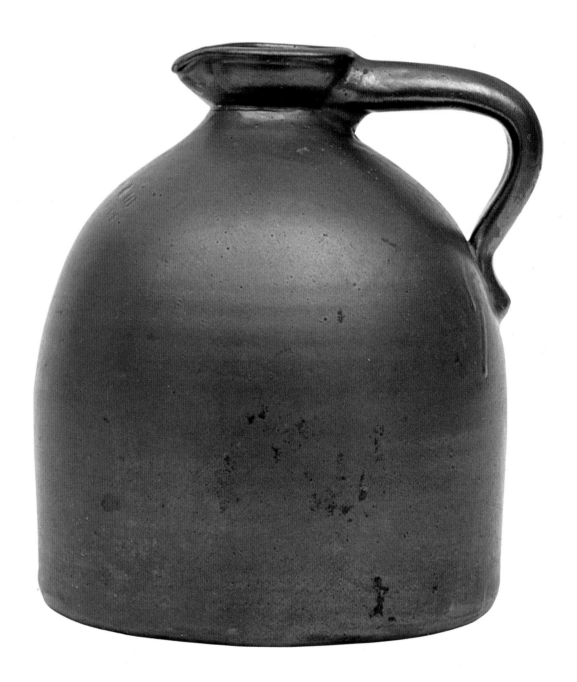

Plate H: A 1-gallon Over-all Brown Glaze Pitcher Jug. *E. Norton and Co.*, 1883–94

THE PRODUCTION
OF THE NORTON KILNS

Marks and Dating

IN ORDER TO PRESENT the changes in the productions of the Norton kilns over the century of their operations, it will be necessary to relate them to a time scale. Fortunately, such a scale has been provided for us by Spargo who worked out the correlation of specific company marks stamped on the pottery with the corresponding names on dated billheads and on the newspaper advertisements offering Norton stoneware for sale.[250] He thus provided eleven time periods with a subsidiary period at the end. For six of these periods, he indicated variant marks in which the words or specific letters varied, and he listed one mark which he was unable to date, thus making a total of twenty-three marks on his list.

We have added one time period, changed two dates, and presented numerous variant marks within the periods based on details which for Spargo's purposes did not seem necessary and, if so desired, may understandably be passed over by the reader here. We shall also make a few critical comments.

First, and perhaps most important, although we do not wish to quarrel with Spargo's assertion that his list "provides a complete and convenient check-list by means of which any piece of stoneware bearing a Norton mark may be dated with virtual certainty," it must be pointed out that the potters were probably not as exacting in their stamping of ware as Spargo and the printed records would have us believe. The initial problem of when some partnerships began and when they ended still remains. The record is far from precise, for example, as to the date that John Norton, Jr. left the firm

or as to when Julius actually displaced his father, Luman Norton. In early cases, such processes seem to have been gradual and the stamping of names—and more particularly the printing and publishing of them—may readily have involved a time lag. Contrariwise, both Luman and Julius may have taken particular pleasure in an early stamping of pieces with their personal names.

It can hardly be a "virtual certainty," for example, that stoneware imprinted *Julius Norton/Bennington, Vt* was manufactured only after 1840 when the Bennington Museum owns a piece with this commonplace mark plus the date of 1838 inscribed in underglaze blue. Also, a billhead in the Bennington Museum printed with a Norton and Fenton mark which bears a date July 30, 1844 seems to resolve Spargo's uncertainty as to the end of the previous period, and we are content to accept this year as the beginning of the partnership. Also with this mark there is the special problem that it was used both before and after the partnership with Christopher Webber Fenton which lasted between 1844 and 1847. From a survey of the available pieces, however, it seems simple to distinguish the earlier and the later ones by their similarity in shape and decoration either with the preceding or the following period. To be specific, the early jugs are oval-shaped while the later ones tend to have straight, vertical sides. Also the early *Julius Norton* specimens in our collection lack decoration which the later ones have in a style that seems to have begun during the Fenton partnership.

There are undoubtedly other cases which would prove Spargo's system of dating unreliable by a year or two, especially in the sense of overlapping usages. Notwithstanding this resiliency, the list is certainly convenient and, on the whole, reliably useful to a degree that warrants our approval and adoption.

Before presenting a list of marks there is another type or critical comment that should be made which involves a fundamental addition in dating. The last of the twenty-three names in Spargo's list is that of *Bennington Factory* to which he adds the comment "This mark is exceedingly rare—I know of only one piece so marked—and the date of its use is unknown."[251] Such a statement would challenge any collector as it immediately did us. With specific awareness, but no more effort than went into the acquisition of pieces with other Norton marks, we have acquired over the years four pieces stamped

Bennington Factory while the Bennington Museum during a considerably longer period has acquired five. We have also seen others. Logically, one might suspect that the use of this mark was earlier than those with specific Norton names and a study of the nine readily available pieces on the basis of shape, designation of capacity, and details of decoration converts a suspicion into a reasonable certainty. We have therefore placed this last mark first with a corresponding date in the series. We are aware that in a later publication Spargo concluded that *Bennington Factory* was an owner's mark placed on stoneware supplied to a local factory.[252] If true, this fact would not change our judgment in placing it first on the list of Norton marks. Curiously, Richard Carter Barret, who pointed out to us the later Spargo note, after considerable search has found no confirmation to support a belief in the existence of an early Bennington factory, or store, of the type Spargo apparently envisioned.

Finally, we come to a consideration of five marks on the Spargo list which are represented in neither our collection nor in that of the Bennington Museum. The first of these is *J. Norton/East Bennington, Vt.*, which is one of the variant stamps for the period 1838–44 (As always, our vertical dash sets off a second line below the first). The mark is unquestionably a rare one, if we accept its actual existence on stoneware. The identical situation obtains in the case of the *E. Norton/Bennington, Vt.* stamp of the short period 1881–83, except that this mark is not a variant, and we have found no specimen whatever for this interval. Pieces marked *Edward Norton/Bennington, Vt., Edward Norton and Co/Bennington, Vt.*, and *Edward Norton and Company/Bennington, Vt.* are also lacking in the two large collections. These are apparently variant stamps of the period 1883–94 of which pieces bearing *E. Norton and Co/Bennington Vt.* are relatively common, we ourselves having acquired fourteen and the Bennington Museum nine.

Let us interpolate here that at the date of last counting our catalogue showed 140 pieces of Norton stoneware with a Norton mark while eighty-five such specimens were listed in our survey of the Bennington Museum collection. These figures, we should add, do not include certain miniatures and other exceptional pieces historically known or attributed to the Norton kilns, but not bearing an established period name. The Bennington Museum collection, however, contains a large per cent of unique or very unusual pieces of stoneware with Norton marks which were preserved locally by members

of the Norton family or by other families in the local community. Therefore, it seems reasonable as well as convenient to reduce the number of ordinary pieces subject to chance acquisition in the Bennington collection to seventy, providing us with a total of 210 with which to compute percentages and probabilities. Thus, to say that a piece marked simply *J. Norton/East Bennington, Vt.* does not occur in two separate collections made over long periods of time gives a measure of its rarity. This also applies to the four other cases, but we must emphasize the fact that only two or three pieces with certain of the other marks are known.

At the other quantitative extreme, there are twenty-five pieces stamped *E. and L. P. Norton/Bennington Vt.* in our collection and twenty-two in the Bennington Museum making a total of forty-seven. Also we have thirty-two pieces with the *J. and E. Norton/Bennington Vt.* mark, while the Bennington Museum has fifteen, which also add up to forty-seven and, for these two periods together, no less than ninety-six, or nearly one-half of the total aggregate. It must be remembered, of course, that these two marks represent two of the longest periods, 1850–59 and 1861–81, totaling twenty-nine years out of the approximately eighty during which stamps were used. Considering the relative lateness of these periods, the ratio of survival is just about what might be expected. Furthermore, there were no variant marks during these two periods. There seems no doubt but that more pieces marked *E. and L. P. Norton/Bennington Vt.* have survived than those with any other stamp, as Lura Watkins long ago noted.[253] We conclude our comments on quantities by adding that the superior number of *J. and E. Norton/Bennington Vt.* specimens in our own collection results from a prejudicial selection based on the attractive ornamentation of that period.

From a technical point of view, all the known marks on the pottery of the Norton kilns at Bennington, with the exception of the last, subsidiary one, are impressed into the surface of the clay, and it is likely that they were made by obtaining the desired metal types from the local printing office and binding them together in some fashion. At least one of the fonts seems to be identical with one used in the Bennington newspaper of the period, the *Vermont Gazette.* The mark of the last, subsidiary period, however, is printed in cobalt blue over an off-white slip, and thus differs fundamentally from all of the earlier marks (See Pl. 10).

The marks are usually in two lines, one balanced below the other (indicated in our text by a vertical dash). Sometimes only one line appears with the name of the town being omitted. Rarely, the stamp forms a circle. Without known exception, on the commoner varieties of stoneware, these marks were placed high on the wall of the vessel as near the rim as convenient and, laterally, approximately half way between the paired handles when they occur, or opposite to the strap handle of a jug. On water coolers or more exceptional pieces, the mark may occur in the middle or even at the bottom. In batter pails, the mark occurs below the spout. There is some variation in the size of the letters used at different periods and, more rarely, within periods. An example has even been found at the Newfane Museum of a mark carelessly put on upside down. We shall now list by period the marks, with their variants, which have been found on or attributed to the Norton stoneware of Bennington. For those interested, a more detailed description of these marks on specimens in our collection is available in Appendix C (p. 192).

The Pre-1823 Period
Bennington/Factory

The 1823–28 Period
L. Norton, and Co.
L. Norton, and Co./Bennington

The 1828–33 Period
L. Norton./Bennington
L. Norton/Bennington

The 1833–38 Period
L. Norton and Son
L. Norton and Son/Bennington
L. Norton and Son/East Bennington

The 1838–44 Period
Julius Norton./Bennington Vt
Julius Norton/Bennington Vt

Julius Norton/East Bennington Vt
J. Norton/East Bennington Vt

The 1844–47 Period
Norton and Fenton,/East Bennington, Vt.
Norton and Fenton/*Bennington Vt*
Norton and Fenton/*Bennington Vt* (in a circle)

The 1847–50 Period
Julius Norton/Bennington Vt.
Julius Norton/Bennington, Vt
Julius Norton/Bennington Vt

The 1850–59 Period
J. and E. Norton/Bennington Vt
J. and E. Norton./Bennington Vt.
J. and E. Norton,/Bennington Vt.

The 1859–61 Period
J. Norton and Co:/Bennington, Vt:

The 1861–81 Period
E and LP Norton/Bennington Vt:

The 1881–83 Period
E. Norton Bennington, Vt.

The 1883–94 Period
E Norton and Co/Bennington Vt
Edward Norton,/Bennington, Vt.
Edward Norton and Co.,/Bennington, Vt.
Edward Norton and Company,/Bennington, Vt

The 1886–94 Subsidiary Period
The Edw'd Norton Co./Bennington, V.T.

Ultimately it may be determined that the variants within the periods—at least in some instances—also indicate a temporal sequence. One might guess, for example, that *Bennington* was added later to the marks of the 1823–28 period, but real evidence for a priority of marks within periods in the above list is not at present available.

The Varieties of Ware

Our two sources of information about the varieties of Norton stoneware of Bennington are first, the printed billheads, of which a considerable number are known (the Bennington Museum has fifteen of six different periods); second, an illustrated centennial price list of 1893 in the Bennington Museum; and third, the specimens themselves. Unfortunately, but as might be expected, the billheads ranging in date from handwritten ones of *John Norton and Son* of Aug 30, 1813 and July 21, 1815 to printed ones between those of *Norton and Fenton* of July 31, 1844 and an undated one of *E. and L. P. Norton* in the eighteen-seventies are not consistent in naming the items mentioned. *J. and E. Norton* and *E. and L. P. Norton* bills have some of the items pictured but the artistry is seldom adequate for identification in the cases where the variety of ware is questionable (Fig. 8, p. 104).

Among the actual stoneware pieces bearing marks there are a few varieties about which there is little or no confusion in either identification or in a correlation between the bill listings and the specimens. These include the jugs, churns, common pitchers, batter pails, molasses jugs, water coolers of two types, and spittoons (Fig. 9, p. 105).

Jugs are almost in a class by themselves as they are always listed first on the Norton bills we have seen although not necessarily so on those of other stoneware potteries (Fig. 9, A, p. 105).

Churns can always be identified on the bills and by the covers with the collared hole on specimens when they are present (Fig. 9, C).

Common pitchers, with handles, are descriptively a recognizable item, but relatively few have apparently survived (Fig. 9, F). We have one of the *E. and L. P. Norton* period in over-all brown glaze (Pl. 12, LL), while the Bennington Museum has one probably even rarer of the *J. and E. Norton* period in salt-

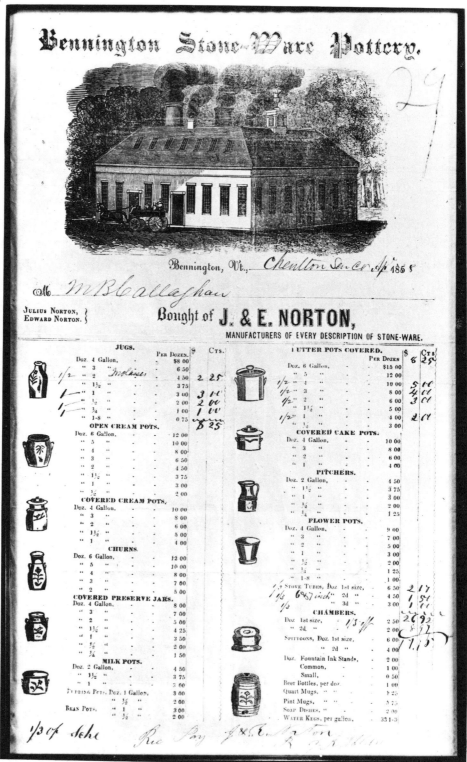

Fig. 8: A Pottery Bill of the J. and E. Norton Period

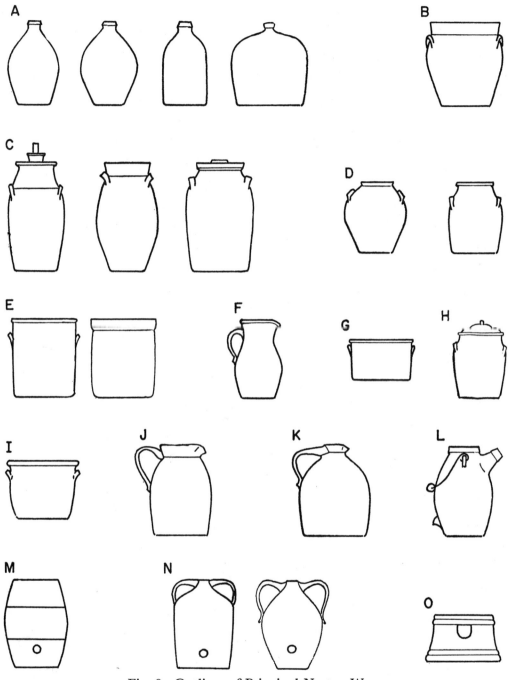

Fig. 9: Outlines of Principal Norton Wares

glazed stoneware with blue circumscribing lines. The latter is illustrated by
Barret (1958: 5). We are unable to distinguish with certainty, however,

between what the bills refer to as fancy pitchers and the common pitchers, although a Fairfax Stone Ware Pottery bill of 1851 seems to do so adequately as it clearly pictures both.[254] On the other hand, fancy pitchers are listed as such only on the *Norton and Fenton* bills and therefore probably refer to some of the more atypical innovations for which Fenton later became famous.

Batter pails do not appear on bills before the *E. Norton and Co.* price list of 1893, but we not only have a specimen of that period but one with an E. and L. P. Norton mark (Fig. 9, L). Probably they were introduced in the late eighteen-seventies. We have referred to them more descriptively as spouted jars and, as far as we have found, they were always made with an over-all brown glaze. They also seem to have been regularly supplied with a tin cover for the top opening as well as for the spout, although these are often missing from surviving jars.

Molasses jugs are first listed on the *E. and L. P. Norton* bills and were apparently introduced in that period. The price list of 1893 pictures one clearly. We have identified them descriptively as jugs with a lip on the basis of three examples in our collection bearing the *E. and L. P. Norton* mark and a fourth with that of the later *E. Norton and Co.* (Fig. 9, K). All four specimens, we should note, are covered with an over-all brown glaze.

Water kegs, or water fountains as they are sometimes termed, we have sub-divided into two categories: barrel coolers (Fig. 9, M) and jug coolers (Fig. 9, N), each having the diagnostic bunghole-like aperture near the base. The Bennington Museum has five of each type. Many are unusually large with elaborate and unique decoration, not infrequently having been presentation pieces.

As for the unmistakable spittoons, we have been able to recover one with the mark of the *E. Norton and Co.* period (Pl. 9, LR), but we find them listed on bills at least since the second Julius Norton or 1847–50 period (Fig. 9, 0). The Bennington Museum has a spittoon which has been illustrated by Barret and appears to be identical with our own.[255] Curiously, the price list of 1893 distinguishes between "bar-room spittoons" and "cuspidores" [sic], but the difference has not been resolved. The words, of course, are given as synonymous by Webster.

We might add that there would seem to be no difficulty in identifying any of the following varieties of Norton ware, but we know of none with period

marks: stove tubes (in three sizes), chambers (two sizes), beer bottles, quart mugs, pint mugs, soap dishes, and ink stands (two sizes). Ink stands, incidentally, were not listed after the *J. and E. Norton* period (1850–59), an indication of technological culture change.

A second group of varieties of ware raises more of a problem when we attempt to correlate the specimens with the listings. This is not only because the printed names on bills were chosen on the basis of function rather than appearance, but because the use of the names is not always consistent on the bills of the various periods. This group includes such categories on bills as pots, *open cream pots*, or open cream and butter pots; covered jars or *covered preserve jars*; *covered butter pots*; *covered cake pots*; *covered cream pots*; and *milk pots*. For example, a single bill of the *J. and E. Norton* period offers all of those types identified by *italics* in the above list, a combination which at first left us in some confusion.

In an effort to reduce this confusion, let us say that what are written down simply as pots in the earliest bills seem later to become open cream pots, and, still later, open cream or butter pots. These vessels seem almost certainly to be what we have termed bulging, wide-mouth jars (Fig. 9, B). It is notable that the price list of 1893 does not list these, nor do we have any specimens of them bearing either the *E. Norton and Co.* or *The Edw'd Norton Co.* mark. As far as we know, they were not produced after 1881.

We have the same confidence that what are called covered jars, or covered preserve jars, are what we have described as jars with inset covers (Fig. 9, D).

About covered butter pots, we are even more secure as these seem certainly to be what we have termed jars with vertical sides (Fig. 9, E).

When we come to the covered cake pots, however, we are faced with more uncertainty. They first appear on the bills of the *J. and E. Norton* period (1850–59), and from their picture then and in 1893 we are inclined to think that they have the same basic shape as the jars with vertical sides except that the walls are low in proportion to the diameter (Fig. 9, G). There is one such piece in our collection with a *J. Norton and Co.* mark. It is of one-gallon capacity and $10\frac{1}{2}$ inches in diameter, but only $5\frac{1}{4}$ inches high. In short, the diameter is double the height whereas among our nine other one-gallon jars with vertical sides, the diameter actually averages less than an inch wider than the height and even in the maximum instance, the diameter is only 2 inches

wider. The typical ratio is approximately 8½ inches by 7½ inches. This proves that the piece we have classified as a cake pot is surely not of the variety we have identified as jars with vertical sides, so what else could it be but a cake

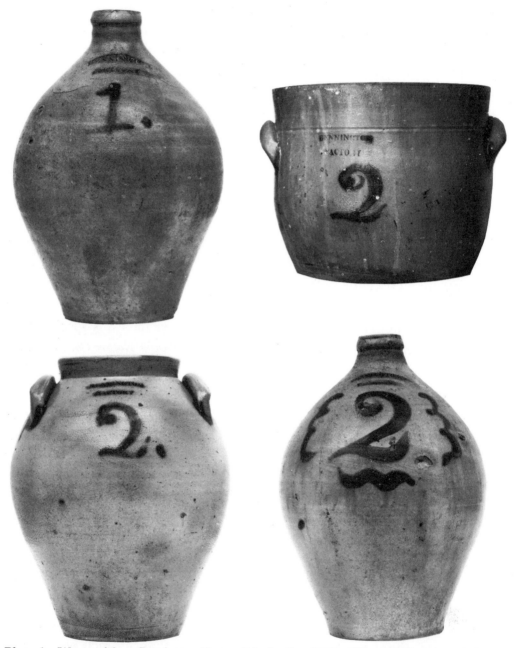

Plate 1: Ware with a *Bennington Factory* Mark, Pre-1823. UL: 1-gallon jug. UR: 2-gallon jar with vertical sides. LL: 2-gallon jar with inset cover. LR: 2-gallon jug.

pot. One the other hand, the proportions of some cake pots were apparently not quite so extreme.

After consideration of the covered cream pots which were also introduced during the *J. and E. Norton* period, we are less happy about a solution. From their depiction on a bill of that period,[256] they look similar in outline to the covered preserve jars which we have termed jars with inset covers, but with the important difference that the cover seems to spread out broadly over the top (Fig. 9, H). Actually the illustrations are better on an 1851 bill of the Farrar and Stearns pottery in Fairfax, Vermont, where the same varieties of wares were sold.[257] We do have one piece in our collection bearing an *E. Norton and Co.* mark which seems to confirm such a distinction. The inner face of the mouth simply narrows as it descends, lacking the clearly modeled horizontal ledge for the inset cover that appears on another specimen of otherwise identical shape, capacity, and period that we fortunately obtained. Thus, we trust we have resolved the matter, but confirmation is needed since the price list of 1893 neither mentions nor depicts such a vessel.

The milk pot is the most difficult variety of ware to identify, and we have found no specimens that could be so-termed with assurance. The rarity is understandable as the milk pot is listed only on the *J. and E. Norton* bills where the picture suggests nothing more closely than a chamber pot with the vertical strap handle characteristic of that vessel replaced by the two horizontal ones that are common to most jars (Fig. 9, I).

The common batter pitcher is apparently a form of pitcher with a cover, this fact being indicated by the fact that "Covered Batter Pitchers" follows "Batter Pails" on the price list of 1893 (Fig. 9, J). We have a one-gallon jar-like vessel in over-all brown glaze with a handle, a pouring lip, and a flat knobbed cover. It bears an *E. and L. P. Norton* mark and is almost certainly an example (Pl. 12, UR).

Finally, we may mention that we have not positively identified the Norton bean pots introduced in the *J. and E. Norton* period, although pieces of the general shape are well known, or the fruit or tomato jars first listed in the *E. and L. P. Norton* period. Probably they did not bear marks. Also two items appear on these stoneware bills that are most probably earthenware. Earthen pans are last seen on the bills of the *Norton and Fenton* period (1844–47), while flower pots in the common sizes continue to be listed in 1893.

Changes of Shape in Time

In this section for the sake of clarity we shall order our comments according to the twelve basic and one subsidiary time periods among which the twenty-nine marks are distributed.

The Pre-1823 Period

The *Bennington Factory* jugs appear in an elongated oval shape with vertical strap handles from mouth rim to body of a type that varies little during the whole period of Norton manufacture (Pl. 1, UL, LR). Jars, whether of the bulging, wide-mouth variety or those with narrow mouths and inset covers, bear a pair of horizontal opposing handles below the rim (Pl. 1, UR, LL). These paired handles also continue essentially unchanged throughout all of the twelve basic periods. The jars with inset covers are also formed in an elongated oval shape as are the jugs (Pl. 1, LL).

The 1823–28 Period

At the time the *L. Norton and Co.* marks were used, there is little change in the forms of the vessels to be observed on the basis of the material available to us. We would like to know, of course, when the first jars with vertical sides were made (Pl. 2, UL, LL).

The 1828–33 Period

During the independence of Luman Norton, we fail to find any significant change in the shapes of the pottery, although it is only for jugs and jars with inset covers that we have adequate data. This consistency in shapes is not surprising, as he had been the dominant figure in the production of stoneware over the many years that culminated in the *L. Norton* period (Pl. 2, UR, LR).

The 1833–38 Period

By the time of the *L. Norton and Son* partnership however, a general improvement in pottery is evident, and we recall Spargo's statement that the son Julius was remembered by his fellow craftsmen as an exceptionally good

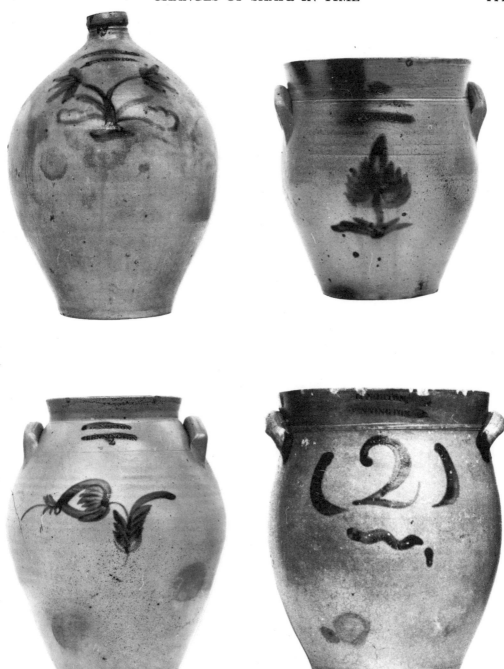

Plate 2: Ware with an *L. Norton and Co.* Mark, 1823–28, or *L. Norton* Mark, 1828–33. UL: 2-gallon jug, *L. Norton and Co.*, 1823–28. UR: 2-gallon bulging, wide-mouth jar, *L. Norton*, 1828–33. LL: 2-gallon jar with inset cover, *L. Norton*, 1828–33. LR: 2-gallon bulging, wide-mouth jar, *L. Norton*, 1828–33.

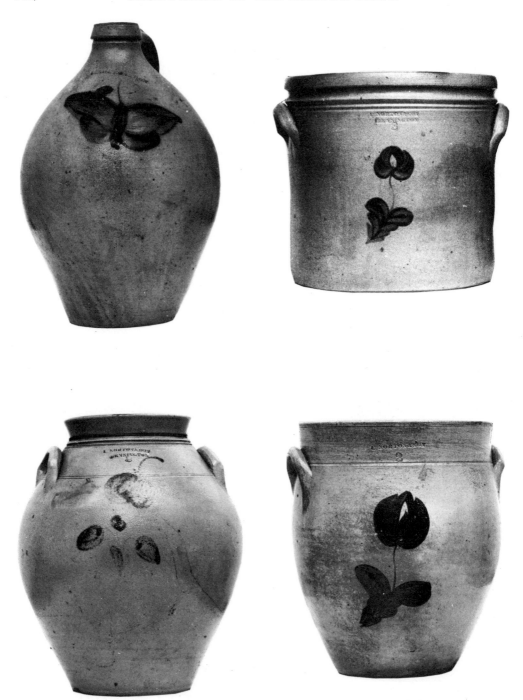

Plate 3: Ware with an *L. Norton and Son* Mark, 1833–38. UL: 1-gallon jug. UR: 3-gallon jar with vertical sides. LL: 3-gallon jar with inset cover. LR: 2-gallon bulging, wide-mouth jar.

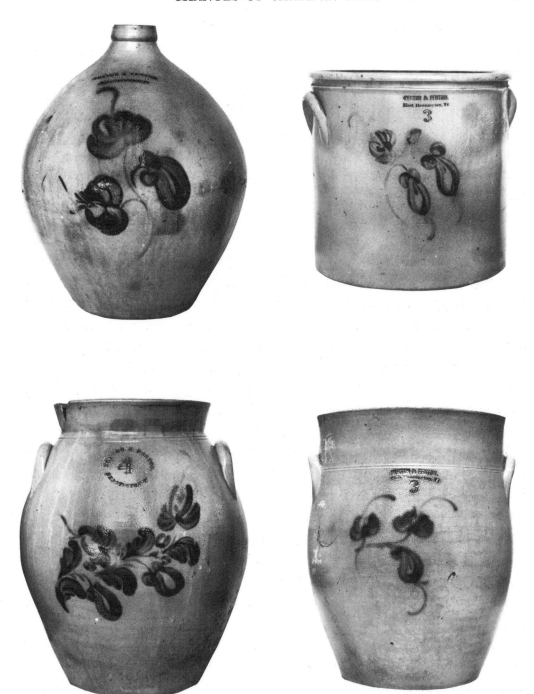

Plate 4: Ware with a *Norton and Fenton* Mark, 1844–47. UL: 2-gallon jug. UR: 3-gallon jar with vertical sides. LL: 4-gallon jar with inset cover. LR: 3-gallon bulging, wide-mouth jar.

potter (Pl. 3).[258] Some jugs are more elongated. Also in this period there is a significant increase, if not the actual introduction, of open-mouth jars with vertical sides (Pl. 3, UR).

The 1838–44 Period

This first *Julius Norton* period, on the basis of our limited number of specimens, is not distinguishable by the shapes from the preceding period, a fact that might well be expected if Julius was the motivating force for change in each (Pl. 5, UL, LR).

The 1844–47 Period

It was the period of the partnership of *Norton and Fenton* that produced the fundamental changes in the shapes of the pottery. During it, the elegant oval-shape jugs appeared in a more robust globular form and gradually spread out at the base until the sides were nearly vertical. The same process can be observed in the change in shape of the jars with inset covers. The exact evolutionary process cannot be theoretically proven, of course, but the empirical evidence is clear that before this period the jugs, as well as most jars, were more or less oval-shaped while afterward they were almost entirely vertical-sided (Pl. 4 and Pl. 13, UM, UR).

We cannot be certain who was responsible for the change. We have noted the introduction of jars with vertical sides about a decade before. Possibly it was Julius Norton himself or perhaps the imaginative Christopher Webber Fenton. Spargo would probably suggest Decius W. Clark, the most remarkable technician among the potters, who joined the firm in 1845, and Lura Woodside Watkins is even more sure that he is responsible for the globular jugs.[259] Perhaps it was none of these men who originated the new shapes, although one or more of them must have been responsible for instigating the changes at the Norton pottery.

The motivation for the revolution in shape was not an esthetic one. As far as one can assume at this late date, the impetus came from the fact that vertical-sided pieces took up less space, volume for volume, and were easier and safer to pack for shipment. In use, they were also less likely to tip over, and this increased stability may also have been a factor in the charging of the kilns. The change of shape in jugs is illustrated in Figure 10 (p. 116).

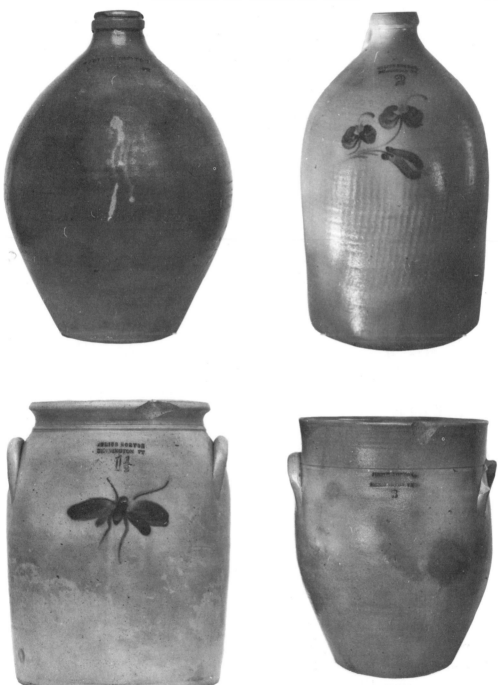

Plate 5: Ware with a *Julius Norton* Mark, 1838–44 and 1847–50. UL: 1-gallon jug, 1838–44. UR: 2-gallon jug, 1847–50. LL: 1½-gallon jar with inset cover, 1847–50. LR: 3-gallon bulging, wide-mouth jar, 1838–44.

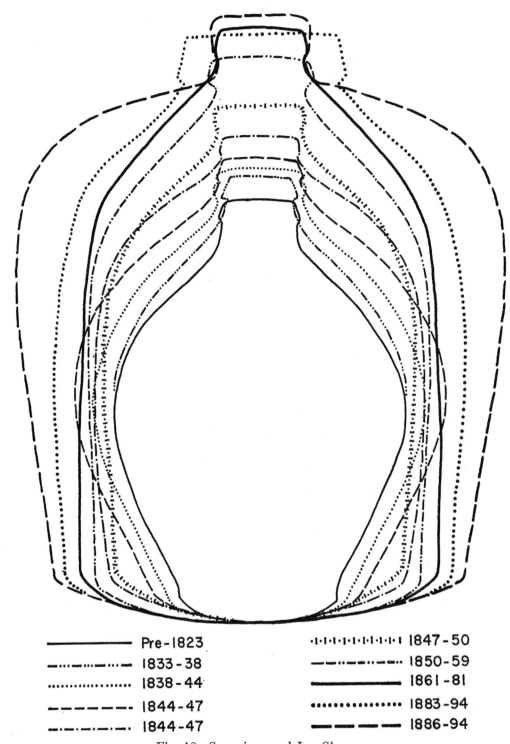

———————	Pre-1823	·ı·ı·ı·ı·ı·ı·ı·ı·ı	1847-50
—·——·——···—·	1833-38	—·——·——···—··	1850-59
····················	1838-44	———————	1861-81
————————	1844-47	●●●●●●●●●●●●●●	1883-94
—·—·——·—·—·	1844-47	▬▬ ▬▬ ▬▬ ▬▬	1886-94

Fig. 10: Superimposed Jug Shapes

The 1847–50 Period

The second *Julius Norton* period seems merely to have consolidated the new style in shapes although we are arguing after the fact, having divided the pieces with this mark on that assumption (Pl. 5, UR, LL).

The 1850–59 Period

By the time the *J. and E. Norton* mark was in use, no doubt remains with respect to those changes in shape largely brought about in the *Norton and Fenton* period. The relatively vertical sides of the jug and two varieties of jars continue consistently (Pl. 6). Bulging, wide-mouth jars, churns, pitchers, coolers, and other specialized types, however, retain distinctive shapes.

The 1859–61 Period

Little change in shape is evident in the *J. Norton and Co.* period, although the walls of the jugs seem even straighter and perhaps slope more gradually toward the neck. Also the vertical face of the mouth rim in some cases is taller than at previous periods (Pl. 7).

The 1861–81 Period

The jugs with the *E. and L. P. Norton* marks are usually distinguished by the fact that the walls slope upward in a manner which leaves less constriction at the neck beneath the mouth rim which itself is of relatively larger diameter with the vertical faces of the rim sloping slightly inward toward the top. There is no noticeable change in the shape of jars (Pl. 8).

The 1881–83 Period

No specimens are available for this period.

The 1883–94 Period

The shapes of the known *E. Norton and Co.* pieces seem almost identical with those bearing the *E. and L. P. Norton* mark which allows us to assume that there was little change during the intervening one (Pl. 9). In some cases, the vertical extent of the mouth rims of jugs seems greater. We should note, however, that bulging, wide-mouth jars and covered cream pots were no longer listed in the price list of 1893 and may not have been produced during

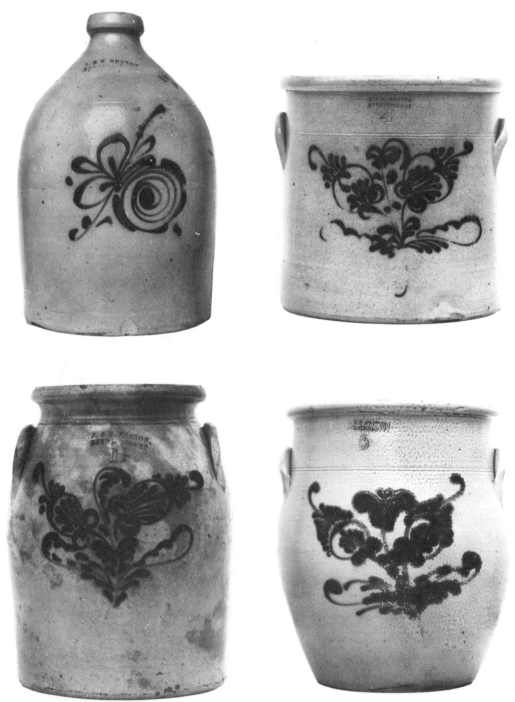

Plate 6: Ware with a *J. and E. Norton* Mark, 1850–59. UL: 1-gallon jug. UR: 4-gallon jar with vertical sides. LL: 1½-gallon jar with inset cover. LR: 5-gallon bulging, wide-mouth jar.

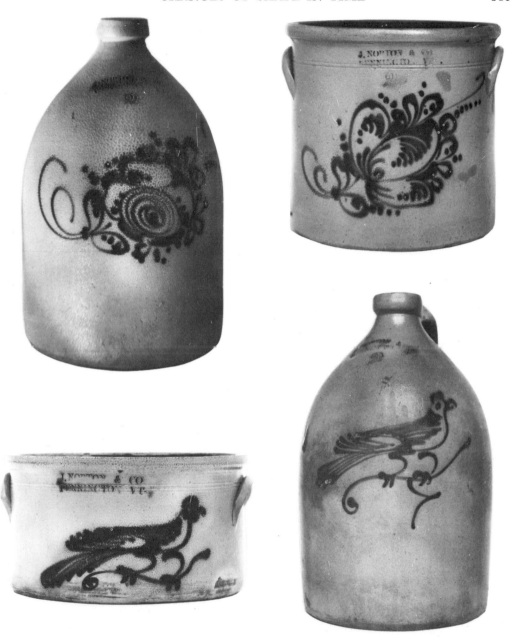

Plate 7: Ware with a *J. Norton and Co.* Mark, 1859–61. UL: 2-gallon jug. UR: 2-gallon jar with vertical sides. LL: 1-gallon cake jar. LR: 2-gallon jug.

the whole of the period. On the same evidence, the $\frac{1}{8}$-gallon jug seems also to have been discontinued.

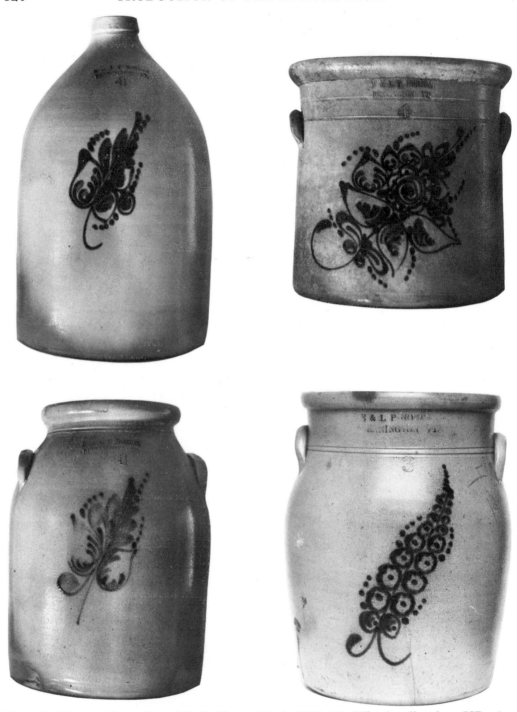

Plate 8: Ware with an *E. and L. P. Norton Mark*, 1861–81. UL: 4-gallon jug. UR: 4-gallon jar with vertical sides. LL: 4-gallon jar with inset cover. LR: 3-gallon bulging, wide-mouth jar.

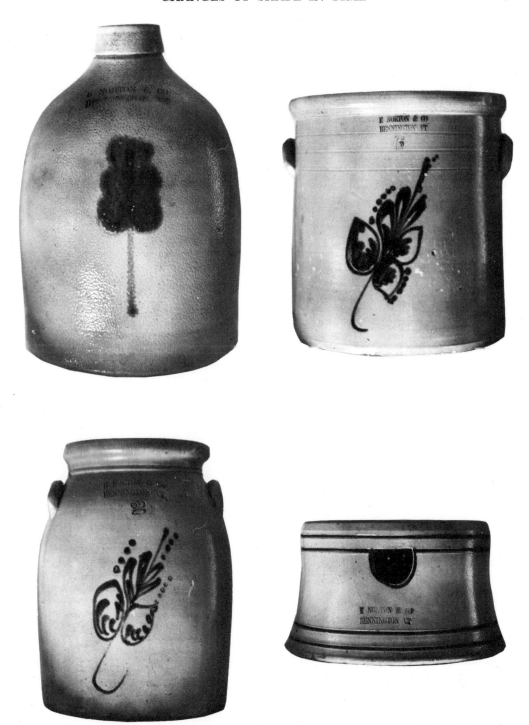

Plate 9: Ware with an *E. Norton and Co.* Mark, 1883–94. UL: 1-gallon jug. UR: 6-gallon jar with vertical sides. LL: 2-gallon jar with inset cover. LR: 1-gallon spittoon.

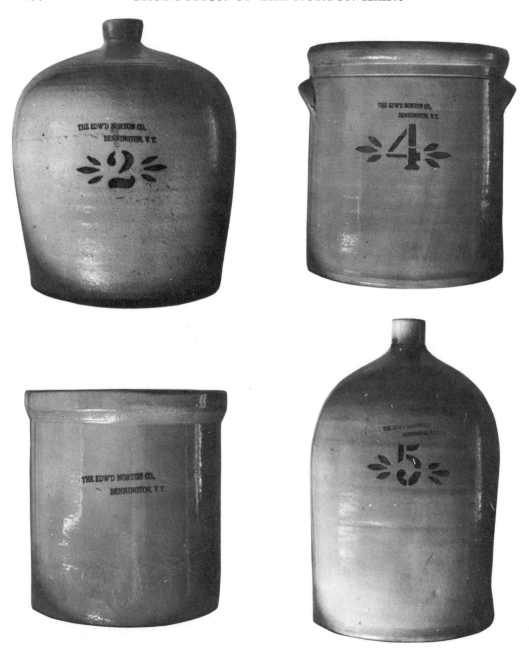

Plate 10: Ware with *The Edw'd Norton Co.* Mark, 1886–94. UL: 2-gallon jug. UR: 4-gallon jar with vertical sides. LL: 1-gallon jar with vertical sides. LR: 5-gallon jug.

The 1886–94 Subsidiary Period

In this subsidiary period which lies within the range of the previous one, the changes in shape are sudden and inconsistent with the Norton tradition.

Indeed, by the empirical evidence, we would judge that pieces bearing the new and atypical stamp of *The Edw'd Norton Co.* were as likely to have been made elsewhere and imported for sale as to have been manufactured in Bennington.

The first jug that we found, we would not have recognized as being connected with the Nortons had we not read the mark (Pl. 10, UL). A 2-gallon piece, it has broad shoulders like a highly padded football player (they measure 10 inches against 8½ at the base). There is also a single incised line on the broad top which passes through the middle of the strap handle. Also the vertical face of the mouth slopes slightly outward toward the top (the reverse of the *E. and L. P. Norton* and *E. Norton and Co.* jugs) and is of much more delicate structure. A 5-gallon jug, however, does not bulge as much at the shoulder, while the mouth rim is thin (⅜ inch), almost vertical, and actually 1½ inches high. The aperture itself is 1⅝ inches which is normal for large jugs (Pl. 10, LR).

One-gallon straight-sided jars are distinguished by lacking the paired horizontal handles that characterize all earlier Norton jars. The one-gallon jar therefore will slip inside of a 2-gallon jar of the same type which is of obvious practical advantage (Pl. 10, LL). The 2-gallon jar does have paired horizontal handles, but they are smooth and worked into (or cut from) the body clay and seem to be of another genus than the ones made at the Norton potteries for decades. The same is true of the 4-gallon jar. (Pl. 10, UR).

Another *The Edw'd Norton Co.* piece, which when found was described as a 2-gallon jar with a missing inset cover, has identical handles. It was something of a surprise to discover later that a duplicate piece was a churn, it having a matching cover with collared hole and the original dasher (Pl. 14, LR).

The Bennington Museum has three pieces with this mark, but two are duplicates of our own and none contribute any further to the already stated limited knowledge of shapes.

Variations in Size and Price of Wares

The variations in the size and price of the stoneware produced at the Norton potteries can be most easily shown in the following table which sum-

A Correlated List of Types of Wares and Prices

		A Julius Norton 12/30/1840 [Benn Mus]	1 Norton and Fenton 2/10/1845 [Ba 58:9]	2 Julius Norton 1847–50 [Ba 58:9]	3 J. and E. Morton 6/26/1856 [Wa 50:147]	4 J. Norton and Co. 1/25/1861 [Benn Mus]	5 E. and L. P. Norton 6/8/1867 [Ba 58:11]	6 E. and L.P. Norton n.d. [Benn Mus]
Jugs	4	—*	8.00	8.00	8.00	9.00	10.00	11.00
	3	—	6.50	6.50	6.50	7.50	8.00	8.00
	2	4.00	4.50	4.50	4.50	4.50	6.00	6.00
	1½	—	—	3.75	3.75	3.75	4.50	4.50
	1	2.50	3.00	3.00	3.00	3.00	3.50	3.50
	½	1.50	1.75	1.75	2.00	2.00	2.50	2.50
	¼	—	1.00	1.00	1.00	1.00	1.50	1.50
	⅛	—	.75	.75	.75	.75	1.00	—
Pots; Open Cream or Butter Pots; (Bulging, Wide-Mouth Jars)	6	—	12.00	12.00	12.00	12.50	14.00	14.00
	5	—	10.00	10.00	10.00	10.00	12.00	12.00
	4	7.50	8.00	8.00	8.00	9.00	10.00	10.00
	3	6.00	6.50	6.50	6.50	7.00	8.00	8.00
	2	4.00	4.50	4.50	4.50	4.50	6.00	6.00
	1½	—	—	3.75	3.75	3.75	4.50	4.50
	1	—	3.00	3.00	3.00	3.00	3.50	3.50
	½	—	1.75	2.00	2.00	2.00	—	—
Churns	6	—	12.00	12.00	12.00	12.00	15.00	16.00
	5	—	10.00	10.00	10.00	10.00	13.00	14.00
	4	8.00	8.00	8.00	8.00	9.00	11.00	12.00
	3	6.00	6.50	6.50	7.00	7.00	9.00	10.00
	2	—	4.50	4.50	5.00	5.00	7.00	8.00
Covered Jars; Covered Preserve Jars (Jars with Inset Cover)	4	8.00	8.50	8.50	8.00	9.00	10.00	10.00
	3	6.50	7.00	7.00	7.00	7.50	8.00	8.00
	2	4.50	5.00	5.00	5.00	6.00	6.00	6.00
	1½	—	—	4.25	4.25	4.75	5.25	5.25
	1	—	3.50	3.50	3.50	4.00	4.00	4.00
	½	—	2.00	2.00	2.00	2.25	2.75	2.75
	¼	—	1.50	1.50	1.50	1.50	1.75	1.75

Item	Size							
Covered Butter Pots; (Jars with Vertical Sides)	6	16.00	16.00	15.00	15.00	14.00	14.00	—
	5	14.00	14.00	12.00	12.00	12.00	12.00	—
	4	12.00	12.00	10.00	10.00	10.00	10.00	—
	3	9.50	9.50	8.00	8.00	8.00	8.00	—
	2	7.00	7.00	6.00	6.00	6.00	6.00	—
	1½	5.50	5.50	5.00	5.00	—	—	—
	1	4.50	4.50	4.00	4.00	4.00	4.00	—
	½	3.50	3.50	3.00	3.00	3.00	—	—
Common Pitchers	2	6.00	6.00	5.00	4.50	4.50	4.50	—
	1½	4.50	4.50	4.00	3.75	—	—	—
	1	3.50	3.50	3.00	3.00	3.00	3.00	—
	½	2.50	2.50	2.00	2.00	1.75	1.75	—
	¼	1.50	1.50	1.25	1.25	1.00	1.00	—
Covered Cake Pots (Cake Jar)	4	12.00	12.00	10.00	10.00	—	—	—
	3	9.50	9.50	8.00	8.00	—	—	—
	2	7.00	7.00	6.00	6.00	—	—	—
	1	4.50	4.50	4.00	4.00	—	—	—
Covered Cream Pots	4	12.00	12.00	10.00	10.00	—	—	—
	3	9.50	9.50	8.00	8.00	—	—	—
	2	7.00	7.00	6.00	6.00	—	—	—
	1½	5.50	5.50	5.00	5.00	—	—	—
	1	4.50	4.50	4.00	4.00	—	—	—
Milk Pots	2	—	—	—	4.50	—	—	—
	1½	—	—	—	3.75	—	—	—
	1	—	—	—	3.00	—	—	—
Common Batter Pitchers	2	7.00	7.00	6.00	—	—	—	—
	1½	5.50	5.50	4.75	—	—	—	—
	1	4.50	4.50	4.00	—	—	—	—
	½	2.75	2.75	2.50	—	—	—	—
Molasses Jugs (Jugs with Lip)	2	6.50	6.50	—	—	—	—	—
	1	4.00	4.00	—	—	—	—	—
	½	2.75	2.75	—	—	—	—	—

* Item not listed on A or not printed on 1 to 6.

marizes the information set forth in various bills that have survived and become available for our examination. We shall list the varieties of wares according to the terms designating them in the bills, correlating the different ways of doing so with the bills of the period using one handwritten bill (A) and six that have been printed (1–6). Other available bills that have not been recorded show only variations in prices that have been accounted for in a sentence or two in the text. To the printed terms we have added, when desirable, our own descriptive substitutes in parentheses. It should be noted that the prices are in U.S. dollars *per dozen* of each article, presumably at the factory.

With the above seven bills, we have compared four others in the Bennington Museum. An earlier printed *Norton and Fenton* bill of July 30, 1844 has identical prices as does a later handwritten one of February 2, 1847. A dated, and presumably earlier, printed, *Julius Norton* bill of September 28, 1848 has the same prices as those listed of the period, but no pieces of $1\frac{1}{2}$-gallon capacity are included. An earlier, printed, *E. and L. P. Norton* bill of December 9, 1865, is identical with that listed except that the $\frac{1}{2}$-gallon open cream pot is also offered at $2.50. Finally, the *E. Norton and Co.* price list of 1893 shows that there had been no increase since the *E. and L. P. Norton* bill of the eighteen-seventies.

We should add that water kegs, also called water fountains in the two earlier periods and which we speak of as barrel-shaped coolers, were supplied first at the rate of $.25 per gallon, and went up to $.33$\frac{1}{3}$ on the *Julius Norton* bills. At the same time, urn-shaped (ornamented) water fountains were supplied at $.50 per gallon. These latter, we judge, were what we have called jug-shaped coolers, being identical in shape with a jug except in having a pair of opposing strap handles in the usual position for handles, and an aperture at the bottom.

Spittoons were usually offered in two sizes at $4.00 and $6.00 per dozen. By the *E. and L. P. Norton* period (1861–81), men were perhaps more careful about expectoration, for we find four regular sizes offered at $4.00, $5.00, $7.50 and $9.00 plus a large barroom size at $13.00 per dozen. Spittoons were also made in a shell pattern at $5.00.[260]

It is interesting to find in the *E. Norton and Co.* price list of 1893 that "Little Brown Jugs" were offered at $1.25 per dozen, and "Hen Jugs" for $5.50.

Also only that list has "Batter Pails." The 1½-gallon size were $9.00 per dozen; the one-gallon, $7.00; and the ½-gallon, $6.00.

On comparing the prices in the lists presented, we are somewhat surprised to find that covered butter pots, or what we call jars with vertical sides, cost more than churns, gallon for gallon. In general, prices increased over the period of fifty-six years covered by the bills listed plus the price list of 1893, but not always at a consistent rate by type or time. For 2-gallon jugs, for example, the increase was 50 per cent, but only 40 per cent for one-gallon jugs. At the extremes of size, 4-gallon jugs increased after 1841 by 37½ per cent, while ¼-gallon pieces did so by 50 per cent. Probably the major influence on prices during the periods covered was the Civil War (1861–65).

To turn to the matter of size with respect to the varieties of ware, we note that bulging, wide-mouth jars, churns, and jars with vertical sides usually ranged up to 6-gallon capacity, while most others went up to 4-gallons or less. In the *E. Norton and Co.* or 1883–94 period, however, an 8-gallon jar with vertical sides was produced at $24.00 per dozen, as well as a 5-gallon jug at $13.00 (Pl. 10, LR). Also it was only jugs that were made as small as ⅛-gallon, and then only through part of the E. and L. P. Norton period, while only jugs, covered preserve jars, and common pitchers were produced of ¼-gallon capacity. The ½-gallon pieces were not so unusual, but the smallest churns for functional reasons were only of 2-gallon size.

In the table below, we give the maximum and minimum heights and diameters of the twenty-eight 2-gallon jugs in our collection, and nine in the Bennington Museum.

(Table on next page)

From the table one can perceive the bulge disappear from the jugs after reaching the more or less globular form in the *Norton and Fenton* or 1844–47 period (Pl. 13) Also the squat quality of the late and abberant *The Edward Norton Co.* jug is evident (Pl. 10, UL). We might add that the smallest piece with a mark in our collection is one of ¼-gallon capacity of the *L. Norton and Son* or 1833–38 period. It is only 8¼ inches in height and 4½ inches in diameter (Pl. 11, LL). The largest piece is a 6-gallon churn of the *J. and E. Norton* or 1850–59 period which has a height of 19 inches and a diameter of 12 (Pl. 14, UM). No. 8-gallon jar of the *E. Norton and Co.* or 1883–94 period has been actually seen.

Sizes of 2-gallon Jugs (in inches)

		Height		Diameter	
		Min.	*Max.*	*Min.*	*Max.*
Bennington Factory	(2)	13¼	13½	9¾	10
L. Norton and Co.	(1)	13¾		10½	
L. Norton	(1)	14½		10	
L. Norton and Son	(1)	13⅝		10¼	
Julius Norton-1st	(3)	12	13	9¼ ?	10
Norton and Fenton	(5)	12	14¾	9	10½
Julius Norton-2nd	(5)	14	14½	9	10⅜
J. and E. Norton	(8)	13½	14	8¾	9¾
J. Norton and Co.	(2)	14		9¼	
E. and L. P. Norton	(3)	13½	14¼	9	
E. Norton	(1)	13⅜		8¾	
E. Norton and Co.	(3)	13	14½	8½	9¾
The Edw'd Norton Co.	(2)	11¼	11½	9¾	10
Total 2-gallon jugs	37				

(When only one specimen of a 2-gallon jug for a given period has been available, the data have been placed between the *Minimum* and *Maximum* columns.)

Decoration

Again we shall order our comments on the basis of a division of the specimens into groups corresponding to the thirteen basic time periods of the Norton partnerships.

The Pre-1823 Period

The four Bennington Factory pieces in our collection all bear a large Arabic numeral applied freehand with underglaze cobalt blue (Fig. 11, p. 129). These are positioned below the stamp and in two of the cases have a blue dot, or period, following them. In one instance, wavy or scalloped lines

have been added at the sides and bottom of the numeral (Fig. 11, LL; Pl. 1, LR). By their similarity, all of the numbers may well have been inscribed by the same hand as was a *2* on a later piece with a *L. Norton* mark (Fig. 11, LL; Pl. 2, LR). Also, all four pieces have a dash of cobalt blue at the ends, or in the case of the jugs, at the bottoms of the handles.

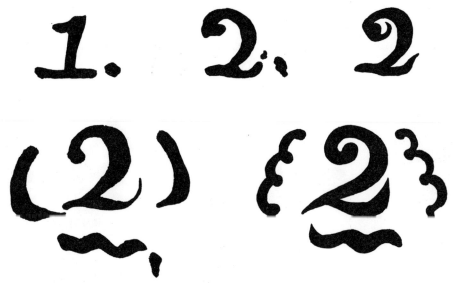

Fig. 11: The Underglaze Blue Arabic Numerals

We should state at this time that, beginning with *Bennington Factory* or pre-1823 period, jars and churns except for some one-gallon vessels have one to three circumscribing incised lines without color around the body. These are normally at handle height on churns as well as on wide-mouth and vertical-sided jars, but just below the neck on jars with set-in covers. Circumscribing lines on other types of vessels, as well as the absence of such incised lines will be noted specifically in the comments on some later periods.

The Bennington Museum has a most unusual *Bennington Factory* 2-gallon jug with the incised design of a dove-like bird below the mark, as well as a barrel cooler with the same mark and sixteen circumscribing incised lines in groups of four (thus making four sets of three bands). A fish is incised between the upper two groups or sets, a bird on a branch between the middle two, and the mark appears between the lower two. There is no capacity numeral on the cooler which is about 26 inches high and 50 inches in circumference, but we would guess that it may hold about fifteen gallons.

The 1823–28 Period

Most of our five *L. Norton and Co.* pieces have crude designs in underglaze blue, usually floral, but sometimes unclear in form. It is quite possible that the cobalt color used for some of these earlier and simpler pieces was applied with the thumb or finger. A vertical blue leaf appears on a 4-gallon churn (Fig. 12, UL, p. 130; Pl. 14, UL). More common is a pair of leaves extending on curved stems from the same type of floral base (Fig. 12, UM, UR; Pl. 2, UL). Most unusual is what appears to be five or more birds sitting on a crescent-shaped support (Fig. 12, D).

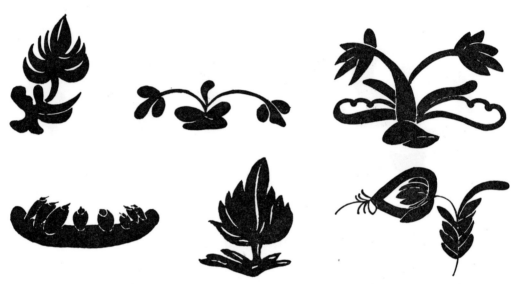

Fig. 12: Early Floral Designs on *L. Norton and Co.* or *L. Norton* Wares

The 1828–33 Period

Two *L. Norton* vessels bear the previously mentioned vertical blue leaf, or a similar form (Fig. 12, LM; Pl. 2, UR). One jar is completely undecorated as must have been commonly the case in these earlier years. An extraordinary flower with a protuberance at its end occurs on a 2-gallon jar with an inset cover (Fig. 12, LR; Color Pl. B; Pl. 2, LL). The style is distinctive and readily distinguished from the cruder work of the same and earlier periods. Then there is a bulging, wide-mouth jar with the previously mentioned underglaze blue Arabic *2* with wavy or curved lines at the bottom and sides which is very like the capacity marks common on the stoneware of the *Bennington Factory* period (Pl. 2, LR). This similarity, together with that of its

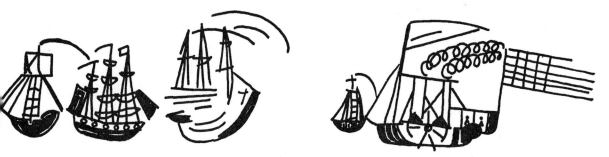

Fig. 13: Early Incised Designs of Ships

body and its minor decoration, plus differences from the other three *L. Norton* specimens, makes one suspect, despite the normative correlation of marks with dates, that it was made closer to 1823 than to 1828.

One of the most remarkable pieces in the Bennington Museum is a 4-gallon jug of this period, 17¼ inches high and 13½ in diameter, which might be described as presenting a brief history of ships (Fig. 13; p. 131; Pl. 19). From left to right are incised a small vessel with a single mast, then a three-masted ship with guns in her ports, and next another of similar rigging but less distinct. Across a noticeably larger area of water than those areas that separate these three ships sails a fourth, much like the first, and almost under the bow of a side-wheeler with two smoking stacks. Side-wheelers, one should be aware, had been plying the Hudson River since Robert Fulton had done so with the *Clermont* in 1807.

The 1833–38 Period

The period of the *L. Norton and Son* marks seems to have been distinguished by the introduction of floral and insect designs in yellow ocher, some of which have a simple esthetic distinction not surpassed by the more ornate blue painting of later periods. The blending of brown pigment with similar clay colors was partly responsible for the effect. It perhaps should be mentioned that late in 1969 Richard Carter Barret acquired for the Bennington Museum a rare 3-gallon jug bearing the mark *Lyman and Clark/Gardiner* with a floral design in yellow ocher in the Norton style but somewhat more ornate. It is probably of the kind seen by Lura Woodside Watkins.[261] The maker of this Maine piece was almost certainly Decius W. Clark who finished his apprenticeship in the potters trade at Troy, N.Y., shortly before he started the

Gardiner venture in 1837 with Alanson Potter Lyman, the latter a business man later associated with Christopher Webber Fenton in Bennington as was Decius Clark himself on their return to that town about 1841./[6]/ What gives importance to these facts is that there seems to have been a connection between the ocher decoration introduced at the Norton pottery in the 1833–38 period and that by Decius Clark between 1837 and 1841, but what it was remains uncertain.

The most characteristic design is perhaps a tulip-like flower shooting up from a leafy stem (Fig. 14, UL, UM, p. 132; Color Pl. C; Pl. 3, UR, LR). Also we find the flowers with a protuberance at their ends in blue as well as in brown (Fig. 14, UR, LL, LR; Pl. 3, LL). They have also reminded people of honeysuckles, anemones, or other flowers, and we suspect that there has been sufficient artistic license to prevent their identification with any specific plant. Indeed, perhaps they represent a sport or some offshoot variety of the tulip-like flower.

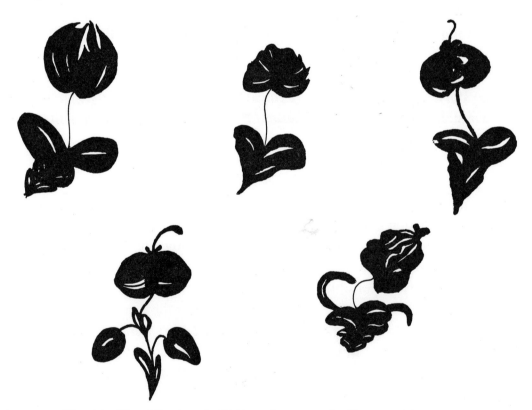

Fig. 14: Floral Designs in Yellow Ocher on *L. Norton and Son* Ware

We should also take note of a simple design consisting of two opposing horizontal leaves which occurs in this period either in umber or in blue. With relatively little change this design can be metamorphased into a butterfly, one of the most delicate of Norton artistic creations (Fig. 15, p. 133; Pl. 13, UL; Pl. 3, UL).

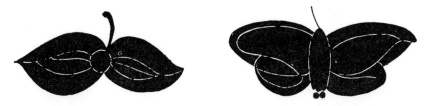

Fig. 15: The Apposing Horizontal Leaf and the Butterfly Design on *L. Norton and Son* Ware

Finally, pieces covered with over-all brown glaze (or Albany slip) became relatively common. This treatment, of course, was not primarily a matter of decoration, but the resultant effect must be so considered. It is impossible to determine when these brown pieces first appeared but examples from the *L. Norton and Son* or 1833–38 period prove that experiments were then being made (Pl. 11, LL). Some bear a chocolate glaze with low luster that seems to have flaked too easily, whereas the effective, high luster slip was soon in use. The same improvement was noticeable in the brown slip used on the interior of vessels from the *Bennington Factory* or pre-1823 period onward.

The 1838–44 Period
Our knowledge of the decoration of the first *Julius Norton* or 1838–44 period is limited as we have only two one-gallon jugs, a 3-gallon jug, all undecorated,

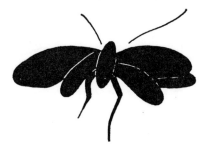

Fig. 16: The Julius Norton Insect

and a 1½-gallon jar with an inset cover. The latter, which may belong to the second *Julius Norton* period, is embellished in blue with a nicely painted insect having two feelers in front and two legs behind (Fig. 16; p. 133; Pl. 5, LL). One of the jugs presents an example of discoloration from the use of contrasting clays (Pl. 5, UL). We do suspect, however, that designs painted in yellow ocher were given up as they do not appear thereafter.

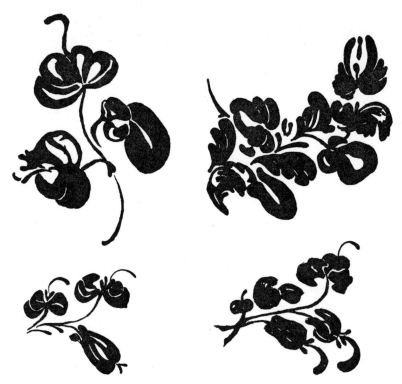

Fig. 17: The So-called Honeysuckle Design on *Norton and Fenton* or *Julius Norton* Ware

The 1844–47 Period

The deficiency in decoration on the first *Julius Norton* stoneware is made up by the florescence of the cobalt blue designs that bursts upon us in the *Norton and Fenton* years with such brilliance that we cannot help but feel that some newcomer was primarily responsible, but of that we are not entirely convinced. Of the thirteen pieces in our collection, no less than ten are generously embellished with a flower that has occasionally been described as the wild honeysuckle by those to whom we have shown it (cf. Pl. 4). Usually there are three such flowers (Fig. 17, UL, p. 134), and on a 4-gallon jar, such

a spray is embellished with leaves (Fig. 17, UR). On one jug the design is aberrant as two of the flowers are in lateral opposition and the third one on top is diminutive, the whole arrangement giving an unusual stiffness to the assemblage. Further, one of the two 3-gallon jugs of the period has a neat design of a leaping animal in cobalt blue which we confidently identify as a rabbit, although one dealer with a specimen has preferred to call it a field mouse (Pl. 13, UR). Finally, there are two one-gallon jugs lacking any decoration at all. We should at this point observe the perhaps obvious fact that the smaller the piece, the less likely it is to be decorated and, concomitantly, the larger the piece, the more likely is it to have an elaborately ornamental design in cobalt blue. Numerous exceptions to this rule do occur, however.

The 1847–50 Period

The second *Julius Norton* period brought an advance in the care with which floral and other designs were made. Experience was bringing its own reward, and Julius was obviously appreciative of esthetic quality in the visual arts as well as the auditory. It is at this time that we find the honeysuckle-like flowers of great perfection (Fig. 17, LL, LR, p. 134; Pl. 5, UR). Four of our six decorated pieces have them, while the other two bear what we are certain are rabbits (Fig. 18, p. 135; Pl. 13, LL). Clearly, it was the quality of the art that changed, not the designs.

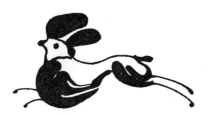

Fig. 18: The Norton Rabbit

The 1850–59 Period

The *J. and E. Norton* or 1850–59 period proves clearly to be the time of maximum excellence in the art of painting in underglaze cobalt blue on Bennington salt-glazed stoneware. The designs may be readily divided into two styles. The earlier tradition is the floral one and in it we note various degrees of elaboration.

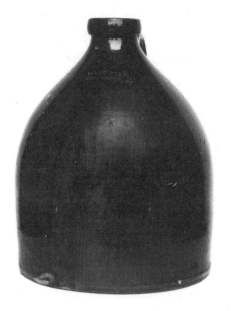

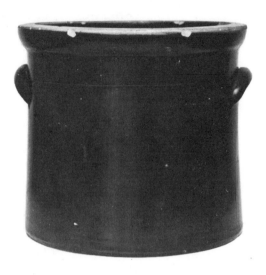

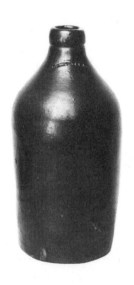

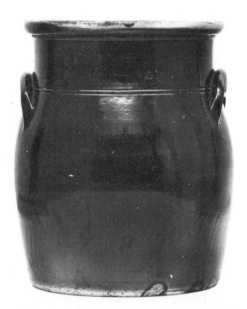

Plate 11: Norton Over-all Brown Glaze Ware. UL: 1-gallon jug, *Julius Norton*, 1847–50. UR: 1-gallon jar with vertical sides, *E. Norton and Co.*, 1883–94. LL: ¼-gallon (40 oz.) jug, *L. Norton and Son*, 1833–38. LR: 1-gallon bulging, wide-mouth jar, *E. and L. P. Norton*, 1861–81.

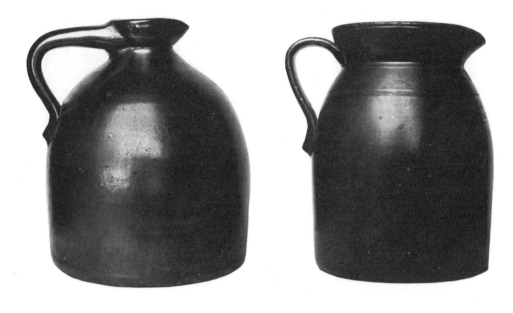

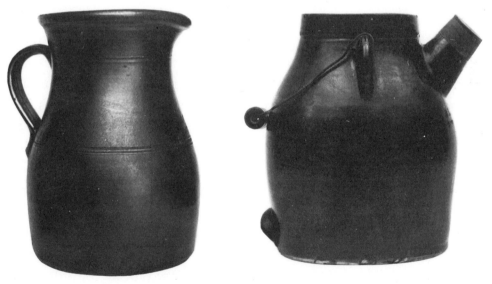

Plate 12: Norton Over-all Brown Glaze Ware. UL: 1-gallon pitcher jug, *E. and L. P. Norton*, 1861–81. UR: 1-gallon pitcher jar, *E. and L. P. Norton*, 1861–81. LL: 1-gallon pitcher, *E. and L. P. Norton*, 1861–81. LR: 1-gallon batter pail, *E. Norton and Co.*, 1883–94.

Fig. 19: Simple Flower Sprays on *J. and E. Norton* Ware

The simpler style begins with a flower spray characterized by a continuation of the stem line which turns over on itself and a flower symbol consisting of an extended line of dots, often decreasing in size toward the end. This design is frequently expanded to include an additional floral element consisting of a spiral of three of four rings ending in a central dot (Fig. 19, UL, UM, UR, p. 138). This element is suggestive of a rose and may be two inches or more in diameter. On larger pieces this basic design may be considerably elaborated with perhaps two rose-like forms, extended accessory petals which seemingly have opened up, three or four stem extensions, and even more numerous flower symbols consisting of a projecting line of blue dots (Fig. 19, LL). This style, of which we have at least eight examples, reaches its apogee on a 4-gallon, straight-sided jar which contains all these floral elements protruding from an open wickerwork basket (Fig. 19, LR; Color Pl. D).

A second and more complex style among the floral designs usually includes the upward continuation of the stem which turns over on itself, but the flower directly below is in an irregular form containing six or more lines roughly parallel to the stem and to each other which become enlarged at the upward, or outer, ends. Similar sets of parallel lines may occur outside the floral element as though in continuation of the inner ones. Additional fernlike leaves enhance the lower end of the stem. In our six examples of this type, four bear two of the floral elements branching from a central stem (Fig. 20,

Fig. 20: The Complex Flower Spray on Norton Ware

UL, UR, p. 139). The two other pieces have their single floral elements extending sidewise (Fig. 20, lower; Color Pl. E).

Two unusual floral variants also occur in the collection. One has a vertical stem bifurcating at the top. There are also distending lateral branches in the middle, above which are a pair of flower elements, each consisting of a wide cobalt blue ring with a large dot, or blurred spiral, in the center. Numerous small line leaflets extend out from the stem. The design, if unusual, is also relatively crude for the period.

A more unusual design occurs on a 4-gallon jug. It consists of a spiral stem bifurcating at the top into double horizontal tendrils which turn back on themselves (Fig. 21, p. 142; Pl. 13, LM). All in all, the design seems sophisticated, yet simple, and quite atypical of Bennington decoration. We might add, however, that we recall having seen one other example.

The newer tradition of cobalt blue designs embodies an elaboration of the animal style and the introduction, as far as we have been able to discover, of the famous blue birds which reached perfection in the following *J. Norton*

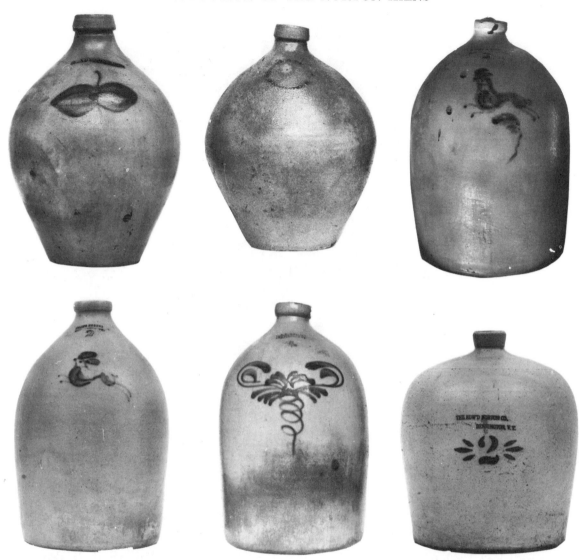

Plate 13: Jugs—Changes of Shape in Time. UL: 1-gallon, *L. Norton* and Son, 1833–38. UM: 1-gallon, *Norton and Fenton,* 1844–47. UR: 3-gallon, *Norton and Fenton,* 1844–47. LL: 2-gallon, *Julius Norton,* 1847–50. LM: 4-gallon, *J. and E. Norton,* 1850–59. LR: 2-gallon, *The Edw'd Norton Co.,* 1886–94.

and Co. or 1859–61 period. We are inclined to identify them as the Canada Jay. These birds characteristically can be distinguished by the following elements—they perch on a twig with a curved line below that bends sharply back on itself, the tail feathers are shorter on top and longer below, four or more wing feathers can usually be distinguished with the tips curving upward,

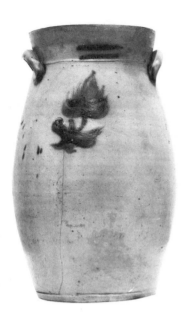
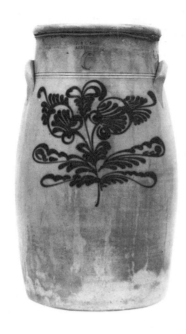
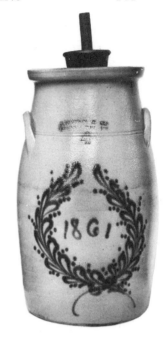
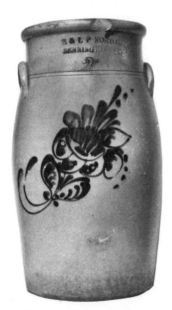
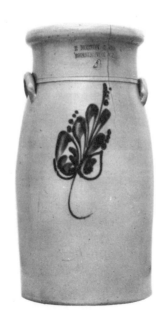
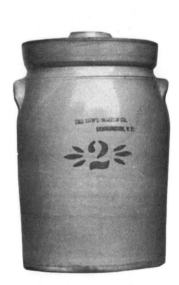

Plate 14: Churns—Changes of Shape in Time. UL: 4-gallon, *L. Norton* and Co., 1823–28. UM: 6-gallon, *J. and E. Norton*, 1850–59. UR: 4-gallon, *J. Norton and Co.*, 1859–61. LL: 2-gallon, *E. and L. P. Norton*, 1861–81. LM: 4-gallon, *E. Norton and Co.*, 1883–94. LR: 2-gallon, *The Edw'd Norton Co.*, 1886–94.

Fig. 21: A Variant Floral Design on *J. and E. Norton* Ware

the neck is slightly elongated upward, and the upper part of the beak extends beyond and usually down in front of the lower part (Fig. 26, UL, p. 147; Pl. 15, UL). We have four of these single birds in the collection of this period, three on one-gallon jugs and one on a 1½-gallon vertical-sided jar. Blue birds in this style are characteristic of later Norton products as well, but are rarely, if ever, seen with these details on the stoneware of any other manufacturer. A fifth *J. and E. Norton* blue bird is somewhat aberrant with variations particularly in the head and beak (Fig. 29, L, p. 150; Pl. 15, UR). Most of the usual elements are present, however, which may indicate an attempt at copying by an inexperienced hand.

Also typical of the period are the long-tailed pheasants which sit on a stump with their heads turned backwards. Of these we have four examples. They also have a curved line that bends sharply back on itself connected with the twiglike top of the stump, and the same type of beaks. The long tail feathers are diagnostic (Fig. 22, p. 143). One must conclude that they have been drawn by the same hand as the jays. We should note that one of our examples on a 1½-gallon *J. and E. Norton* jar with vertical sides has an additional element of a two-rail fence with three to five pickets at each side of the stump (Fig. 22). Furthermore, we have a 4-gallon jug with two of these pheasants sharing branches of the same stump and with their heads turned toward each other (Fig. 22; Pl. 16, LL).

Among rarer *J. and E. Norton* designs, we have the deer, the dog, and the chicken. The deer is on a 2-gallon jar with an inset cover and has the characteristic features of the projecting upper jaw and dotted body (Color Pl.

Fig. 22: Pheasants on *J. and E. Norton* Ware

F; Pl. 17, L). On the head are the horns with a rather unrealistic set of four tines. The deer is lying down, as is usual in this design, with its head turned backward as though watching for a hunter. Associated with the deer is an evergreen tree, a stump, and a pair of a two-rail fences each with four pickets

or posts. After all, a deer in a farmer's field is not unreasonable in Vermont—although it is not the usual place for them to lie down.

Our dog, described as a lion by the dealer from whom it was obtained, sits on its haunches with two trees, of which at least one is deciduous, in the background (Fig. 23, p. 144; Pl. 17, R). Also there is a rail fence with three pickets in the background and one with five in the foreground which add to the doglike aspect of the scene. Actually, the details of the animal are pleasantly primitive, if not too accurately drawn from the point of view of anatomy.

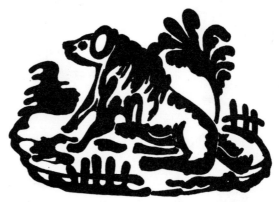

Fig. 23: The Dog on *J. and E. Norton* Ware

As for the cock or rooster, which may well be a chicken or hawk, little could be asked in the way of esthetic improvement (Fig. 24, p. 144; Color Pl. A; Pl. 16, UR). There is the usual segment of a rail fence in the background

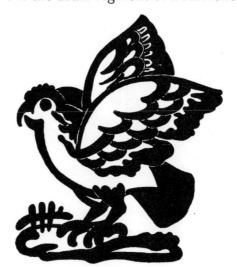

Fig. 24: The Cock on *J. and E. Norton* Ware

while the bird rises on its two legs with its wings with the carefully delineated feathers wide spread as though suddenly in pursuit of a mate. Esthetically, this piece has probably seldom been equalled or surpassed by the artists of the Norton kilns.

A simple 4-gallon cooler in our collection has four circumscribing incised lines at the top filled with cobalt blue and four at the bottom.

As might be expected, it is this period during which most of the famous and unusual pieces in the Bennington Museum were made. Of these, the most outstanding is the great barrel-shaped water cooler of perhaps 30-gallon capacity which long ornamented a Bennington hotel. This cooler stands 34 inches in height, is $13\frac{1}{2}$ inches in diameter at the top, and $59\frac{1}{2}$ inches in maximum circumference. We estimate its capacity as about 35 gallons. It has bung holes at three of its four quarters so that the thirsty need not wait. Its main design, viewing left to right from the center bung hole, consists of a house, a pheasant, a dog, an ornate tree, an elaborate house with gables, a barn, two trees with a blue bird above them, and then three characteristic deer in succession above fences. There are also five variously ornamented diaper bands above the decorated area and five below. It would seem that this great cooler has almost all the design elements used by the *J. and E. Norton* artists of the 1850–59 period, but the pheasant is missing. The Bennington Museum also has two smaller barrel-shaped water coolers decorated with figures of the deer, the dog, and the house, as well as a 2-gallon jar with vertical sides bearing a pheasant plus a house. Then there is the 4-gallon jar with an ugly, badly drawn animal, although in this case the lion most probably was intended. We might add at this point that large shows with wild animals had been visiting Bennington more or less annually since at least the early eighteen-thirties.[263]

Although we have not attempted a comparative study of the Norton stoneware of Bennington that exists in many other local museums, we have made an exception in the case of the Smithsonian Institution to which Lura Woodside Watkins gave her collection. In it is a barrel-shaped water cooler of the *J. and E. Norton* or 1850–59 period that is almost the equal artistically of that in the Bennington Museum (Pl. 18). It stands 24 inches in height, has a circumference of 54 inches, and is 12 inches in diameter at the base. On the basis of these measurements, we compute that its capacity is about $17\frac{1}{2}$-

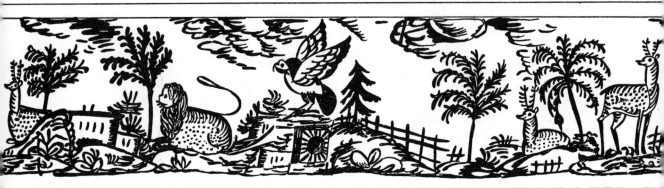

Fig. 25: Decoration on the Smithsonian Water Cooler

gallons. We are privileged to illustrate it here 'n an unrolled perspective, so to speak, of the continuous pictorial band in underglaze cobalt blue embellishing the middle area of the piece.

We begin with a deer partly obscured by a rise of ground and behind it a deciduous tree (Fig. 25, above). To the right, and also partly obscured by rising ground, are two sections of a rather symbolically treated structure which from the chimneys apparently represents a house rather than a barn. Next, seated in the foreground is an animal which we must refer to as a dog although it has the mane and extraordinary tail that have led some to think of similar Norton figures as lions. To the right of the dog, we find our familiar cock, which may be a hawk, with its wings spread and occupying the area above a bung-hole. Continuing clockwise, we encounter an evergreen in the background. To the left of it is a small segment of fence that is continued on the right by a six-stake section of fence with a second small segment to balance the picture before one comes upon another large deciduous tree. Beyond the tree is a third deer, this one clearly resting on the ground, then another four-stake section of fence and a fourth deciduous tree. We return to the place of beginning with a typical Norton deer standing beneath the *J. and E. Norton* mark and, finally, there is a four-picket two-rail section of fence. Besides these main features, there are minor ones consisting of cloudlike constructions in the sky plus leaf forms and other indicators of ground at the bottom of the band. There are also seven circumscribing incised lines, emphasized with underglaze cobalt blue, beginning at the edge of the pictorial band and extending in even intervals to the top and bottom of the cooler.

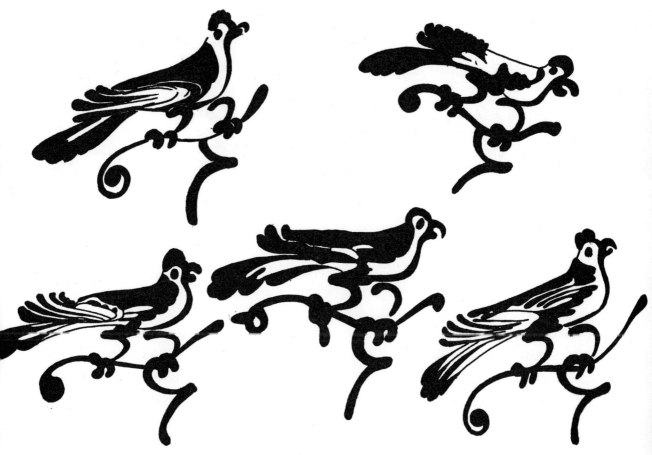

Fig. 26: Typical Norton Blue Birds

The 1859–61 Period

Of the eight pieces in our collection bearing the mark *J. Norton and Co.*, five have the typical blue jays in perfect form with all the design elements described for the previous period (Fig. 26, UR, LL, LM, LR, p. 147; Pl. 7, LL, LR). We also have a pair of these birds, one behind the other, facing in opposite directions (Pl. 16, LR). It would seem that they were all made by the same hand. One 2-gallon jar with vertical sides and a 2-gallon jug have the design with a flower spray characterized by a continuation of the stem line which turns over on itself and a flower symbol consisting of an extended line of dots (Fig. 27, p. 148; Pl. 7, UL, UR). Finally, we have a 4-gallon churn with a cobalt blue floral wreath enclosing in its center the inscription 1861 (Pl. 14, UR).

Fig. 27: Flower Spray on *J. Norton and Co.* Ware

The 1861–81 Period

The decoration of the pieces bearing the *E. and L. P. Norton* mark shows not so much a decline in the ability of the artists as a reduction in the number of designs, although when blue birds appear, they are in a new style which many people will regard as inferior. Furthermore, one floral design with minor variations is repeated over and over again. Although it differs slightly from those of the *J. and E. Norton* or 1850–59 period, it is obviously in the same tradition which continued into the *J. Norton and Co.* or 1859–61 period where the design occurs in an intermediate form. The *E. and L. P. Norton* design consists essentially of three or more leaves on a stem which curves back upon itself at the bottom (Fig. 28, UL, p. 149; Pl. 8, UL, LL). The stem may project above but it does not clearly turn back upon itself at the top as in previous periods. The leaves are partially filled with parallel curved lines that usually decrease in size toward the tip of the leaf. Lines of dots also project from various parts of the floral cluster.

On one-gallon jugs, the typical ornament of the period is a single blue stylized leaf with four or five teeth on each side. On a 4-gallon jar, we have found this leaf in a cluster of three on a stem with a few accessory dots. Elaborate floral sprays reminiscent of the ornate adornment of the *J. and E. Norton* or 1850–59 period also occur on the largest specimens (Fig. 28, UR, LL; Pl. 8, UR; Pl. 14 LL).

The most unusual decoration in the group studied and which occurs on a 3-gallon jar consists of seven or more blue circles enclosing dots on each side

Fig. 28: Floral Designs of the *E. and L. P. Norton* Period

or a single stem which itself ends in dots. The circles decrease slightly in size as they ascend. A hollyhock is suggested, but as with all Norton floral designs, the exact species is always open to question (Fig. 28, LR; Pl. 8, LR).

Finally we come to two pieces each bearing a blue bird. Let us state first of all that these are not members of the numerous and distinctive variety of bird found so commonly in the *J. and E. Norton* or 1850–59 period. Specifically, their posture is different, particular wing feathers and the lower and upper beak cannot be distinguished, while they do not rest on a twig with the distinctive curved line below it. On the positive side, both of our *E. and L. P. Norton* birds have a wing heavily outlined with a continuous stroke of the brush, a design element which suggests a single artist. One of the birds on a 4-gallon jug rests on a typical floral spray of the period (Fig. 29, M, p. 150;

Fig. 29: Variant Vorton Blue Birds

Pl. 15, LL), the other on a typical leaf. All in all, the result is crude compared to the efforts of earlier periods.

As a concluding comment on the underglaze cobalt blue painting of the period, we should note that of our twenty-five pieces of the period, seven or over 25 per cent have an over-all brown glaze (Pls. 11, 12). Of the remaining eighteen pieces, sixteen have floral designs, be they simple or complex, and two are birds.

We should perhaps note as a continuing tradition that churns and vertical-sided or wide-mouth jars have two or three circumscribing lines incised at handle height while jars with inset covers have one or two at the neck. Such lines also occur at the points of attachment of the vertical strap handle of an over-all brown glaze pitcher, and, more extraordinarily at middle handle height on a 2-gallon over-all brown glaze molasses jug. Ordinarily, incised lines do not occur on jugs unless the ridges on the strap handles be so construed.

Plate 15 (next page): Norton Blue Birds. UL: 1-gallon jug, classic design, *J. and E. Norton*, 1850–59. UR: 1-gallon jug, variant design, *J. and E. Norton*, 1850–59. LL: 4-gallon jug, late design, *E. and L. P.* Norton, 1861–81. LR: 3-gallon jug, late design, *E. Norton and Co.*, 1883–94.

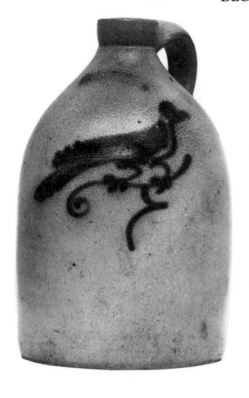

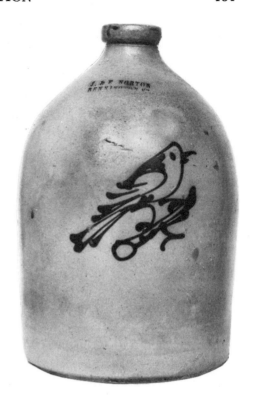

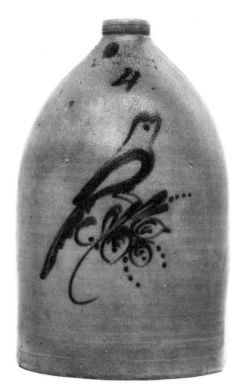

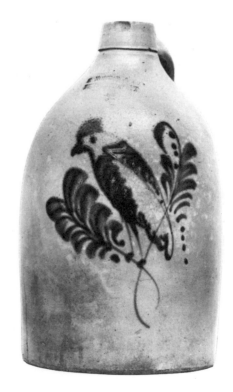

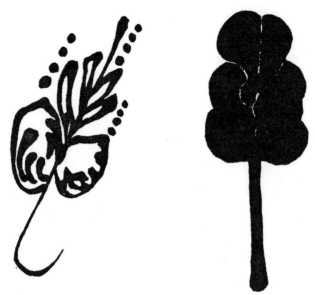

Fig. 30: Floral Designs of the *E. Norton and Co.* Period

The 1881–83 Period

No pieces have been found of this period.

The 1883–94 Period

Of our nine decorated *E. Norton and Co.* pieces, five have the floral design of the *E. and L. P. Norton* or 1861–81 period, but usually are slightly less ornate (Fig. 30, L, p. 152; Pl. 9, UR, LL). Two one-gallon jugs and a 2-gallon jar with an inset cover have the blue stylized leaf of that previous period (Fig. 30, R; Pl. 9, UL). Finally, there is one blue bird on a festoon of two leaves which is a superior production unlike any of the previous Norton birds (Fig. 29, R, p. 150; Pl. 15, LR). Although the tail is weakly characterized, the bird is otherwise of superior quality, leaving us with the wish that we had more decorated specimens of this period for comparison.

The jars and churn have the usual circumscribing incised lines, while a spittoon has two around the top and two around the bottom which are impressive because they have been carefully filled with cobalt blue (Pl. 9, LR).

The 1886–94 Subsidiary Period

The appearance of the ware in this closing subsidiary period of the potteries is so inconsistent with those bearing an earlier Norton mark that we

perhaps overlooked these late pieces during the first decade of collecting. Indeed, we had about come to the conclusion that we would find none with this mark. It is surprising that we since have found seven.

The primary difference in these specimens is in the color which is grayish white due to a white slip covering the outside of the ware. More significant, the pottery does not seem to be salt-glazed. The color is an attraction, however, and the large blue stamps showing the capacity in gallons on the larger pieces have a decorative effect (Color Pl G; Pl. 10).

We should add that the commonplace incised lines on Norton jars occur on those of this period, but only when the piece is over one gallon in size. We have already noted the unusual use of an incised line above the broad shoulders of a 2-gallon jug. Such a rare use of the incised line on a jug, however, we should recall was found once before on an over-all brown glaze molasses jug of the *E. and L. P. Norton* or 1861–81 period.

Commemorative and Other Unusual Pieces

The Bennington Museum which has been primarily devoted to the various types of ceramics produced in Bennington understandingly enough has accumulated over the years many pieces of salt-glazed and over-all brown slip-glazed stoneware which are unique. The interest in such unusual pieces is a specialized one to be differentiated from the study of normal productions of the Norton kilns. Nevertheless, atypical pieces must not be passed over without recognition. Fortunately for us, a number of these specimens have already been illustrated, and we shall refer the reader to the relevant source.

Before continuing, let us say that we do not consider in the category mentioned above those pieces distinguished merely by more elaborate decoration in traditional Norton styles on vessels of standard shapes, as for example, the great barrel-shaped water cooler previously discussed. Here we shall concentrate on the odd pieces, not simply the ornate.

First we shall take note of some marked pieces of more or less unusual shape. For example, the Bennington Museum has a 5-gallon bulging, wide-mouth jar of the *Norton and Fenton* or 1844–47 period with an aperture near the bottom. Although the latter characteristic suggests a water cooler, the func-

tion of the vessel may have been quite different. In the same collection is a one-gallon jar with over-all brown glaze and more or less vertical sides distinguished by a lip. Barret, who has illustrated it, calls it a batter bowl.[264] It bears the *E. and L. P. Norton* mark, but has no handle. We recall having seen only one other example of this shape and it bore no mark. The Museum also possesses a one-gallon chicken feeder, likewise with over-all brown glaze, but with the *E. Norton and Co.* mark. These bell-shaped vessels with an aperture at the bottom and a saucer fastened beneath them may not in themselves be so rare, but we dare say that another with a Norton mark will not be easy to find.

Better known are a series of commemorative jug-shaped coolers with a pair of opposed vertical strap handles. A relatively small 4-gallon one with a *Julius Norton* mark is perhaps one of the most unusual of Norton pieces. The clay itself has a bright terracotta color and it bears an elaborately embossed diaper band above which an eagle of modeled clay spreads its wings while perching on a lozenge containing the name *A. Hathaway* incised in script. This specimen, like the following three, has been illustrated by Barret.[265]

A larger jug-shaped cooler, 26 inches high and 12 in diameter, was made for presentation to Luman P. Norton. His name appears in a circular mark together with *In Vino Veritas*, inside of which mark is *12 galls—1859*. The mark itself is surrounded by a cobalt blue wreath, below which is a basket of fruit, and beneath it above the aperture, a serpent. Obviously, the motto is contrasted with the symbols of sin in the Garden of Eden.[266]

A third commemorative jug cooler, about $24\frac{1}{2}$ inches high, $14\frac{1}{2}$ in diameter at the base, and 48 inches 'n circumference, was made for Calvin Park on his election to the Vermont State Legislature. Again, the mark is in a circle and reads *Calvin Park/Member For Woodford*, the legend enclosing the date *1864*. Beneath the mark is a prancing horse in cobalt blue bearing what is most unusual, the signature *George J.* which Richard Carter Barret now informs us stands for George J. Gregg, the brother of James A. Gregg mentioned below, both of whom were employees of the pottery.[267] Calvin Park, incidentally, was a business associate of Alanson Potter Lyman and Christopher Webber Fenton in a dry goods firm and later, for a short period, in a pottery.[268]

The largest of the commemorative jug coolers, said to be of 25-gallon capacity, is 27 inches high, $17\frac{1}{4}$ in diameter at the base, and 56 inches in

circumference. It also was made for Calvin Park whose name is incised at the top above an *1864*. Below is the following legend in incised script:

> *Hic Jacet**
> *The animating Spirit*
> *and divine afflatus*
> *of the owner*
>
> *Were it the last drop in the Jug*
> *and you gasped upon the spout*
> *Ere your fainting Spirit fell*
> *I'd advise—to draw it out*

The poetry is hardly inspired, but the advice is clear.[269]

Before concluding the discussion of unusual dated pieces, we must mention the miniature jugs with over-all brown glaze produced as souvenirs for the centennial of the Battle of Bennington which took place on August 16, 1777. Of these, we have accumulated four, and the Bennington Museum has even a larger number. Three of our specimens are $2\frac{7}{8}$ inches high and $1\frac{7}{8}$ inches in diameter, while the fourth is 3 inches by $2\frac{1}{4}$. All hold approximately two ounces of liquid. The three smaller have *Little Brown Jug* incised in script on them, while the larger one has *Little Brown Jug 1877*. The glaze color varies slightly, but in all except one of the smaller pieces, the script is obviously by the same hand. That these miniatures were also produced later is known from the *E. Norton and Co.* price list of 1893.

The Bennington Museum, besides the miniature jugs, has one small flower pot with over-all brown glaze bearing the inscription *Bennington August 16, 1877 Centennial* and another in several colors, but the latter one does not properly come within the scope of the Bennington wares with which we are concerned.

A fifth jug-shaped cooler lacks a specific date, but it does bear the dateable *J. and E. Norton* mark with an Arabic *9* below it to indicate its 9-gallon capacity. The cooler is 22 inches high and $12\frac{3}{4}$ inches in diameter. The decoration consists of an unusually large ornate basket of flowers below which is in-

* *Here lies*

scribed the name *James A. Gregg* in cobalt blue script. This, and the following three pieces have been illustrated by Barret.[270]

Other pieces commemorative in the sense of bearing personal names include an otherwise undecorated and unmarked oval-shaped one-gallon jug with *J. Norton* incised in script under the salt glaze, and a smaller $\frac{1}{2}$-gallon jar with an inset cover and over-all brown glaze, which has incised on it through the pre-fired glaze the name of *Julius Norton* in script with accessory flourishes beneath and some floral designs at the sides. This latter piece is $7\frac{3}{4}$ inches high and $5\frac{7}{8}$ inches in diameter.[271]

Finally, we must mention the 6-gallon cooler-shaped jug about 18 inches high and $13\frac{1}{2}$ inches in diameter which bears the type-incised name *I. Judd* and the mark *Bennington*. This piece has been dated as being made between 1830 and 1835 which is important, if correct, since the floral decoration below the mark is incised and washed with cobalt blue in a style that is usually early.[272]

We should add that we have seen a number of oddly decorated Norton specimens in private hands or in those of dealers. A cannon, barely recognizable as such, is an example. We have not reproduced such pieces as our primary interest in this volume has been to present the typical productions of the Norton kilns, an aggregate which we regard as culturally more significant.

Summary and Conclusions

In this section we shall summarize the principal facts that have presented themselves in the course of analyzing the data set forth in this chapter. Certain problems have also been made more apparent by our study and unfortunately, in some cases they have not been resolved. We can thus only delineate them for further consideration and give our personal opinions when the latter seem warranted by our long interest in the stoneware production of the Norton potteries in Bennington.

To begin with the important matter of marks and dating, we have introduced three changes involving dates based on the marks. The *Bennington Factory* period for the various reasons presented has been given priority in position

with the date *Pre-1823*. The end of the first *Julius Norton* period has been extended backward from 1841 to 1838 on the basis of a dated jar with an inset cover in the Bennington Museum, and thirdly, Spargo's uncertainty as to the beginning of the *Norton and Fenton* partnership has been settled as 1844 rather than 1845 on the evidence of a dated bill. We can now give a revised list of the Spargo periods which he deduced by correlating the marks on the stoneware with advertisements and billheads of the various Norton partnerships.

Bennington Factory	Pre-1823
L. Norton and Co.	1823–28
L. Norton	1828–33
L. Norton and Son	1833–38
Julius Norton (first)	1838–44
Norton and Fenton	1844–47
Julius Norton (second)	1847–50
J. and E. Norton	1850–59
J. Norton and Co.	1859–61
E. and L. P. Norton	1861–81
E. Norton	1881–83
E. Norton and Co.	1883–94
(*The Edw'd Norton Co.*	1886–94)

There remains a primary problem related to these thirteen basic marks. It is simply that we have found no piece of stoneware with the postulated *E. Norton* stamp of 1881–83. Considering that there are over 225 specimens with marks in the combination of our collection and that of the Bennington Museum, together with the fact that we have searched elsewhere for a piece with this mark, its absence cannot but be regarded as peculiar. Admittedly the period is a short one embracing at the most only three years, but the earlier *J. Norton and Co.* period is no longer, and our joint collections contain fourteen pieces with this mark. Of course, the latter period was in the heyday of production, not during the decline. Nevertheless, there are forty-seven pieces in the joint collections with the mark of the *E. and L. P. Norton* period which preceded that of *E. Norton*, an average of over two specimens for each year, *and* twenty-six for the *E. Norton and Co.* period which followed it, which

is again an average of over two specimens for each year, and that not counting the coterminous subsidiary period of *The Edw'd Norton Co.* for which there are an additional eleven specimens. We must consequently assume until it is proven otherwise that there is a considerable possibility that no pieces were made with the *E. Norton* mark, and also that the marks of either the preceding or following periods were used during the unaccounted for year 1882.

We must also record in this summation that the following variant marks listed by Spargo[273] have not been encountered and do not occur on specimens in our collection or in that of the Bennington Museum.

> Julius Norton/East Bennington Vt.
> J. Norton/East Bennington Vt.
> Edward Norton,/Bennington, Vt.
> Edward Norton and Co.,/Bennington, Vt.

The probability of finding specimens with variant marks within a time period, however, might be small indeed, even if such pieces were made. On the other hand, the uncertainty of such variant marks having been used simply because the wording was found on billheads or on advertisements seems even greater. In short, specimens with some of these variant marks may not exist.

Differences in the size of type and length of lines, which have been summarized at the end of Appendix C, were partly a concomitant of the number of words in the legend. *L. Norton and Son*, for example, obviously was too large to stamp on most vessels if the type size of the previous *L. Norton* period were continued. Lesser variations in the length of lines of identical marks of the same period indicate that more than one stamp with the identical legend was used, but no correlation with an earlier or later time is evident. The variant, circular mark of the *Norton and Fenton* period, we suppose was the contribution of the new partner, Christopher Webber Fenton, who, by the variety of marks that were later used on the products of his U.S. Pottery, apparently had a special interest in them. At least this circular type of impression was not used on Norton stoneware either before or after his association with the firm. No major change in the quality of the stamps occurs until the late subsidiary period of *The Edw'd Norton Co.* when the marks were superficial, being no longer incised.

One of the most interesting things about the marks is their change in content. The Nortons had been making stoneware for many years before they stamped it with their family name, although there was precedent for so doing among potters. We have only two suggestions with respect to the matter. First, John Norton, the founder of the firm, was a modest, retiring man and he may have well lacked the motivation to put his name on his work. The second suggestion in explanation of the time lag is that since the first partnership was never quite clearly defined, there may have been some question as to what the content of the mark should be. Unquestionably, Luman was a good enough business man to see an advantage in identifying the Norton productions by means of a mark. He was proud of the pottery and wanted to own it himself. Therefore it does not seem strange that the first mark with the family designation should present *L. Norton* as the preeminent member of the firm.

We should also note the role of the place of manufacture in the marks, as well as that of a personal name. When the latter was introduced in 1823, the name of the town was apparently at first regarded as unnecessary and some marks without it appear until the end of the *L. Norton and Son* period in 1833. Apparently, Luman thought *L. Norton and Co.* or *L. Norton and Son* in themselves took all the room to which a mark was entitled on a pot, but *Bennington* was sometimes added, and always, it would seem, when the L. Norton name stood alone. As was natural, the *East Bennington* variant came into use after the pottery was moved to that village (now called Bennington) in 1833, and it disappeared again after 1847 when the East Village had preempted the older and simpler name. We should perhaps emphasize this fact by stating that as far as the pottery marks are concerned, after 1833, East Bennington and Bennington were names for the same place.

As for the addition of the abbreviation *Vt.* for Vermont, we note that it was not added until the first *Julius Norton* period beginning in 1838, but its use was continued consistently during all later periods. The earlier absence was certain'y not due to any lack of state consciousness; such would be impossible for Vermonters of any period. Neither was there confusion with any other town called Bennington. Indeed, the local residents probably considered this battle-famed name more than sufficient to identify the provenience of the pottery wherever it spread in the civilized world. The reference to

Vermont was added, it would seem, when sales began to be regularly solicited in the neighboring states, an activity which brought statehood into prominence commercially.

Capacity marks were first painted on the ware in large Arabic numerals of cobalt blue. During our research which has required the frequent handling of scores of vessels, the importance of capacity numbers in identifying sizes has become clear. It is easy to make a mistake if one disregards the numeral. This identification, we believe, would be particularly important to both buyer and seller—to the former in the sense of making sure he had a piece of the size that he wanted and, for the seller, in being certain that the price was correct. Perhaps the use of a font of type large enough to be readily visible for this purpose was at first not considered, or perhaps such large type was not immediately available. On the other hand, it may be more reasonable to assume that the space taken by the first large printed numerals was wanted for the floral decoration which was soon to assume importance. Whatever motivated the change, for many years afterward beginning with the *L. Norton and Son* or 1833–38 period, large type was used, and from only one or two fonts. Toward the close of the pottery, interestingly enough, the floral decoration was eliminated and there was a reversion to the large Arabic numerals in blue which characterize *The Edw'd Norton Co.* stoneware of the late subsidiary period.

When we come to summarize our data on the varieties of ware, we are left with one of the most annoying of unresolved problems, the lack of a truly satisfactory identification of two of them. This is no doubt the result of an insufficient number of specimens in our collection, we having concentrated on the acquisition of jugs, a category which alone comprises seventy-seven, or more than 50 per cent of our over 140 marked Norton pieces embracing over a dozen varieties of ware. In the following list which correlates the names on various bills with our more descriptive ones (in parentheses), the questionably identified varieties are marked with an asterisk.

1. Jugs
2. Pots; Open Cream or Butter Pots (Bulging, wide-mouth jars)
3. Churns
4. Covered Jars; Covered Preserve Jars (Jars with inset covers)

5. Covered Butter Pots (Jars with vertical sides)
6. Common Pitchers
7. Covered Cake Pots
8. Covered Cream Pots*
9. Milk Pots*
10. Common Batter Pitchers*
11. Batter Pails (Jars with spouts)
12. Molasses Jugs (Jugs with lip)

It may be noted that the three varieties which remain unsatisfactorily identified do not appear on the bills until at least the *J. and E. Norton* period, a fact which has reduced the number of specimens that might be distinguished as belonging to these categories. Furthermore, the milk pots are listed only during that period. Eventually, we hope that the problem of identification will be fully resolved. We can conclude our summation of the data on varieties by adding that covered cake pots also do not appear on bills before the *J. and E. Norton* period, that jars with spouts are first offered on *J. Norton and Co.* bills although we have one with an *E. and L. P. Norton* mark, while jugs with lips seemingly also make their advent only in the latter period.

About the changes of shape in time, there is one conclusion that seems both incontravertible and reducible to ready definition in words. It is that there were three discernible time periods with diagnostic characteristics for the shape of jugs and in some degree to other varieties of ware. These are as follows:

1) Pre-1823 to 1844. Oval-shaped jugs predominated (Fig. 10; Pls. 1–5).

2) 1844–47. The *Norton and Fenton* period which exemplified a transition from oval-shaped jugs, through globular ones, to the commonplace later jugs with more or less vertical sides (Fig. 10, page 116; Pls. 13, UM, UR).

3) 1847–94. Jugs and jars with essentially vertical sides (Fig. 10; Pls. 5–9).

To this statement we must add that some jugs of *The Edw'd Norton Co.* subsidiary period have most unusual broad shoulders (Fig. 10; Pl. 10, UL).

The change in bulg'ng, wide-mouth jars i; more variable and less certain on the basis of the limited number of specimens avai'able for study. Apparently they were no longer made in the *E. Norton and Co.* period. The churns show litt'e change, bulging sl'ghtly in the midd'e and having more or less flaring necks, again with the exception of the final subsidiary period (Pl. 14). *The Edw'd Norton Co.* churns have vertical sides, the pieces being indistinguishable, it would seem, from late period jars with inset covers (Pl. 14, LR). This latter category of jars, we may add, follows the changes in shape of the jugs. The shapes of other varieties of ware of which we have even fewer examples may be judged from the illustrations.

A word should be inserted about handles. The typical handle on jugs, irrespective of period, begins with a bulge at the back of the neck and lip— which is to say on the opposite side from the mark and decoration—and extends horizontally for a few inches before bending downward to join the wall of the jug just above its middle. At that point the strap handle is flattened out for adhesion. Usually the under surface of the handle is smooth while the outer surface is more or less three-sided or grooved. Inevitably, the silhouette of such handles vary somewhat in conformity to the shape of the jug, but the variation in the curve seems to have been more the product of chance than of any developmental change. The shape of the paired, horizontal handles of the jars is even more consistent in time, although the arc, usually forming a semicircle, may be more crudely formed in the earlier specimens.

In the matter of size and pr'ces of the ware, a few points should be emphasized in review. Jugs are listed only up to 4-gallon capacity until 1893 when a 5-gallon jug appears. They were also made as small as $\frac{1}{8}$-gallon, but only until the early part of the *E. and L. P. Norton* period. Churns, bulging wide-mouth jars, and jars with vertical sides as large as 6-gallon capacity were usually offered for sale, but those only as small as 2-gallon for the churns and $\frac{1}{2}$-gallon for the others. Then, in 1893, we suddenly find a jar with vertical sides of 8-gallon size. Milk pots, whatever their shape may have been, were made only of 1-, $1\frac{1}{2}$-, and 2-gallon capacity, while jugs with lips, although supplied one size smaller, were made no larger.

The one comment that can be made on prices is that although they increased with time, as was almost inevitable, the rate of doing so was remarkably inconsistent with respect to either the variety or size of the ware. If

there was a principle governing the varying increase in prices other than the general rising costs over time, we have not discovered it.

Finally, when we come to the summary and conclusions with respect to decoration, there are certain fundamental facts to be noted. Most important, there were two consistent types of treatment of the surface of the stoneware as follows:

 1) Salt glaze
 2) Over-all brown glaze

Then in the aberrant final subsidiary period of *The Edw'd Norton Co.* we find a white slip on the pottery which may not have been manufactured by the Nortons, or at Bennington (Color Pl. G).

Two techniques of further treating the pottery surfaces were used:

 1) Incising
 2) Painting

Also there were two principal pigments in the paint.

 a) Cobalt blue
 b) Ocher

As a comment on these basic facts, we can say without hesitation that the great majority of pieces produced by the Norton potteries was covered with a salt glaze. Certain varieties of ware of not over 2-gallon capacity, however, were covered by hand with an over-all brown glaze so that they could be fired successfully under larger, open mouth vessels and thus utilize the space in the kiln that the atmospherically applied salt glaze could not reach. This latter technique of glazing was apparently especially used for common pitchers, batter pitchers, batter pails, and molasses jugs, while churns and coolers seem to be the varieties of ware exempted by size. This over-all brown glaze seems none other, incidentally, than the so-called and well-known Albany slip used on the inner surfaces (unexposed in the kiln) of the salt-glazed wares, although some experimental variations seem to exist. This Albany slip was undoubtedly made from local clay (Color Pl. H).

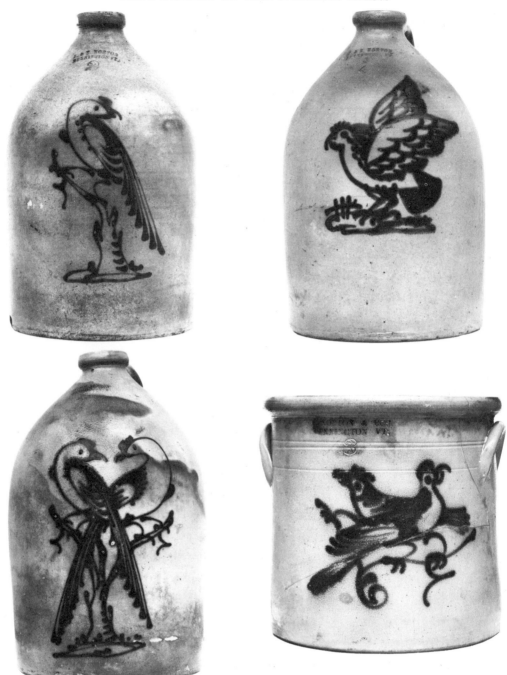

Plate 16: Other Norton Birds. UL: 2-gallon jug, *J. and E. Norton*, 1850–59, pheasant. UR: 2-gallon jug, *J. and E. Norton*, 1850–59, cock. LL: 4-gallon jug, *J. and E. Norton*, 1850–59. LR: 3-gallon jar with vertical sides, *J. Norton and Co.*, 1859–61, paired blue birds.

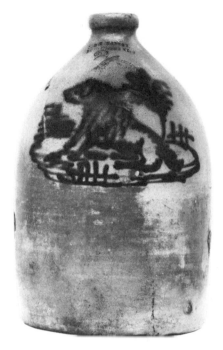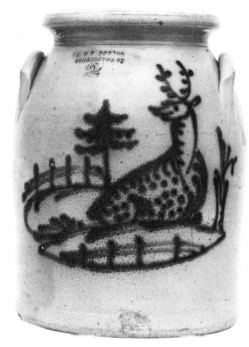

Plate 17: The Dog and the Deer. L: 2-gallon jug, *J. and E. Norton*, 1850–59, dog. R: 2-gallon jar with inset cover, *J. and E. Norton*, 1850–59, deer.

As for the two techniques of further treating the pottery surface, both incising and painting were used throughout the entire period of production definitely attributable to the Norton potteries. Incising, at least in the form of complex designs on salt-glazed ware, is practically limited to the first three periods, however, painting dominating the scene thereafter. Here we might interpolate the opinion that the better examples of such incising were the artistic contribution of certain journeyman potters. The incising on salt-glazed ware, it may be pointed out, was done on the plain clay ware, whereas the later incising on over-all brown ware was usually undertaken after the piece was glazed and before it was fired.

The utilization of cobalt blue pigment which can withstand the temperatures necessary for firing stoneware was introduced early to touch up the ends of handles as a wash on incised designs, and in order to denote the capacity of vessels in gallons. From the earliest periods, however, some effort was made to produce floral designs. These had been brought to a degree of perfection by the *L. Norton and Son* period in the middle eighteen-thirties. A design suggestive of the wild honeysuckle appears, and also insects. These art

forms flourished in the *Norton and Fenton* period of a decade later (Pl. 4) and reached their most ornate, stylized treatment in the *J. and E. Norton* period of the eighteen-fifties (Pls. 6, 16, and 18), gradually declining in quality thereafter. In the last period mentioned, we find complex floral patterns. The introduction of the blue bird on jugs (Pl. 15, UL, UR), and on jars with vertical sides is likewise particularly notable. The *J. and E. Norton* period is also known for the animals (Pl. 17), as well as some designs of inanimate objects, that quite commonly appear on larger vessels.

Before concluding, we should mention the special development of decoration with a brown pigment—probably ocher from a source of color which has been recognized as used by the local potteries, the site being shown as *Ochre Mills* on the northeast part of an 1856 map of Bennington City. This effort at harmony in browns was almost, if not entirely, limited to the period of *L. Norton and Son* (Pl. 3, LL, LR). It may be regretted that this distinctive manner of decoration was given up, for with it some of the most simple and esthetically pleasing of the Norton designs were produced.

COMPARISON
WITH THE PRODUCTIONS
OF OTHER KILNS

Introduction

OUR CONCERN WITH the product'on of other kilns has been casual, and proper comparisons must be reserved for such a time as comparable studies of such potteries have been published. Inevitably, however, it has been necessary to learn what one could and to observe as avidly as possible in order to sharpen one's awareness of the stoneware created by the Nortons of Bennington. As might be expected, this has most easily been done with respect to decoration, an interest which we shall take up in its turn.

Marks and Dates

There is little or no question but that type-incised marks were used in New England before they were adopted by the Nortons. Most probably, the technique diffused from Massachusetts or Connecticut through the hands of itinerant potters. There is always the possibility of influence from New York via the Albany-Troy area, but the historical facts with respect to pottery development in the latter region have unfortunately not been available. It is most pertinent that Lura Woodside Watkins, who illustrates several pieces with marks attributed to the end of the eighteenth century, has found one jug that is impressed with the place name *Boston* above the date *1804*,[274] a time at which stoneware most probably had not been made in Bennington.

167

Also, we ourselves have a jug with *J. Fenton* in incised script below the neck. The name could be that of Jacob Fenton who worked in New Haven, Connecticut, before the end of the eighteenth century but is more likely that of his nephew Jonathan Fenton, the father of the Christopher Webber Fenton who was for a short time a partner of Julius Norton. By its shape we judge it to have been made while Jonathan Fenton was in Boston between 1794 and 1797.

Certainly the use of marks was common among stoneware potters of the nineteenth century, but seldom can they be dated before 1820 with certainty. Rare survivals from the kiln of the partners Stephen Orcutt and Luke and Obediah Wait who worked in Massachusetts and marked their ware *Orcutt and Wait/Whately* in the first decade or two or the nineteenth century are among the exceptions.[275] Quite a number of the later Massachusetts and Vermont marks can be more or less accurately dated by the town records of the residence period of the potters. Those of the Crafts family of Whately are an example and, more closely connected with the Nortons, the pottery of the Fentons in East Dorset, Vermont, where the mark *R and C Fenton/Dorset, Vt.* designates a period between 1830 and 1833.[276] The mark *R. L. Fenton and Co/East Dorset* almost as certainly represents the preceding and equally brief period from 1827 to 1830 when Jonathan Fenton's son, Richard Lucas, was in partnership with his brother-in-law, Seth Curtis.

We should also recall the case of Franklin Blackmer Norton, the son of John Norton, Jr. who moved from Bennington to Worcester, Massachusetts in 1858, and made stoneware there in partnership with Frederick Hancock. Their pottery is thus roughly datable as Norton was running the business alone in 1865 with the mark *Frank B. Norton/Worcester, Mass.*, and in 1868 took his sons into partnership with the mark *F. B. Norton Sons/Worcester, Mass.*[277]

Sometimes the marks on stoneware are not those of the makers but rather of retailers who commissioned the wares in quantity and with their own names and addresses as an advertising device. For example, we acquired a 2-gallon jug with the mark *David Scott, Jr.,/Wholesale Druggist,/243 Main Street, Worcester, Mass.* If the name of the city was not sufficient to suggest that the maker was F. B. Norton, the floral decoration would, as we shall see later. We have other examples of retailers' marks replacing those of the

makers, the best indication being the inclusion of a street address which suggests that the firm might be more difficult to find than a pottery.

Varieties and Shapes

We have no proof that the Nortons originated any of the varieties of ware they produced, and it would be surprising if they did so. Going back into the eighteenth century, we find jugs, pots, churns, covered jars, pitchers, and jugs with lips. The word *pot* was used for various styles of jars (a word that does not appear on early potters' lists), uncovered and covered including the inset variety of the latter.[278] If there was an innovation at the Norton potteries, it may have been the batter pails (jars with spouts) (Pl. 12, LR). Furthermore, from our limited evidence consisting of a few bills and some scores of vessels, it would seem that contemporary stoneware potteries in New England and adjacent New York produced the same general varieties of vessels. A definitive statement, of course, must wait on published descriptions of specimens from other than Norton kilns.

Shapes are a more subtle matter than varieties of ware, and they do vary slightly from maker to maker, as well as from time to time. The differences are difficult to verbalize, but nonetheless we have learned usually to distinguish a Norton vessel standing outside an antique store from those produced by other potteries even when speeding by at fifty miles an hour in an automobile. The outline of an object is one of the formal elements immediately perceived by the eye, one which does not have to endure the time span of reasoning.

We have mentioned a jug inscribed with the name *J. Fenton* and attributed it to Boston on the basis of shape. When we try to describe why, we would say that it is because of the relatively elongated outline and the way the mouth has been drawn upward. Pieces at the turn of the eighteenth century were apt to be like the later oval-shaped ones but seem stretched out a little more from top and bottom. Among contemporaries of the Nortons, we would say that the slope of the neck and the formation of the mouth rim are differentiating features in jugs. In some instances, the neck slopes into the side of the lip and continues in a continuous line to the rim with perhaps only a circum-

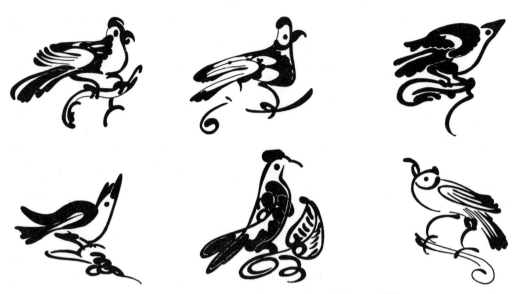

Fig. 31: Blue Birds from Other Than Norton Kilns

scribing incision distinguishing the neck. Some shoulders are higher and the mouth rim may be straight, high, narrow, round, as well as sloping or flaring inward or outward. One of our examples with the mark *N. A. White and Son/ Utica, N.Y.* has a slight ridge around the neck instead of the usual incised line (Pl. 22, LM). Jug necks may be even more complicated.

It would be nice if the contour of neck and mouth rims alone were diagnostic of the jugs of a particular maker or town. Unfortunately, that does not seem to be the case. On the other hand, despite the variations in details that occur on Norton products, they are of limited number, while many such variations that appear elsewhere have not been found on Bennington pieces.

Blue Birds and Other Decoration

Probably no form of decoration on salt-glazed stoneware has been so popular as the blue bird. Early in our collecting years we heard the opinion voiced that these birds were painted on jugs and jars by itinerant artists who traveled from pottery to pottery. Both liking the birds and being interested in this thesis, we began to collect blue birds. Thus we accumulated nine blue birds other than the dozen or more on our Bennington pieces. Now we find that only one of them has the typical Norton blue bird characteristic of the

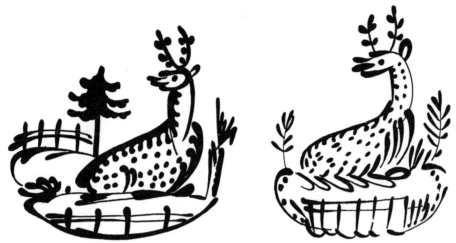

Fig. 32: *J. and E. Norton* and *Edmands and Co.* Deer

periods between 1850 and 1861. It appears on a 1½-gallon jug bearing the mark *Haxtun, Ottman and Co/Fort Edward, N.Y.*, a location that is not far from Bennington, being about forty miles northward of Troy (Fig. 31, UL, p. 170; Pl. 20, UL). Even this painting, in which the blue bird does have all the diagnostic features (See p. 140), is not in the best classic style and might have been produced by copying. Another species of blue bird, but still with a few of the Norton diagnostic features, occurs on a 3-gallon jug from the *Troy, N.Y./Pottery* (Fig. 31, UM; Pl. 20, UM). Perhaps the artist created this one by memory, rather than direct copying.

It is also pertinent that another Fort Edward jug with a different mark (and unfortunately an illegible upper line) has a blue bird with one or two of the diagnostic Norton features, but actually looks more like a pigeon. Indeed, the latter is nearest in features to a blue bird on a jug marked *Lamson and Swasey/Portland, Me* with the beak pointing upward as its distinctive feature (Fig. 31, UR; Pl. 20, UR).

To continue our survey, we discover that an unmarked jug and an un-marked jar have almost identical and excellent blue birds of a distinct style with sharply upturned heads and beaks (Fig. 31, LL; Pl. 20, LL). We can add only that they were purchased seven years apart, one near Deerfield, Massachusetts, and the other a few miles to the south just east of the Con-necticut River. Our other alien blue birds are more difficult to classify al-though a Norton feature such as a beak that gently curves downward, is

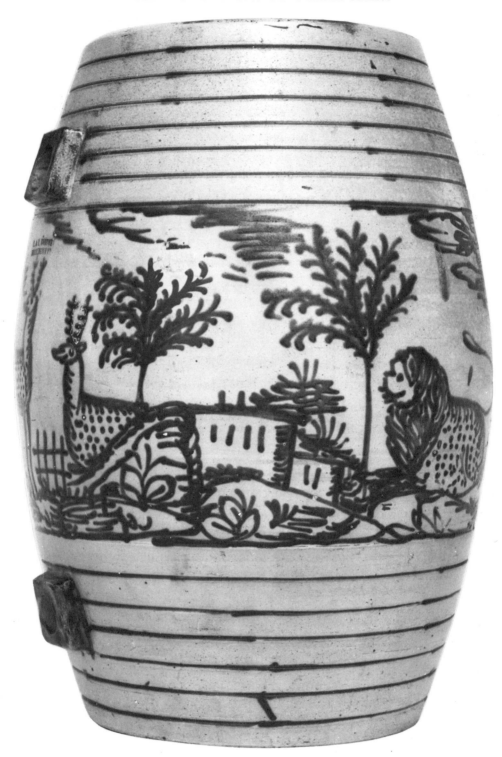

Plate 18: The Water Cooler in the Smithsonian Institution.

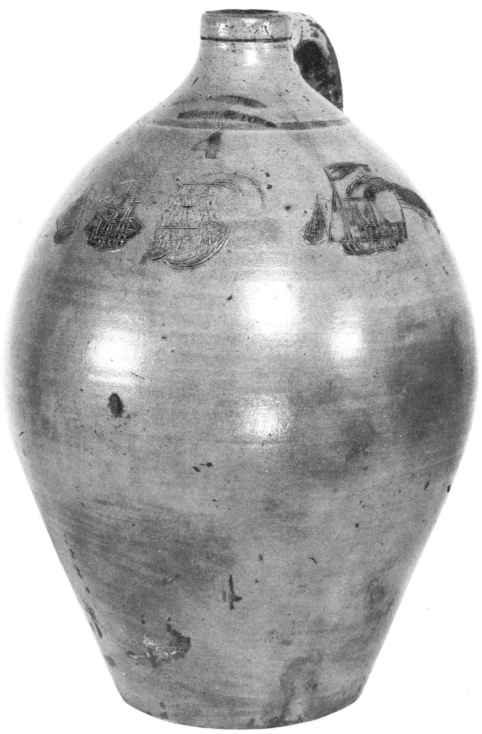

Plate 19: Ships on a 4-gallon jug, *L. Norton*, 1828–33.

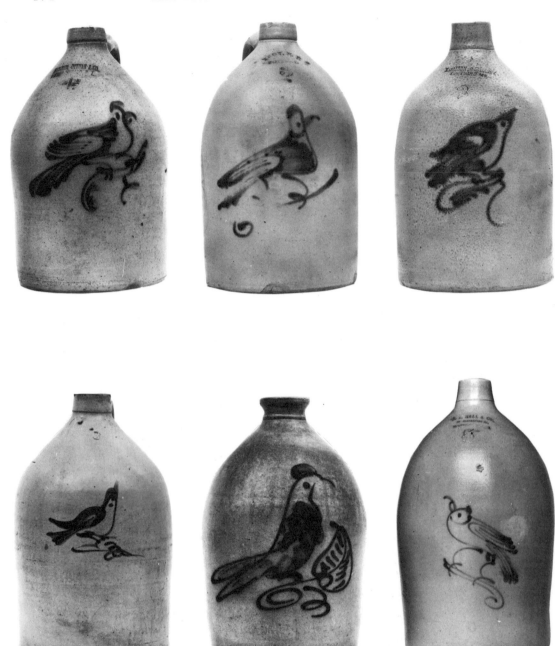

Plate 20: Alien Blue Birds. UL: 1½-gallon jug, Norton style bird, Fort Edward, N.Y. UM: 3-gallon jug, Norton style bird, Troy, N.Y. UR: 2-gallon jug, bird with up-pointed beak, Portland, Maine. LL: 3-gallon jug, bird with up-pointed beak, no mark. LM: 1-gallon jug, exceptional design, no mark. LR: 5-gallon jug, pencil work design, [retailer's mark].

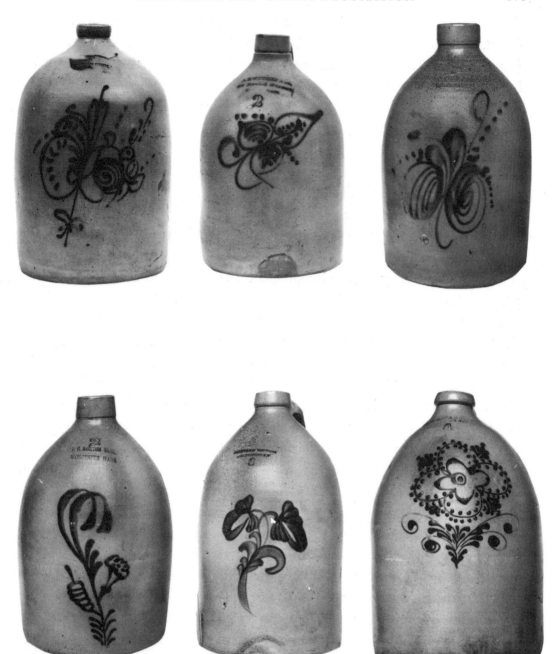

Plate 21: Alien Designs. UL: 3-gallon jug, possible Norton floral design, Utica, N.Y. UM: 2-gallon jug, classic Norton floral design. [Worcester, Mass.]. UR: 2-gallon jug, classic Norton floral design, Worcester, Mass. LL: 2-gallon jug, unusual floral style, Worcester, Mass. LM: 3-gallon jug, unusual floral style, Burlington, Vt. LR: 4-gallon jug, abstract floral design, W. Troy, N.Y.

shared by two birds. One of these is as striking an achievement as we have found, being characterized by a bold blue outline, a crest, and a split tail (Fig. 31, LM; Pl. 20, LM). The one-gallon jug which harbors this blue bird has no mark, although a notably unusual neck. The bird perches on the stem of a distinctive leaf, the outline of which reminds us of another leaf, again unfortunately, on a jug with no maker's mark (Fig. 35, LM, p. 179; Pl. 23, LM).

The last of our alien blue birds, which ornaments a 5-gallon jug, in some features is even more extraordinary (Fig. 31, LR; Pl. 20, LR). The painting is like pencil work, the head most peculiar, and the body mounted on a branch in what is opposite to the usual direction. Its impressionistic delicacy is its distinction.

We have not disproved the hypothesis that an itinerant artist went around painting the same blue birds, but we have made it harder to believe. More likely, it was the jug themselves that diffused and provided copy material. On the other hand, a decorator who learned the Norton style in Bennington may have carried this art form to one or more places.

Before going further, we should also mention the distinctive deer which appears a considerable number of times on the stoneware of Bennington (Fig. 32, L, p. 171). We regrettably have not been able to collect many of these animals, or any comparative material, as the painted deer are infinitely rarer than natural ones in Vermont. Lura Woodside Watkins (1950: Fig. 101), however, illustrates a jar marked *Edmands and Co* with a deer having some general characteristics shared by the deer of the Norton artist (Fig. 32, R). The location of the pottery is Charlestown, Massachusetts, a considerable distance from Bennington and the date is said to be after 1850. Although the opinion is in print that this deer was almost certainly by the same hand as a Norton deer in the Bennington Museum, we believe it to be a copy—but perhaps we are prejudiced.[279] In any event, on the basis of a barrel-shaped cooler in the Smithsonian Institution (Fig. 25, p. 145; Pl. 18), another in the Bennington Museum (Barret, 1950: 7, Pl. 10), as well as a jar with an inset cover illustrated by Spargo (1926: Pl. IV), and the same variety of jar in our own collection (Pl. 17), all of which bear the *J. and E. Norton* mark of 1850–59, we note the following things that the above share in common which differ on the *Edmands and Co* jar. First, the Norton pieces show

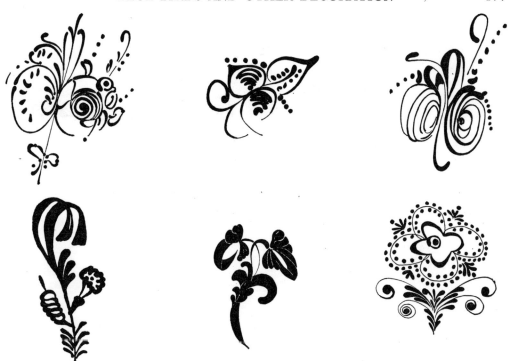

Fig. 33: Floral Designs from Other Than Norton Kilns

antlers with opposing tines only at the top, and with two or more single tines branching to the left off the beam below them, while the Edmands deer has two sets of opposing tines on each antler. Secondly, the nose and mouth of the deer which are made in three parallel lines in all cases appear to be more exactly defined on the Norton specimens. Third, the dots on the Norton deer are round and do not extend up the animal's neck, while on the Edmands animal the dots are elongated and do extend up the neck. Finally, the latter specimen lacks the typical Norton evergreen which is replaced by Edmands style floral symbols, and the Edmands fence lacks the character of those on the Norton pieces. That the Edmands deer was drawn by the same hand that almost certainly created all the others is simply not credible.

Apart from our blue birds on pieces without Bennington marks, we have at least eighteen jugs and several jars which were collected for the purposes of comparing their elaborate cobalt blue designs with Norton pieces. Bringing them together for examination we find only three with an unmistakable Norton design. Two 2-gallon jugs and one of three gallons each bear one of the classic conventionalized floral designs of the *J. and E. Norton* period (Com-

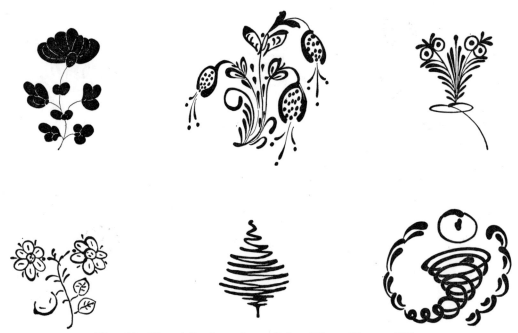

Fig. 34: Floral Designs from Other Than Norton Kilns

pare Fig. 19, UL, UM, UR, p. 138). The latter (Fig. 33, UL, p. 177; Pl. 21, UL) might take a second glance for one to recognize the origin of the art work since the lines are less heavy than usual and the general appearance is somewhat peculiar as though an example of one style and been laid over another. Nevertheless, the spiral roselike flower, the extended stem with the end turned back on itself, the accessory dots, and the sets of parallel lines all recall what is commonplace on the later Bennington stoneware. This jug, however, bears the mark *White's Utica.* in one line, and we should note, in passing, its extraordinarily high shoulders. We suspect that in its decoration the artist used a free hand in copying a Norton piece.

On the 2-gallon jugs, however, the designs are so familiar that they would make one think they were made at a Norton pottery, and such was apparently the case. One bears the retailer's mark *A. B. Wheeler and Co.,/69 Broad Street/Boston, Mass.* (Fig. 33, UM; Pl. 21, UM), but the other we were delighted to find is impressed with the legend *Frank B. Norton/Worcester, Mass.* (Fig. 33, UR; Pl. 21, UR). As this Norton was a grandson of the founder of the Bennington pottery, there is little difficulty in tracing the diffusion of the design to the latter town. Furthermore, a close comparison of various details

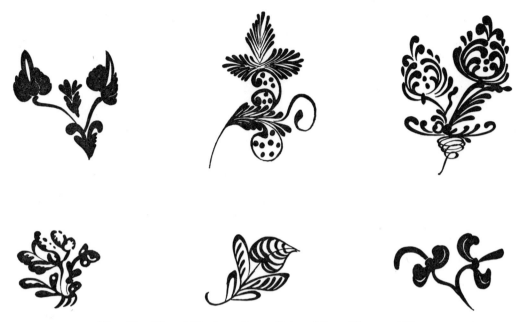

Fig. 35: Floral Designs from Other Than Norton Kilns

on the piece with the Boston mark (Fig. 33, UM; Pl. 21, UM) leaves little doubt that it was made in Worcester as well. We have still another Worcester jug with the mark of *F. B. Norton Sons* which is in a style of its own (Fig. 33, LL; Pl. 21, LL).

Most of the designs on jugs we have collected that lack the Norton mark of Bennington seem to have little or no similarity to those that we know were made in the latter town. The flower on a 3-gallon jug, for example, with the mark of *Nichols and Boynton* of Burlington, Vt. which can be assigned to the late eighteen-fifties,[280] is in a charming manner distinguished by a carefully outlined wash of cobalt blue (Fig. 33, LM; Pl. 21, LM). Next to it, a floral design emphasized by a double row of dots stands out in sharp contrast (Fig. 33, LR; Pl. 21, LR). This 4-gallon jug bears the mark *W. M. E. Warner/ West Troy.*

In another group we find a 2-gallon jug bearing the single word *Charlestown* and a complex but delicate floral design that by the separation of its parts gains distinction (Fig. 34, UL, p. 00; Pl. 22, UL). Boldness characterizes the decoration on a 4-gallon jug, also from Charlestown, Massachusetts, with the mark *Edmands and Co.* of the eighteen-fifties (Fig. 34, UM; Pl. 22, UM). We

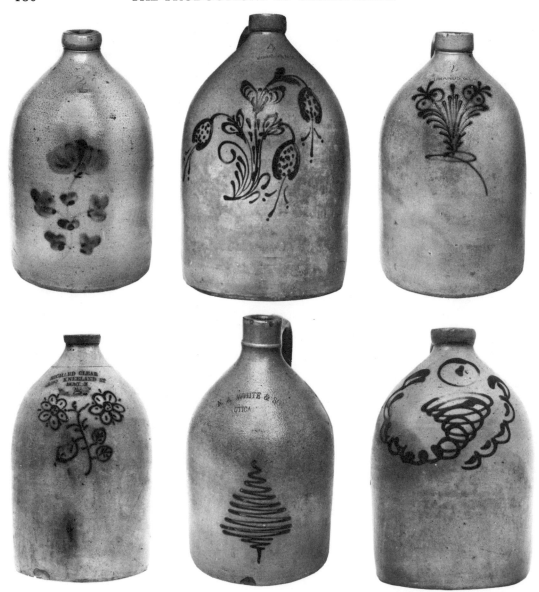

Plate 22: Alien Designs. UL: 2-gallon jug, ornate leaf design, Charlestown, [Mass.]. UM: 4-gallon jug, floral design, [Charlestown, Mass.]. UR: 2-gallon jug, abstract flower, [Charlestown, Mass.]. LL: 2-gallon jug, floral design, [retailer's mark]. LM: 1-gallon jug, triangular zigzag design, Utica, N.Y. LR: 1-gallon jug, spiral cornucopia, no mark.

should recall that Lura Woodside Watkins has observed that jars bearing the earlier *Charlestown* mark are usually undecorated, except for tiny impressed motives, while those with the later mark were made "in the period of freest

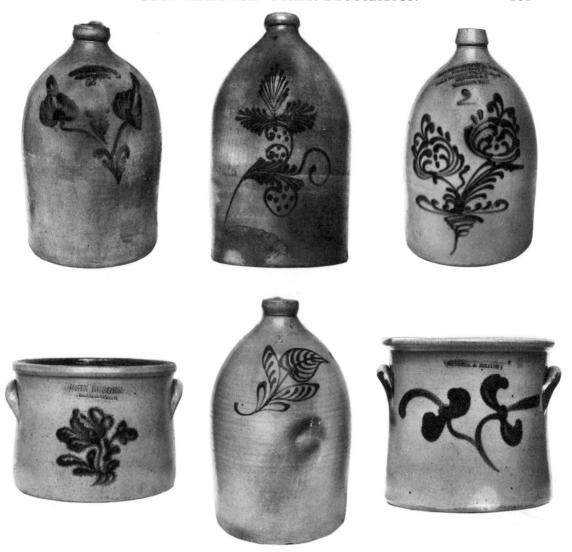

Plate 23: Alien Designs. UL: 2-gallon jug, design suggestive of early Norton period, Hartford, [Conn.]. UM: 4-gallon jug, leaf and dot design, no mark. UR: 2-gallon jug, floral design, [retailer's mark]. LL: 1-gallon jar with vertical sides, floral design, Rochester, N.Y. LM: 2-gallon jug, simple leaf design, no mark. LR: 1¼-gallon jar with vertical sides, floral design, *Hastings, and Belding*, [Ashfield, Mass.].

decorative expression . . . remarkable for elaborate and often striking design."[281] In a quite different style is a second *Edmands and Co.* jug with two flowers growing out of a cluster of fernlike leaves. The flower consists of opposing circles with a dot in the center of each (Fig. 34, UR; Pl. 22, UR). Somewhat related in manner is a design also consisting of two flowers, but

more elaborate ones with six petals and accessory dashes and dots (Fig. 34, LL; Pl. 22, LL). This 2-gallon jug bears the retailer's mark of *Richard Clear, 130 Kneeland St. Boston* and may itself be an *Edmands and Co.* product.

More extraordinary is a descending zigzag design on a one-gallon jug bearing the mark of *N. A. White and Son/Utica, U.Y.* (Fig. 34, LM; Pl. 22, LM). The neck on this jug is also most unusual in its height and in having an extruded encircling ring. Equally striking is a one-gallon jug with no mark, but decorated in unusually pale cobalt blue with a spirally-conceived cornucopia with a balancing border on the right side and the capacity mark painted in the middle of a circle (Fig. 34, LR; Pl. 22, LR).

In our last group of alien designs we have an equally broad range of styles. First, we must draw attention to a 2-gallon jug with the mark of *M. C. Webster and Son/Hartford*, which Connecticut piece is probably datable between 1840 and 1857.[282] This piece has two leaf-shaped elements rising upward from a common stem in a style vaguely reminiscent of the Norton art of the eighteen-twenties (Fig. 35, UL; Pl. 23, UL). The next design on a 4-gallon jug, except in the use of simple lines and dots, is suggestive of no other we have seen. Its leaf and dot decoration provides the strange effect of two related units placed perpendicularly and one above the other (Fig. 35, UM; Pl. 23, UM).

Then an ornate floral design in a striking purplish blue appears on a 2-gallon jug with the long retailer's mark *Gillett, Snow and Thayer/Dealers in/ Dry Goods and Crockery/Groceries and C/Westfield, Mass* (Fig. 35, UR; Pl. 23, UR). Some elements of the art work, including the spiral base, have been found on other pieces of stoneware, but the over-all effect, and especially the deep color of the cobalt, set it off alone.

An unusual floral design appears on a one-gallon jar with vertical sides and the mark of *John Burger/Rochester* (Fig. 35, LL; Pl. 23, LL). The decoration is an outstanding example of floral painting. As a charming contrast to many of our jugs, we have a 2-gallon unmarked specimen with a leaf and four supplementary fronds on a stem (Fig. 35, LM; Pl. 23, LM). Seldom does such lightness of touch occur on stoneware decoration and we regret that we do not know its place of manufacture.

Finally, among alien designs, we show a spray of the flowers we have called honeysuckles as they appear on a $1\frac{1}{4}$-gallon jar with near vertical sides bearing

the mark of *Hastings, and Belding* which can be dated between 1850 and 1854 (Fig. 35, LR; Pl. 23, LR).[283] This rare vessel from Ashfield, Massachusetts, may well have been made by Franklin Wright, one of the greatest New England potters according to Lura Woodside Watkins. Its artistry appears not only in the graceful simplicity of the floral design, but in the equally distinctive gentle sloping of the sides so as to accommodate the eye to the slightly projecting horizontal handles. In conclusion we may record that it has been contended by some collectors that the most extraordinary cobalt blue decoration on salt-glazed stoneware was produced in New York state but, if this is true, our Massachusetts pieces, to say nothing of those from Bennington, give no support to that theory.

Such a brief discussion comparing the designs on salt-glazed stoneware cannot be conceived as in any way doing justice to the painting on jugs and jars distributed over the country. We can only hope that our comments will stimulate the interest in some future scholar to produce a definitive work on this aspect of folk art in America.

GLOSSARY
OF CERAMIC TERMS

ANNEALING: the process of firing a kiln for a continuing period at a maturing temperature.

BODY: a general term for clay that has been prepared for the manufacture of pottery.

CELADON: a gratuitous term given by the French to the low intensity, somewhat bluish green glaze color of early Chinese and Korean porcelains.

CHARGING: a term referring to the arranging of clay ware in a kiln in preparation for firing (also called setting).

CLAY: a widely distributed, unctuously plastic material when wet, which becomes hard when baked in a fire.

CLAY WARE: any ware that has been formed but not fired.

CRACKLE: a glaze which has been crazed, or shattered, because its rate of contraction on cooling only approximates that of the body which it covers. Often accidental, a crackle may be intentionally produced for decorative effects.

EARTHENWARE: any pottery that has been fired at a temperature below which sintering occurs, thus leaving a permeable body.

ELUTRIATION: purification of clay by suspending it in water so that the heavier particles fall to the bottom and can be discarded while the finer particle float off for a continuation of the process in lower tanks.

FELDSPATHIC: used of kaolin clays decomposed from crystalline rocks such as granite which contain aluminum silicates with either potassium, sodium, calcium, or barium.

FETTLING: the process of trimming or cleaning up a piece of clay ware with a knife.

FILLER: any material added to a too plastic clay in order to stiffen it (also called temper).

FIRING: a term used to refer to the burning of ware in a kiln.

FLUX: any material which will reduce the maturing temperature of clay.

FOOT-RING: a circular protuberance of clay on the bottom of ware for the primary purpose of preventing pottery from sticking to another piece below while being fired in a kiln.

FORMING: pinching or squeezing a clay body into a desired pottery shape.

FRITTED GLAZE: glaze that has been partly fused over a fire and then ground up when cool before being suspended in water and applied as a coating on ware.

GLAZE: a complex material applied to the surface of earthenware so as to form a thin, glasslike coating in order to make the clay body impermeable or, similarly applied to stoneware in order to provide a smooth surface or decorative effect.

GROG: filler which consists of pulverized clay that has already been fired, as in the form of wasters or brick.

INCISING: cutting into a piece of clay ware for decorative purposes.

KAOLINITE: a hydrated aluminum silicate (Al_2O_3. $2S_1O_2$. $2H_2O$) comprising the chief constituent of most high grade clays and consisting of platelike crystals which vary in size between 0.5 microns (0.00005 mm) and 3.51 microns.[284]

KILN: a furnace, or ceramic oven, in which pottery is fired.

LEATHER-HARD: a term applied to clay ware that has been satisfactorily dried in anticipation of firing (also called green-hard).

LUTING: the process of attaching handles, spouts, or decorative elements to clay ware by using some slip as one would glue.

MATURING TEMPERATURE: an expression used to denote the maximum temperature to which ware can be brought and retain its shape without vitrifying and collapsing (it may also be used quite contrarily of glaze to indicate the temperature at which the latter will vitrify and run).

MUFFLE KILN: a special subsidiary kiln used for re-firing at low temperatures the decorative paints or enamels that have been added to ware already fired at high temperatures.

OXIDIZING ATMOSPHERE: an expression used to designate the atmosphere in a kiln which is being fired with a full draft of air.

PETUNTSE: a Chinese term (pai tun tzu) meaning "little white blocks" after the shape in which this material, consisting of feldspar, kaolin, and quartz in approximately equal parts, was transported. Mixed with silicates, it forms the glaze of Chinese porcelains.

PLASTIC: a clay is said to be plastic when it can be formed readily in the hands.

PORCELAIN: stoneware of feldspathic clays which mature only at a high temperature of over 1300° centigrade (2372° F).

POTTERY: a general term embracing all ware made by forming clay, as well as its place of manufacture (It is not used here in its sometime narrow sense referring only to earthenware).

PRIMARY CLAY, see RESIDUAL CLAY.

PUG MILL: a machine that performs the task of wedging clay.

PYROMETRIC CONES: clay cones with predetermined melting points for demonstrating the temperature reached inside a kiln.

RAW GLAZE: a simple suspension of glaze in water.

REDUCING ATMOSPHERE: an expression used to designate the atmosphere in a kiln which is being fired with a reduced draft of air, thereby allowing carbon monoxide to be produced which will change the chemical structure of the oxides in glazes and consequently their color.

REFRACTORY CLAY: one that has an extremely high melting point and thus will serve for the manufacture of saggers.

RESIDUAL, OR PRIMARY CLAY: clay that remains in contact with the rock from which it has resulted by decomposition.

SAGGER: a ceramic box made of clay with a high vitrifying temperature in which to enclose and protect a piece of ware.

SALT GLAZE: a product of sodium chloride which, when thrown into the top of a hot kiln, reacts with steam to create, besides unused hydrochloric acid, sodium oxide which forms a thin, orange peel glaze after contact with the silica in the ware itself.

SECONDARY CLAY, see TRANSPORTED CLAY.

SETTING, see CHARGING.

SINTERING: the process of achieving a temperature in a kiln which will cause the outer surfaces of the ware to vitrify, or melt.

SLIP: fine-grained clay converted to a soupy consistency by the addition of water.

SLIP GLAZE: a glaze consisting principally of clay.

SLIP-TRAILING: the application of slip to pottery through one or more tubes.

SOAKING: the process of firing a kiln for a continuing period at a steady temperature.

SPUR: a multi-pronged bit of clay used to support clay ware in a kiln.

STONEWARE: any pottery that has successfully been brought to a temperature which has cause the outside surface to vitrify, and hence become impermeable and capable of holding liquids.

TEMPER: any material added to a too plastic clay in order to stiffen it (also called filler).

TEMPLET: a simple tool that may be used to control the forming of body clay on a potter's wheel.

TRANSPORTED, OR SECONDARY, CLAY: clay that has been removed by wind, water, or glaciers from the rock from which it has resulted by decomposition.

VITRIFY: a term used of pottery to indicate that clay has melted.

VOLATILIZE: to cause to pass off in vapor, as when sodium chloride is thrown into a hot kiln to produce salt glaze.

WARE: any clay that has been intentionally formed by the potter.

WASTER: a piece of pottery discarded because of some flaw in firing.

WATER SOAKING: a steady heating of a kiln at a low temperature to dry out the last superficial water in leather-hard ware.

WEDGING: the process of cutting, rolling, and beating clay into an even consistency.

GENEALOGICAL CHART

A Genealogical Chart of the Nortons and the Fenton Who Were Stoneware Potters at Bennington

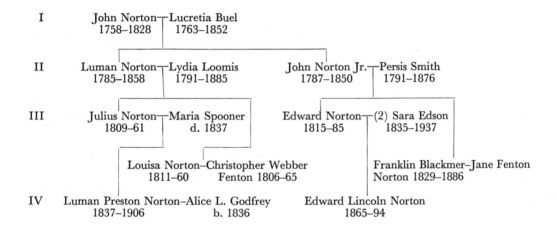

I John Norton—Lucretia Buel
1758–1828 1763–1852

II Luman Norton—Lydia Loomis John Norton Jr.—Persis Smith
1785–1858 1791–1885 1787–1850 1791–1876

III Julius Norton—Maria Spooner Edward Norton—(2) Sara Edson
1809–61 d. 1837 1815–85 1835–1937

Louisa Norton–Christopher Webber Franklin Blackmer–Jane Fenton
1811–60 Fenton 1806–65 Norton 1829–1886

IV Luman Preston Norton–Alice L. Godfrey Edward Lincoln Norton
1837–1906 b. 1836 1865–94

Supplementary Data on the Norton Family of Bennington*

ALICE C. N. b. 14 Aug 1847, d. 25 Jul 1865 (unmarried). The second daughter and child of Julius and Sophia Olin Norton.

ALICE L. GODFREY N. b. 25 Sep 1836, m. Luman Preston Norton 12 Oct 1858. The daughter of Bradford and Sarah (McGowan) Godfrey.

* Except where otherwise noted, it is presumed that members of the Norton family were born in or near Bennington, Vt.

CLARISSA B. N. b. 10 Jan 1789, m (2) 8 Oct 1828. First daughter and third child of John and Lucretia Buel Norton.

EDWARD N. b. 23 Aug 1815, d. 3 Aug 1885, m (1) Helena Lincoln Nov 1856, m (2) Sarah Edson. The fifth Norton potter of Bennington, being the first son and child of John and Persis Smith Norton.

EDWARD LINCOLN N. b. 20 Mar 1865, d. 13 Dec. 1894. The eighth and last Norton potter of Bennington, being the first son and second child of Edward and Sarah Edson Norton.

ELIZA N. b. 5 Mar 1800, d. 12 Nov 1891, m. 11 Nov 1824. Fourth daughter and seventh child of John and Lucretia Buel Norton.

ELIZA N. b. 23 Nov 1843, d. 29 Oct 1889. First daughter and child of Julius and Sophia Olin Norton.

EMMA SYBIL N. b. 12 Feb 1863, d. 5 Nov 1937, m. 14 Nov 1894. The first child of Edward and Sarah Edson Norton.

FLORENCE N. N. b. 29 July 1857, d. 14 Dec 1857. The first daughter and child of Edward and Helena Lincoln Norton.

FRANKLIN BLACKMER N. b. 23 May 1829, d. 3 Jan 1886, m. Jane Fenton 26 Aug 1850. The sixth Norton potter of Bennington, being the fourth son and sixth child of John and Persis Smith Norton. He later operated a pottery in Worcester, Mass.

HELENA N. b. 19 Sept 1866, d. 15 April 1966. The second daughter and third child of Edward and Sarah Edson Norton. She died unmarried at the age of 99.

JANE FENTON N. m. Franklin Blackmer Norton 26 Aug 1850. The daughter of Richard Lucas Fenton, granddaughter of Jonathan Fenton, and niece of Christopher Webber Fenton whose wife, Louisa Norton, was her husband's cousin.

JOHN N. b. 29 Nov 1758 in Goshen, Conn., d. 24 Aug 1828, m. Lucretia Buel 6 Mar 1782. The founding potter of Bennington.

JOHN N. Jr. b. 25 Feb 1787, d. 27 Nov 1850, m. Persis Smith 16 Feb 1815. The third Norton potter of Bennington, being the second son and second child of John and Lucretia Buel Norton.

JONATHAN BUEL N. b. 26 May 1797, d. 16 Nov 1831, m. Harriet Peck. The third son and sixth child of John and Lucretia Buel Norton.

JULIUS N. b. 23 Sept 1809, d. 5 Oct 1861, m. (1) Maria Spooner 1836 and

(2) Sophia Olin 5 May 1841. The fourth Norton potter of Bennington, being the first son and first child of Luman and Lydia Loomis Norton.

LAURA N. b. 3 June 1815, m. 29 Feb 1836. The second daughter and third child of Luman and Lydia Loomis Norton.

LAURA A. N. b. 13 Dec 1793, d. 21 Oct 1868, m. 2 Mar 1815. Third daughter and fifth child of John and Lucretia Buel Norton.

LOUISA N. b. 27 June 1811, d. 3 Dec 1860, m. Christopher Webber Fenton, the potter of Bennington, 29 Oct 1832. The first daughter and second child of Luman and Lydia Loomis Norton and the mother of Fanny, Frank, Augusta, and Henry Fenton.

LUCRETIA N. b. 1 Jan 1791, d. 1885, m. 27 Jan 1814. Second daughter and fourth child of John and Lucretia Buel Norton.

LUCRETIA BUEL N. b. 3 June 1763 in Litchfield, Mass., d. 15 Aug 1852, m. John Norton 6 Mar 1782. Mother of four sons and five daughters.

LUMAN N. b. 9 Feb 1785 in Williamstown, Mass., d. 27 April 1858, m. Lydia Loomis 16 Nov 1808. The second Norton potter of Bennington, being the first son and child of John and Lucretia Buel Norton.

LUMAN PRESTON N. b. 20 Mar 1837, d. 26 April 1906, m. Alice L. Godfrey 12 Oct 1858. The seventh Norton potter of Bennington, being the only son of Julius and Maria Spooner Norton.

LYDIA N. b. 7 June 1806 (?), d. 16 April 1838. Fifth daughter and ninth (?) child of John and Lucretia Buel Norton.

LYDIA LOOMIS N. b. 1791, m. Luman Norton 16 Nov 1808. The mother of Julius, Louisa, and Laura Norton.

MARIA SPOONER N. d. 22 May 1837, m. Julius Norton 1836. The mother of Luman Preston Norton.

MARY P. N. b. 23 May 1859, d. 11 Sept 1942, m. 19 June 1903. The second daughter and child of Edward and Helena Lincoln Norton.

NORMAN JUDD N. b. ? m. Dorcas Ester. The fourth son and eighth (?) child of John and Lucretia Buel Norton.

PERSIS SMITH N. b. 10 Sept 1791, d. 29 July 1876, m. John Norton Jr. 16 Feb 1815. The daughter of Ephraim Smith and the mother of Franklin Blackmer Norton and Edward Norton.

SOPHIA OLIN N. b. 7 May 1819, d. 3 Mar 1892, m. Julius Norton 5 May 1841. The mother of Eliza and Alice C. Norton.

DESCRIPTION OF MARKS

A Description of the Marks on the
Norton Stoneware of Bennington

The Pre-1823 Period

BENNINGTON
FACTORY

In all four examples, the mark consists of two lines in upper case type $\frac{1}{4}$ inch in height (we have given the approximate heights in inches rather than in the more technically correct number of points, as the latter would be meaningless to most readers). The word *Bennington* is $2\frac{3}{8}$ inches long and *Factory*, $1\frac{3}{4}$ inches. The second line is approximately centered under the first. This arrangement is followed in the case of all other two-line marks with one exception which will be specially noted. All the marks of the period are washed with cobalt blue. The capacity in gallons on each of our *Bennington Factory* pieces is indicated on the body below the mark by a large, underglaze blue, Arabic numeral.

The 1823–28 Period

L. NORTON, & Co.

or

L. NORTON, & Co.
BENNINGTON

The type size in all instances is the same $\frac{1}{4}$ inch in height used during the previous period, but all four cases, somewhat peculiarly, have the *o* of *Co.* in lower case type. On two examples (a one-gallon jug and a 3-gallon jar with an inset cover), the mark consists of one line $1\frac{3}{4}$ inches long. On the other two specimens (a 2-gallon jug and a 4-gallon churn), the mark has an added second line with the word *Bennington* of the same length as was used for that word in the *Bennington Factory* mark of the previous period. Again, reference to Vermont does not appear. All the marks are washed with cobalt blue. Although three of the specimens hold more than a gallon, none bears any indication of its capacity.

The 1828–33 Period

L. NORTON.
BENNINGTON

or

L. NORTON
BENNINGTON

The type, as previously, is all in capitals $\frac{1}{4}$ inch in height. In one example (a bulging, wide-mouth jar), there is a distinct period after *Norton* making the line $2\frac{1}{8}$ inches long, or $\frac{1}{8}$ inch longer than the other three cases bearing the second variant mark. This first jar, however, has a large, underglaze cobalt blue *2* on the body indicating the capacity in gallons. The other three pieces bearing the second variant mark lack merely the period after *L. Norton.* As previously, the marks have a wash of cobalt blue.

In these three specimens, however, we find the introduction of type-impressed numerals indicating the capacity of the vessel in gallons. Perhaps as might be expected of a new practice, a *2* has been imprinted by error above the mark on a one-gallon bulging, wide-mouth jar, while a *3* is correctly placed over another vessel of the same type. There is also a jug with a *2*, in this case placed below the mark.

The 1833–38 Period

L. NORTON & SON

or

L. NORTON & SON
BENNINGTON

or

L. NORTON & SON
EAST BENNINGTON

The type face continues to be all in upper case, but the size has been reduced to $\frac{3}{16}$ inch in height on pieces of one-gallon capacity or more, no doubt due to the lengthening of the mark. A $\frac{1}{4}$-gallon jug, however, bears the single-line mark in type only $\frac{1}{8}$ inch high, while the legend is but $1\frac{9}{16}$ inches long. Two other stamps seem to have been in use for each of the first two variant marks as the *L. Norton and Son* is $2\frac{1}{2}$ inches long in seven cases and only $2\frac{3}{8}$ inches in six, while the *Bennington* also varies, being $2\frac{3}{16}$ inches long in two cases and only 2 inches long in the other two.

Four of the fourteen pieces have the second variant mark with the name of the town. No correlation between the length of the line and any other factors has been found. The second, or double-line, variant occurs on jars of 2-gallon capacity or larger, but not necessarily on all large jars, nor on a 4-gallon jug.

In our collection there are no specimens with the third variant mark of the period which introduces the term *East Bennington*, but the Bennington Museum has two, a one-gallon jug and a 2-gallon jar with an inset cover.

Of our fourteen pieces, five have the mark washed with cobalt blue, three are brown since the specimens are covered all over with a brown glaze, and six lack any added color. It is notable, however, that salt-glazed pieces with brown floral decoration all have plain, unwashed marks, while pieces with cobalt blue designs may or may not have their marks washed with blue.

An Arabic numeral is stamped below the period mark on pieces of over one-gallon. Four examples of a *2* and three of a *3* are $\frac{5}{8}$ inch high, while one example of a *6* is $\frac{7}{8}$ inch high.

The 1838–44 Period

JULIUS NORTON.
BENNINGTON VT

or

JULIUS NORTON
BENNINGTON VT

or

JULIUS NORTON
EAST BENNINGTON VT

or

J. NORTON
EAST BENNINGTON VT

We find that we have four pieces of the first *Julius Norton* period as determined by their oval-shaped appearance. Four variant marks apparently were used, but only the first two which, incidentally, introduce the reference to Vermont, appear in our collection. No example of either the third or the fourth variant has been seen.

On our four specimens, the marks all appear in capital letters $\frac{3}{16}$ inch high. The first variant on a one-gallon jug has an upper line $2\frac{1}{8}$ inches long and a lower line $2\frac{3}{8}$ inches long. On a 3-gallon bulging, open mouth jar, both lines are $2\frac{1}{4}$ inches long.

For the second variant mark which is distinguished by a lower line in italic type, only one stamp seems to have been used on our pieces, for the two

specimens (a one-gallon and a 2-gallon jug) each have both lines of the same $2\frac{1}{4}$ inch length.

Capacity marks appear on the specimens holding over two gallons, a *2* below the mark being $\frac{5}{8}$ inch high, and a *3* curiously enough, only $\frac{3}{8}$ inch high.

The 1844–47 Period

NORTON & FENTON,
East Bennington, Vt.

or

NORTON & FENTON
BENNINGTON VT

or

We have found three variant marks of the *Norton and Fenton* period, the first on ten of our thirteen pieces. It consists of two lines, the first in upper case and the lower in caps and lower case. The upper case font is approximately $\frac{1}{4}$ inch high and the lower line font $\frac{3}{16}$ inch. Six of the pieces were made with a stamp which has an upper line $2\frac{1}{4}$ inches long and a lower which is $2\frac{1}{2}$ inches, while in the four others the corresponding lengths are $2\frac{1}{8}$ and $2\frac{1}{4}$ inches. Actually, the lines of this mark may be slightly curved.

The second variant has the two lines all in caps but the lower one is in

italic type. Our one example of the second variant has the upper line $2\frac{7}{8}$ inches long in type $\frac{1}{8}$ inch high. The second line in italic caps and lower case is $2\frac{1}{2}$ inches long and $\frac{1}{8}$ inch high.

Two examples of the third variant have the stamp in circular form one creating an almost perfect circle, one slightly elliptic. The *Bennington Vt* is also in italic type. The circles are $2\frac{1}{4}$ and $2\frac{3}{8}$ inches in diameter with type $\frac{3}{8}$ inch high for the family names and $\frac{1}{4}$ inch for the town. All the marks are washed with cobalt blue (Pl. 4 LL).

All but three of the pieces have an Arabic numeral indicating the capacity. Of these, all but one are under the period mark, the exception being in the center of the circular mark. The *2* is $\frac{1}{2}$ inch, the *3* is $\frac{5}{8}$ inch, and the *4* is $\frac{7}{8}$ inch high. Two of the three specimens without a capacity mark are one-gallon jugs, the other a three. All the marks are washed with cobalt blue.

The 1847–50 Period

JULIUS NORTON
BENNINGTON VT.

or

JULIUS NORTON
BENNINGTON, VT

or

JULIUS NORTON
BENNINGTON VT

Of the later Julius Norton marks we find three variants, one with a period after *VT.*, one with a comma after *Bennington*, and one with neither the period nor the comma. Six of the nine specimens bear the first variant, two have the second, and one the third. Seven of the nine have the upper line in caps $\frac{3}{16}$ inch high and the lower line only $\frac{1}{8}$ inch high. The other two have both lines with upper case type $\frac{1}{8}$ inch high. The latter includes a 6-gallon churn,

one of the largest pieces in the collection, thus indicating a lack of any correlation between vessel and type size. In all cases the lower and upper lines are of equal length, but on four specimens they are $1\frac{3}{4}$ inches long, on four others $1\frac{7}{8}$ inches, and on one specimen $2\frac{1}{8}$ inches. Again there is no correlation with type or size of vessel. All the marks have a blue wash except that on one jug which has an all-over brown glaze.

Capacity marks occur in Arabic numerals on all except the two one-gallon pieces. A $1\frac{1}{2}$ is $\frac{5}{8}$ inch high, a 2 is $\frac{3}{8}$ inch, three 3's are $\frac{1}{2}$ inch and two other $\frac{5}{8}$ inch, while a 6 is $1\frac{1}{8}$ inches high.

The 1850–59 Period

J. & E. NORTON
BENNINGTON VT

or

J. & E. NORTON.
BENNINGTON VT.

or

J. & E. NORTON
BENNINGTON VT.

All the J. and E. Norton marks which we have recorded consist of two lines of upper case type and end in the abbreviation *VT* with or without the period. The twenty-two specimens of the first variant are in type $\frac{3}{8}$ inch high. Ten of these have the two lines $1\frac{7}{8}$ inches long, while on twelve they are 2 inches long. The six specimens of the second variant which differs in having a period after *Norton.* and *Vt.*, are also in $\frac{3}{8}$ inch type and both lines are $1\frac{7}{8}$ inches long. Only two specimens have been recorded with the third variant which is distinguished by larger, $\frac{1}{4}$ inch high type. The lines of one specimen are both $2\frac{5}{8}$ inches long; of the other, $2\frac{3}{4}$ inches. Two specimens have been found without the usual cobalt blue wash on the mark.

Arabic numerals indicating the capacity in gallons are stamped below the makers' mark on pieces over one-gallon in size. The three $1^1/_2$-gallon numerals and one *2* are $\frac{1}{2}$ inch high; another *2* and a *4* (no example of 3 or 5) are $\frac{3}{4}$ inch, and the *6* is $1\frac{1}{4}$ inches high. All except one are in the familiar font found in previous periods. We may emphasize the fact that the Arabic numeral *1* continues not to be used.

The 1859–61 Period

J. NORTON & CO:
BENNINGTON VT:

This mark of which we have eight specimens consists of a double line of upper case type $\frac{1}{4}$ inch in height and $3\frac{1}{4}$ inches long. Each line appears to end in a colon although the impression is faint or uncertain in some cases.

Arabic numerals are stamped below the mark on pieces of over one gallon, as has been usual. A $1^1/_2$ and two *2*'s are $\frac{1}{2}$ inch high; a *3* is $\frac{5}{8}$ inch, while another *2* and a *4* are $\frac{3}{4}$ inch high.

The 1861–81 Period

E & L P NORTON
BENNINGTON VT:

The mark of the long *E. and L. P. Norton* period on our twenty-five pieces is consistently in two lines all in capitals with a colon at the end of *VT*: In twenty-one instances type $\frac{1}{4}$ inch high has been used, in three instances $\frac{3}{8}$ inch, and in one, the upper line is $\frac{1}{4}$ inch and the lower $\frac{3}{8}$ inch. The length of the lines does vary indicating different stamps in use. The most common is used on sixteen vessels with the upper line $2\frac{7}{8}$ inches and the lower is $2\frac{3}{4}$ inches. In two other cases, both lines are $2\frac{3}{4}$ inches, and in one, both lines are $2\frac{7}{8}$ inches. A major change in the stamp length occurs in five instances where the upper line is $3\frac{1}{4}$ inches and the lower $3\frac{5}{8}$ inches. Not only is this stamp longer but the relative length of the upper and lower lines are reversed in comparison to the first mentioned stamp. There is also one instance in which both lines

are 3¼ inches long. There seems to be no correlation between the size of the stamp and the size or type of vessel. Excepting those on seven pieces with an all-over brown glaze, all marks but one are washed with blue.

Arabic numerals, as usual, are impressed below the stamp of vessels of over one-gallon capacity. Two *1¹/₂*'s, one *3*, and five *4*'s are ⅝ inch high while six *2*'s and *3*, and one *4* are ¾ inch high. In the case of one four-gallon jug, the use of the capacity numeral was apparently forgotten and the decoration supplied the deficiency by adding in the usual place a crudely made *4* in cobalt blue 1½ inches high.

The 1881–83 Period

E. NORTON
BENNINGTON, VT.

No pieces with this mark are known to us.

The 1883–94 Period

E NORTON & CO
BENNINGTON VT

or

EDWARD NORTON,
BENNINGTON, VT.

or

EDWARD NORTON & CO.,
BENNINGTON, VT.

or

EDWARD NORTON & COMPANY,
BENNINGTON, VT.

We have seventeen pieces with the first variant mark which is consistently in two lines of upper case type $\frac{1}{4}$ inch high and lacks any punctuation. In eight instances, both lines are $2\frac{11}{16}$ inches long; in five instances, both are $2\frac{9}{16}$ inches long; and in four instances, the upper line is $2\frac{11}{16}$ inches and the lower $2\frac{1}{16}$ inches. As usual, there is no correlation with type or size of vessel. All the marks except four on brown over-all glaze specimens are washed with cobalt blue. As in the previous period, this wash is sometimes faint.

Also, only pieces of over one-gallon have Arabic numerals below the period mark to indicate the capacity, three *2*'s, two *3*'s, and one *4* are each $\frac{5}{8}$ inch high, and one *6* is $\frac{7}{8}$ inch high. One 2-gallon jar with an inset cover lacks the usual indication of capacity.

No pieces bearing any of the other three variants listed by Spargo are known to us.

The 1886–94 Subsidiary Period

THE EDW'D NORTON CO.
BENNINGTON, V.T.

The final subsidiary period corresponding to the last eight years of the previous period has many unique features including the mark which is not incised into the clay body of the ware but printed in cobalt blue over an off-white slip. The uniformity of the marks on all seven of our specimens suggests that a rubber stamp may have been used. The letters, as had become customary, are all in capitals, and the mark is in the usual two lines. The punctuation itself is unique in having a gratuitous period after the *V* as well as the *T* of the abbreviation for *Vermont*. The upper line, we may note, is $2\frac{5}{8}$ inches long, while the lower, which is offset to the right as another unique feature, is 2 inches long. The type is $\frac{3}{8}$ inch high and there is $\frac{1}{4}$ inch between the two lines.

Arabic numerals showing the capacity in gallons appear on all pieces of over one-gallon size. They are seemingly made with a stencil as the numerals

show characteristic separations in the figures which seem to have been out-lined by hand. The numerals are conspicuously large, and each has a three-line embellishment spreading like rays from each side. The four *2*'s are $1\frac{3}{8}$ inches high and, including the rays $3\frac{5}{8}$ inches wide; the *4* is $2\frac{1}{8}$ inches high and, including the rays, 5 inches wide; while the *5* on a jug is $2\frac{3}{8}$ inches high and with the rays, $4\frac{7}{8}$ inches wide.

The data on type size and line length has been summarized in the following table.

Table of Type Size and Line Lengths in Inches

	Mark	Height of Type	Length of Lines	Ht. of Capacity Numerals						
				1	1½	2	3	4	5	6
1.	Bennington Factory	¼, ¼	2⅜, 1¾							
2a.	L. Norton, & Co. [1]	¼, ¼	1¾, 1¾							
2b.	L. Norton and Co. Bennington	¼, ¼	1¾, 2⅜							
3a.	L. Norton. Bennington	¼, ¼	2⅛							
3b.	L. Norton Bennington	¼, ¼	2, ?							
4a.	L. Norton & Son [2]	3⁄16	2½, 2⅜	⅝		⅝	⅝			⅞
4b.	L. Norton & Son Bennington	3⁄16	2⅓, 2⅜; 2 3⁄16, 2				⅝			
5a.	Julius Norton. Bennington Vt	3⁄16	2⅛, 2¼			⅝	⅜			
5b.	Julius Norton *Bennington Vt* [3]	3⁄16	2⅜, 2¼; 2¼, 2¼							
6a.	Norton & Fenton [4] East Bennington, Vt. [5]	¼, 3⁄16	2¼, 2⅛; 2½, 2¼		½		⅝	⅞		
6b.	Norton and Fenton *Bennington Vt* [3]	⅛, ⅛	2⅞, 2½		½		⅝	⅞		
6c.	Norton and Fenton *Bennington Vt* [3,6]	⅜, ⅜	2½D, 2⅜D							

over

	Mark	Height of Type	Length of Lines	Ht. of Capacity Numerals						
				1	1½	2	3	4	5	6
7a.	Julius Norton Bennington Vt.(7)	3/16, 1/8; 1/8, 1/8	1¾, 1⅞; 1¼, 1⅞		5/8	3/8	½, ⅝			1⅛
7b.	Julius Norton Bennington Vt.									
7c.	Julius Norton Bennington, Vt									
8a.	J. & E. Norton Bennington Vt	3/8 3/8; 3/8 3/8	1⅞, 2; 1⅞, 2		½	½, ¾		¾		1¼
8b.	J. & E. Norton Bennington Vt.	3/8 3/8; 3/8 3/8	1⅞; 1⅞							
8c.	J. & E. Norton Bennington Vt.	1/4 1/4; 1/4 1/4	2⅝, 2¾; 2⅝, 2¾							
9.	J. Norton & Co: Bennington Vt:	1/4 1/4; 1/4 1/4	3½; 3½		½	½, ¾	⅝	¾		
10.	E. and L. P. Norton Bennington Vt:	1/4, 3/8(8)	2⅞, 2¾, 2⅞, 3¼; 2¾, 2¾, 2⅞, 3⅝		5/8	¾	¾	¾		
12a.	E. Norton & Co Bennington Vt	1/4 1/4; 1/4 1/4	2 11/16, 2 9/16, 2 11/16; 2 11/16, 2 9/16, 2 11/16			⅝	⅝	⅝		⅞
13.	The Edw'd Norton Co. Bennington, V.T.	3/8 3/8; 3/8 3/8	2⅝"; 2			2 = 1⅜ by 3⅝ 4 = 2½ by 5 5 = 2⅝ by 4⅞(9)				

(1) *o* of Co. is l.c.
(2) Ht. 1/8" on a ¼ gal. jug + 1 9/16
(3) Lower line in italics
(4) Line slightly curved
(5) Caps and lower case
(6) Mark in circle
(7) Both lines always equal
(8) Rare. Also one case of upper line ¼, lower ⅜
(9) Including rays

ACKNOWLEDGMENTS

IN OUR RECOGNITION of help received, we would like to acknowledge the authors of certain books and papers whose previous research has been the foundation on which our present study has been erected, as well as the gracious support of individuals who have given personal assistance in carrying on our studies. Inevitably, however, only a few of the contributors will be mentioned by name, a fact which makes us nonetheless grateful to those many—dealers, collectors, and other individuals—from whose efforts and cooperation we have profited.

Beyond doubt it was John Spargo's *The Potters and Potteries of Bennington* that fused our early interest in ceramics with the stoneware producers of Bennington, and without this valued work of 1926, we would probably have never made a collection of jugs from that famous town. In our own presentation, we have depended largely on his timely researches respecting the Nortons and their business undertakings, data which without his efforts would not have survived. Then, in order to enlarge the base from which to approach a specialized interest in Vermont, we have borrowed from that generous account of *Early New England Potters and Their Wares* by Lura Woodside Watkins, a scholarly segment of research without which the cupboard of knowledge on early American folk ceramics would be almost bare. What we have somewhat succinctly written on the same subject is hardly more than a condensation of the results of her decades of labor. In order to aid in an understanding of the technical aspects of ceramics, we have mixed in our clay the more meticulous accounts and different approaches that have been presented in authoritative papers by Henry Hodges and Anna O. Shepard. To these four scholars we record our particular gratitude and recommend

205

their publications listed in our bibliography to any reader who wishes to reinforce his knowledge of the subject we have herein surveyed.

Among individuals who have aided us personally, we wish specially to thank Richard Carter Barret of the Bennington Museum whose gracious cooperation has extended over the years. Not only has he made the Museum collections completely available to us but he has freely given information with respect to Norton stoneware which in one's own interest others might have retained. He was quick to point out how a date on a jug contravened Spargo's assumed year for the beginning of the *Julius Norton* period and directed us to various manuscript material which otherwise might not have been found. He not only was our guide on our first visit to historic Norton sites but he gave a final reading and approval to the manuscript. Such helpful response from an unobligated stranger has seldom persisted so consistently.

Also we must mention personally our peripatetic friend, Edward J. Slanetz of Townshend, Dorset, and Star Lake, Vermont. From him we obtained many jugs over nearly a score of years. Indeed, when our interest lagged, he thrust newly discovered pieces upon us that he had enticed from old farmers during his weekly journeys over the state of Vermont. When we wanted to find a kiln site, it was he who led us to it and helped us to sample its wasters. Thus we record our thanks to an old friend. To another friend with still longer forbearance, the art historian George Kubler of Yale, we are grateful for a reading of the manuscript which, more significant than praise, resulted in the correction of two errors of commission.

Acknowledgment and thanks for the reproductions of designs on the stoneware as well as for maps and other text illustrations is due Rosanne Rowen who at an early stage took over and completed the task initiated by Jan Janosik. The original photographs of the stoneware which serve to illustrate the text were attempted by the writer, but the improvement demonstrated by Alonso H. Coleman of Yale's Audio Visual Center leaves us obligated to him for half of those published, including the color plates, as well as to his associate, Diane Barker, for the processing of hundreds of prints. One photograph (Plate 18) was supplied by the Museum of History and Technology, Smithsonian Institution, through the kindness of C. Malcolm Watkins, and for another (Plate 19) we are indebted to Richard Carter Barret of the Bennington Museum.

Sui-ling Soo shared in the pleasure of acquiring most of the pieces in our collection of salt-glazed stoneware and in all of the work on the manuscript apart from its writing. For such intimacy in activities, one praises heaven, not a person. As a last gesture, it is agreed that this endeavor should be dedicated to that gracious lady in whose company we first learned the salubrious satisfaction to be derived from an antiquarian taste.

<div align="right">CORNELIUS OSGOOD</div>

Yale University

BIBLIOGRAPHY

THIS BIBLIOGRAPHY lists only the sources selected for use in this study. There are hundreds of others that may attract the attention of collectors or those with specialized interests.

BARBER, EDWIN ATLEE

 1893. *The Pottery and Porcelain of the United States: An Historical Review of American Ceramic Art from the Earliest Times to the Present Day*, pp. xvii, 446, New York and London.

 1906 [1907]. *Salt Glazed Stoneware: Germany, Flanders, England and the United States*, pp. 1–32, Penn. Museum, Phila.

BARRET, RICHARD CARTER

 1958. *Bennington Pottery and Porcelain: A Guide to Identification*, pp. 1–342, New York.

 1964. *How to Identify Bennington Pottery*, pp. 1–72, Brattleboro, Vt.

BROOKS, HERVEY

 1935. *A History of South End Goshen, Connecticut*, pp. 1–16, John Norton Brooks, [Goshen?]

Bushell, S. W.
　1899.　*Oriental Ceramic Art* (text edition), pp. xiv, 942, New York.

Chang, Kwang-chih
　1969.　"Fengpitou, Tapenkeng, and the Prehistory of Taiwan," *Yale University Publications in Anthropology*, no. 73, pp. xviii, 279, New Haven, 1969.

Cheng Te-k'un
　1959.　*Archaeology in China: Vol. I. Prehistoric China*, vol. 1, pp. xix, 250, Cambridge.
　1960.　*Archaeology in China: Vol. II. Shang China*, vol. 2, pp. xxviii, 368, Cambridge.

Clow, A. and N. L.
　1958.　"Ceramics from the Fifteenth Century to the Rise of the Staffordshire Potteries," in Singer, Charles, et al. (Editors), *A History of Technology*, vol. IV, pp. 328–357, Oxford.

Cothren, William
　1879.　*History of Ancient Woodbury, Connecticut, from 1659 to 1871 Including the Present Towns of Washington, Southbury, Bethlehem, Roxbury, and a Part of Oxford and Middlebury*, 3 vols., pp. xi, 833; 841–1610; 1–706, Waterbury, Conn.

Dana, Henry Swan
　1889.　*History of Woodstock, Vermont*, pp. xv, 641, Boston and N.Y.

Davis, John Francis
　1857.　*China: A General Description of that Empire and Its Inhabitants; with the History of Foreign Intercourse Down to the Events which Produced the Dissolution of 1857*, 2 vols., pp. xx, 480; vii, 428, London.

Day, Henry Clay
　1844 (Sept. 5)–1919 (May 26).　*Historical Writings* (Mss), Bennington, Vt.

DIMOCK, SUSAN W.
 1898. *Births, Baptisms, Marriages and Deaths from the Records of Town and Churches in Mansfield, Connecticut, 1703–1850,* pp. vi, 475, New York.

DOW, GEORGE FRANCIS
 1935. *Every Day Life in the Massachusetts Bay Colony,* pp. xii, 293, Soc. for the Pres. of N. England Antiquities, Boston.

Encyclopaedia Britannica: Fourteenth Edition, New York, 1929.

FIELD, DAVID DUDLEY, ET AL.
 1829. *A History of the County of Berkshire,* pp. 1–468, Pittsfield, Mass.

FLINT, WILLIAM W.
 1927. "The Millville Pottery, Concord, N. H." *Old-Time New England,* vol. 17, no. 3, pp. 99–106, Boston.

GODWIN, H.
 1962. "Half-life of Radiocarbon," *Nature,* vol. 195, no. 4845, p. 984, London.

GOYLE, G.A.R.
 1934–35. "First Porcelain Making in America," *The Chronicle of the Early American Industries Association,* vol. 1, no. 8, pp. 1, 3–4 (1934); no. 9, pp. 3, 7; no. 10, p. 3; no. 11, p. 6 (1935), Flushing, N.Y.

HALL, BENJAMIN H.
 1858. *History of Eastern Vermont From Its Earliest Settlement to the Close of the Eighteenth Century with a Biographical Chapter and Appendixes,* pp. xiii, 799, New York.

HARWOOD, BENJAMIN AND HIRAM
 1805 (Mar. 22)–1837 (Oct. 23). *Harwood Diaries* (Mss), n.p., Bennington.

HETHERINGTON, A. L.
 1948. *Chinese Ceramic Glazes,* pp. x, 116, Los Angeles.

HIBBARD, A. G.

　　1897. *History of the Town of Goshen, Connecticut with Genealogies and Biographies*, pp. 1–602, Hartford, Conn.

HODGES, HENRY

　　1964. *Artifacts: An Introduction to Primitive Technology*, pp. 1–248, New York and London.

HONEY, WILLIAM BOYER

　　1945. *The Ceramic Art of China and Other Countries of the Far East,* pp. vii, 238, London.

HYDE, J. A. LLOYD

　　1931. "The Yesterday and Today of Oriental Lowestoft," *Antiques*, vol. 19, pp. 447–448, New York.

JENNINGS, ISAAC

　　1869. *Memorials of a Century. Embracing a Record of Individuals and Events Chiefly in the Early History of Bennington, Vt. and Its First Church*, pp. xviii, 19–408, Boston.

JOHNSON, FREDERICK

　　1951. "Radiocarbon Dating," *American Antiquity*, vol. 17, no. 1, part 2, pp. 1–65, Salt Lake City.

JOPE, E. M.

　　1956. "Ceramics: Medieval," in Singer, Charles, et al (Editors), *A History of Technology*, vol. II, pp. 284–310, Oxford.

KILBOURNE, PAYNE KENYON

　　1859. *Sketches and Chronicles of the Town of Litchfield, Connecticut, Historical, Biographical, and Statistical; Together with a Complete Official Register of the Town*, pp. vii, 264, Hartford.

MORGAN, EDMUND S.

　　1962. *The Gentle Puritan: A Life of Ezra Stiles, 1727–1795,* pp. ix, 490, New Haven.

NEEDHAM, JOSEPH AND WANG LING

1962. *Science and Civilization in China. Vol. 4 Physics and Physical Technology. Pt. 1. Physics*, pp. xxxiv, 434, Cambridge.

NORTON, F. H.

1931a. "The Crafts Pottery in Nashua, New Hampshire," *Antiques*, vol. 19, pp. 304–305, New York.

1931b. "Potter and Potter's Wheel: A Pictorial Demonstration," *Antiques*, vol. 19, pp. 23–25, New York.

1932. "The Exeter Pottery Works," *Antiques*, vol. 22, pp. 22–25, New York.

NORTON, F. H. AND V. J. DUPLIN JR.

1931. "The Osborne Pottery at Gonic, New Hampshire," *Antiques*, vol. 19, pp. 123–124, New York.

OBA, TOSHIO AND CHESTER S. CHARD

1963. "New Dates for Early Pottery in Japan," *Asian Perspectives: 1962*, vol. 6, pp. 75–76, Hong Kong.

OSGOOD, CORNELIUS

1951. *The Koreans and Their Culture*, pp. xvi, 387, New York.

1956. *Blue-and-White Chinese Porcelain: A Study of Form*, pp. xvii, 166, New York.

PITKIN, ALBERT HASTINGS

1918. *Early American Folk Pottery Including The History of Bennington Pottery*, pp. 1–152, Hartford.

RIES, HEINRICH AND HENRY LEIGHTON

1909. *History of the Clay-Working Industry in the United States*, pp. ix, 270, New York.

ROBINSON, JOHN

1924. "Blue and White 'India-China'," *Old-Time New England*, vol. 14, no. 3, pp. 99–121, Boston.

Rowe, William Hutchinson
 1937. *Ancient North Yarmouth and Yarmouth, Maine, 1636–1936. A History*, pp. xiii, 415, Yarmouth, Me.

Scott, Lindsay
 1954. "Pottery" in *A History of Technology*, pp. 376–412, Oxford.

Shepard, Anna O.
 1956. *Ceramics for the Archaeologist*, pp. xii, 414, Carnegie Institution of Washington, Pub. 609. Washington, D.C.

Singer, et al. (Editors)
 1954. A History of Technology, pp. xlvii, 827, Oxford.

Spargo, John
 1926. *The Potters and Potteries of Bennington*, pp. xv, 270, Boston.
 1948. *The A.B.C. of Bennington Pottery Wares: A Manual for Collectors and Dealers*, pp. 1–38, Bennington, Vt.

Sundius, Nils
 1961. "Some Aspects of the Technical Development in the Manufacture of the Chinese Pottery Wares of Pre-Ming Age," *Museum of Far Eastern Antiquities*, Bull. 33, pp. 103–124, Stockholm.

Watkins, Lura Woodside
 1950. *Early New England Potters and Their Wares*, pp. x, 291, Cambridge.

Weaver, William L. (Compiler)
 1867. *Genealogy of the Fenton Family, Descendants of Robert Fenton, an Ancient Settler of Ancient Windham, Conn., (Now Mansfield)*, pp. 1–34, Willimantic, Conn.

Woodruff, George C.
 1910. *A Genealogical Register of the Inhabitants of the Town of Litchfield, Conn.*, pp. 1–267, Hartford.

Wu, G. D.
 1938. *Prehistoric Pottery in China*, pp. xi, 180, London.

REFERENCES TO SOURCES

For full details see the Bibliography, pp. 207–212.

1. Osgood, 1956
2. Johnson, 1951: 1–2; Godwin, 1962: 984
3. Chang, 1969: 217–218, 221, 248; Oba & Chard, 1963: 75–76
4. Cheng, 1959: 58
5. *Ibid*: 57
6. Cheng, 1960: 137
7. Wu, 1938: 23–24, 40; Cheng, 1960: 138
8. Sundius, 1961: 106
9. Cheng, 1960: 140
10. *Ibid*: 146–147
11. *Ibid*: 245
12. Wu, 1938: 41–42: Cheng, 1960: 151
13. Sundius, 1961: 109
14. Cheng, 1960: 152
15. Sundius, 1961: 111
16. Cheng, 1960: 245
17. Sundius, 1961: 111
18. Honey, 1945: 97
19. Clow, 1958: 328
20. Needham, 1962: 101
21. Jope, 1956: 299–300
22. Clow, 1958: 329
23. Jope, 1956: 287
24. Clow, 1958: 331; Jope, 1956: 295, 297
25. Ency. Brit., 1929: 350
26. Jope, 1956: 287
27. Honey, 1945: 17
28. *Ibid*: 182
29. Ency. Brit., 1929: 351
30. *Ibid*: 351
31. *Ibid*: 351, 353
32. *Ibid*: 1929: 348
33. Shepard, 1956: 8; Hodges, 1964: 21
34. Shepard, 1956: 10
35. *Ibid*: 7, 11; Hodges, 1964: 23
36. Shepard, 1956: 16
37. *Ibid*: 11
38. Hodges, 1964: 24
39. Shepard, 1956: 16–17
40. Hodges, 1964: 19
41. *Ibid*: 20
42. *Ibid*: 20
43. *Ibid*: 23
44. *Ibid*: 20; Shepard, 1956: 26
45. Shepard, 1956: 24–25
46. *Ibid*: 27
47. *Ibid*: 25; Hodges, 1964: 20
48. Shepard, 1956: 28
49. Hodges, 1964: 20
50. *Ibid*: 25–27
51. *Ibid*: 28
52. *Ibid*: 28–29
53. *Ibid*: 30
54. *Ibid*: 30
55. *Ibid*: 31
56. Osgood, 1951: 264
57. Hodges, 1964: 35

58. *Ibid.* 35
59. Scott, 1954: 379
60. Hodges, 1964: 31
61. *Ibid*: 34
62. *Ibid*: 32
63. *Ibid*: 33
64. Watkins, 1950: 8
65. Hodges, 1964: 36
66. *Ibid*: 35–38
67. Jope, 1956: 296
68. Hodges, 1964: 23
69. *Ibid*: 24
70. *Ibid*: 25
71. *Ibid*: 23
72. Watkins, 1950: 46, 128
73. Hodges, 1964: 38–39
74. *Ibid*: 39
75. *Ibid*: 42
76. *Ibid*: 69
77. *Ibid*: 46
78. *Ibid*: 49
79. Hetherington, 1948: 4; Bushell, 1899: 334–335, 425
80. Hodges, 1964: 49
81. *Ibid*: 49–50
82. *Ibid*: 40
83. Hetherington, 1948: 15
84. *Ibid*: 24
85. *Ibid*: 16
86. *Ibid*: 54–56
87. *Ibid.* 30
88. Watkins, 1950: 14
89. *Ibid*: 16
90. Jope, 1956: 28
91. Ries & Leighton, 1909: 9
92. Jope, 1956: 304
93. Watkins, 1950: 54, 160
94. *Ibid*: 80, 127
95. Morgan, 1962: 256
96. Watkins, 1950: 80
97. Hyde, 1931: 448
98. Barber, 1893: 105
99. Watkins, 1950: 15
100. *Ibid*: 3
101. Norton & Duplin, 1931: 123
102. Watkins, 1950: 125
103. Norton, 1932: 23

104. Watkins, 1950: 157; Rowe, 1937: 325; Flint, 1927: 99
105. Watkins, 1950: 5–6, 77; Norton & Duplin, 1931, 123
106. Norton, 1932: 23
107. Norton, 1932: 23–24; Norton, 1931b: 23–25; Watkins, 1950: 6, 137
108. Watkins, 1950: 63
109. Norton & Duplin, 1931: 123
110. Watkins, 1950: 53
111. *Ibid*: 128
112. Norton & Duplin, 1931: 124
113. Norton, 1932: 24–25
114. Watkins, 1950: 64
115. *Ibid*: 126
116. Norton & Duplin, 1931: 124
117. Watkins, 1950: 9
118. Norton & Duplin, 1931: 124
119. Norton, 1932: 25
120. Norton & Duplin, 1931: 124
121. Jope, 1956: 296
122. Watkins, 1950: 9
123. *Ibid*: 26
124. Norton & Duplin, 1931: 124
125. Watkins, 1950: 64
126. Norton, 1932: 25
127. Watkins, 1950: 9, 36
128. Norton & Duplin, 1931: 124; Norton, 1932: 25; Watkins, 1950: 9
129. Watkins, 1950: 2
130. Norton, 1932: 23, 25
131. *Ibid*: 24
132. Watkins, 1950: 160
133. Norton & Duplin, 1931: 124
134. *Ibid*: 124; Watkins, 1950: 6
135. Watkins, 1950: 97
136. Norton & Duplin, 1931: 124
137. Watkins, 1950: 171
138. *Ibid*: 3, 10
139. *Ibid*: 234
140. *Ibid*: 236
141. *Ibid*: 58, 102
142. *Ibid*: 176
143. *Ibid*: 234
144. *Ibid*: 13

145. Flint, 1927: 105
146. Watkins, 1950: 58
147. Davis, 1857: 2: 404–405
148. Watkins, 1950: 35
149. Barber, 1893: 63, 105
150. Goyle, 1934: 3
151. Watkins, 1950: 35
152. *Ibid*: 35–38
153. *Ibid*: 178
154. *Ibid*: 184
155. Cf. Watkins, 1950: 83
156. Watkins, 1950: 180, 210
157. *Ibid*: 82–83
158. *Ibid*: 82, 167
159. *Ibid*: 118
160. Hodges, 1964: 48
161. Robinson, 1924: 108
162. Jennings, 1869: 20
163. *Ibid*: 20
164. *Ibid*: 21–22
165. *Ibid*: 25, 336, 355
166. Hall, 1858: 130
167. *Ibid*: 130
168. Hibbard, 1897: 507–508, 516
169. Pitkin, 1918: 16
170. Harwood, 8/24/28
171. Spargo, 1926: 4
172. Watkins, 1950: 172–173
173. Hibbard, 1897: 438, 518
174. Kilbourne, 1859: 71
175. Watkins, 1950: 100
176. Field, 1829: 197
177. Harwood: 8/24/28; Spargo, 1926: 3–5
178. Day, Book V: 95; Spargo, 1926: 5
179. Day, Book M: 218
180. Harwood: 11/3/10
181. Watkins, 1950: 136–137
182. *Ibid*: 137
183. *Ibid*: 113
184. *Ibid*: 148–150
185. Weaver, 1867: 3–15
186. Watkins, 1950: 151–152
187. *Ibid*: 141
188. *Ibid*: 255
189. *Ibid*: 142
190. Harwood: 4/16/31
191. Watkins, 1950: 142, 255
192. *Ibid*: 89
193. *Ibid*: 142
194. *Ibid*: 152
195. Spargo, 1926: 15–16
196. *Ibid*: 11
197. Watkins, 1950: 137
198. Spargo, 1926: 37; Watkins, 1950: 258
199. Woodruff, 1910: 117
200. Spargo, 1926: 13
201. Harwood: 10/23/10
202. *Ibid*: 5/9/17; Spargo, 1926: 17
203. Spargo, 1926: 15
204. Harwood: 6/18/15
205. Spargo, 1926: 16
206. Harwood: 6/16/12
207. *Ibid*: 7/25/12
208. Spargo, 1926: 45
209. Harwood: 4/11/23; Spargo, 1926: 17
210. Harwood: 11/18/27; 11/16/31; Spargo, 1926: 51–52
211. Spargo, 1926: 52
212. Harwood, 4/18/13
213. *Ibid*: 1/1/11
214. Harwood: 4/18/13; 4/25/26; 4/29/26
215. *Ibid*: 2/12/15
216. *Ibid*: 12/27/31; 11/16/31
217. *Ibid*: 2/23/32
218. *Ibid*: 9/1/34
219. *Ibid*: 6/24/15
220. *Ibid*: 5/3/30; 4/25/27
221. *Ibid*: 6/29/31
222. *Ibid*: 5/30/26
223. *Ibid*: 4/19/31
224. *Ibid*: 10/7/33; 12/10/33
225. *Ibid*: 10/3/33
226. Spargo, 1926: 44
227. *Ibid*: 44
228. Harwood: 11/24/31
229. *Ibid*: 3/29/33
230. Spargo, 1926: 64
231. *Ibid*: 43, 68
232. Watkins, 1950: 145
233. Spargo, 1926: 65–66

234. *Ibid*: 80–82
235. *Ibid*: 90
236. *Ibid*: 89
237. *Ibid*: 89
238. *Ibid*: 92
239. *Ibid*: 93, 94
240. *Ibid*: 95
241. *Ibid*: 92
242. *Ibid*: 95–96
243. *Ibid*: 96
244. *Ibid*: 97
245. *Ibid*: 93
246. *Ibid*: 74
247. *Ibid*: 65, 93
248. *Ibid*: 21, 90
249. *Ibid*: 68
250. *Ibid*: 98
251. *Ibid*: 98
252. Spargo, 1948: 4
253. Watkins, 1950: 146
254. *Ibid*: 151
255. Barret, 1958: 110
256. Watkins, 1950: 147
257. *Ibid*: 151
258. Spargo, 1926: 68
259. *Ibid*: 72; Watkins, 1950: 169

260. Barret, 1958: 11
261. Watkins, 1950: 169
262. *Ibid*: 168–169, 213
263. Harwood: 10/24/31; 5/18/32
264. Barret, 1958: 111
265. *Ibid*: 6
266. *Ibid*: 8
267. Cf. Barret, 1958: 8
268. Watkins, 1950: 212–213
269. Barret, 1958: 8
270. *Ibid*: 7
271. *Ibid*: 4
272. *Ibid*: 5
273. Spargo, 1926: 98
274. Watkins, 1950: fig. 92
275. *Ibid*: 101
276. *Ibid*: 142
277. *Ibid*: 89 and our jugs
278. *Ibid*: 238
279. *Ibid*: 146
280. *Ibid*: 150
281. *Ibid*: 85
282. *Ibid*: 195
283. *Ibid*: 106
284. Shepard. 1956: 13

INDEX